The Victorian Self

The Victorian Self

Autobiography and Biblical Narrative

Heather Henderson

Cornell University Press

ITHACA AND LONDON

First published 1989 by Cornell University Press.

International Standard Book Number 0-8014-2294-9
Library of Congress Catalog Card Number 89-7270
Printed in the United States of America
*Librarians: Library of Congress cataloging information
appears on the last page of the book.*

*The paper in this book is acid-free and meets the guidelines for
permanence and durability of the Committee on Production Guidelines
for Book Longevity of the Council on Library Resources.*

For my mother
SHIRLEY HAZLEWOOD GREENBERG
and
in loving memory of my grandmother
MARIAN GERBER GREENBERG

Contents

Acknowledgments

WHILE JOHN RUSKIN complained that he had "neither goddess guides nor prophetic teachers," I have been more fortunate. My greatest debt is to John D. Rosenberg: I am grateful for his superb teaching, wise guidance, and critical insight. Without him this book would never have been written. I would also like to thank James McDonnell, who introduced me to the pleasures of Victorian literature; K. J. Fielding, who supervised the first steps I took as a scholar; and George Levine and Carl Woodring, whose teaching helped shape my thinking.

The original conception of this project came, in part, from conversations with David Damrosch, whose unfailing enthusiasm and support enabled me to get started and persuaded me to continue; at every stage I have profited from his close reading and imaginative criticism. Carl Woodring, Karl Kroeber, and Holland Hendrix read the manuscript and improved it with their thoughtful suggestions. Many other friends and colleagues at Columbia University and Mount Holyoke College have offered advice and encouragement. The book has also benefited from the efforts of my editor at Cornell University Press, Bernhard Kendler, and of the Press's readers, George P. Landow and Barry V. Qualls.

Acknowledgments

The dedication acknowledges two profound influences. My grandmother first aroused my interest in the Bible; her career as a scholar and teacher, and her devotion to the life of the mind, will always be an inspiration. My mother taught me to read and to think for myself; she has been my constant advocate.

Finally, I wish to thank my husband, William Chapman Sharpe, my best critic, who saw me through.

HEATHER HENDERSON

South Hadley, Massachusetts

Introduction

There was a pear-tree near our vineyard, loaded with fruit that was attractive neither to look at nor to taste. Late one night a band of ruffians, myself included, went off to shake down the fruit and carry it away. . . . Perhaps we ate some of [it], but our real pleasure consisted in doing something that was forbidden.

—Saint Augustine, *Confessions*

W E NEED old stories to tell new stories. In writing his own history, Augustine had recourse to Genesis, to the archetypal story of forbidden fruit, of transgression, fall, and exile. He thereby placed the account of his own sins in a universal context, making them part of the divine design of human history. For real experience is constructed experience—or, put another way, "autobiography is a shaping of the past. It imposes a pattern on a life, constructs out of it a coherent story."[1]

The writing of any autobiography necessarily involves a process of selection: the autobiographer chooses those events from his past which will form a story, a "personal myth."[2] For

[1] Roy Pascal, *Design and Truth in Autobiography* (Cambridge: Harvard University Press, 1960), 9.

[2] The term comes from Carl Jung's autobiography, *Memories, dreams, reflections*, ed. Aniela Jaffe, trans. Richard Winston and Clara Winston (New York: Pantheon, 1963).

[3]

autobiographers since Augustine, that personal myth has frequently been founded on the biblical narratives of conversion and salvation. The stories of Moses and Job, Jesus and Paul, provided models on which autobiographers could build, shaping their own life stories to emphasize significant parallels. Beginning in the seventeenth century, spiritual autobiography based on biblical figuration, or typology, flourished in Britain. But how could typology continue to function as a pattern for autobiographical narrative in the nineteenth century, an age when faith in providential history was threatened both by scientific discoveries in biology and geology, and by the new biblical criticism coming from Germany? That is the question this book explores, focusing on the autobiographies of John Henry Newman, John Ruskin, and Edmund Gosse.

The following chapters investigate how a typological conception of history influences the writing of autobiography—the history of the self—during the Victorian era. I show how typological motifs and structures persist, even while being questioned, modified, and subverted. For the continued use of typology by nineteenth-century autobiographers reveals more than the mere lingering of outmoded habits of mind.[3] Rather, my thesis will be that these writers made innovative use of the traditional imagery and structural patterns provided by typology to make statements very different from those of earlier spiritual autobiographers. I have chosen to discuss Newman's *Apologia*, Ruskin's *Praeterita*, and Gosse's *Father and Son* not only because they make perhaps the fullest use of typological motifs but also because, taken together, they illustrate the wide range of typology's narrative possibilities for the Victorian autobiographer.

More than just a rich source of literary allusion, typology was for nearly two thousand years the dominant Western

[3] In *Victorian Types, Victorian Shadows: Biblical Typology in Victorian Literature, Art, and Thought* (Boston: Routledge & Kegan Paul, 1980), George P. Landow notes that "many men and women retained habits of mind associated with typology long after its initial religious basis had changed or vanished" (56).

system of literary and philosophical interpretation. Originally conceived as a means of placing Jesus in the context of Hebrew scripture, Christian typology read the Bible as an end-oriented system of progressive revelation in which figures such as Adam, Moses, and David were viewed as "types" or fore-shadowings of Christ. This approach derived its authority in part from Paul, who called Adam "the figure of him that was to come" (Rom. 5:14). Typological exegesis stressed the parallels between distant events (Jonah swallowed by a whale and Christ descended into hell), discovering patterns of repetition in order to connect particular occurrences to a larger frame-work of religious and historical significance. Events in the Old Testament were seen to be fulfilled by events in the New; thus, only in light of the end did the full meaning of earlier history become apparent.[4]

The writing of the gospels was heavily influenced by the desire to perceive similarities between recent events and biblical history or prophecy. For example, Jesus fasts in the wilderness forty days and forty nights (Matt. 4:2), just as Moses spent forty days and forty nights on Mount Sinai (Exod. 24:18), or as the Israelites were forty years in the wilderness after the flight from Pharaoh (Exod. 16:35). As Frank Kermode says, "The new text is shaped to conform with the old." He describes how "the Old Testament and the Apocrypha are treated as a sort of seminary of narrative germs, which are transplanted and grow into the actual history-like story of the Passion. . . . In principle any Old Testament text had a narra-tive potential that could be realized in the New Testament."[5]

But if the gospels were patterned on the Hebrew scriptures

[4]In *Mimesis: The Representation of Reality in Western Literature*, Erich Auerbach notes that "the tremendous venture of missionary work among the Gentiles" provided a partially political motivation for the spread of typological interpretation. The Old Testament "was played down as pop-ular history and as the code of the Jewish people and assumed the appearance of a series of 'figures,' that is of prophetic announcements and anticipations of the coming of Jesus and the concomitant events" (trans. Willard R. Trask [Princeton: Princeton University Press, 1953], 48).

[5]Frank Kermode, *The Genesis of Secrecy: On the Interpretation of Narrative* (Cambridge: Harvard University Press, 1979), 83, 88.

in specific ways in order to highlight similarities, the technique of composition emphasizing repetition was even older, existing in the Hebrew writings themselves. For the Hebrew Bible utilizes both linear and cyclic views of history and narrative techniques. It tells a story that unfolds in history, moving, for example, in a continuum from Abraham to Isaac to Jacob to Joseph. Yet at the same time, recurring situations, such as the conflicts between pairs of brothers (Cain and Abel, Isaac and Ishmael, Jacob and Esau, Joseph and his brothers) or the scenes of annunciation (Sarah, Rebekah, Hannah), are at least as important as the forward progressive movement. The variations between similar episodes generate an intricate commentary on one another. For example, they can suggest a kind of moral development, as when Noah, Abraham, and Moses all question God when he is on the verge of punishing men by destroying them: Noah obeys God silently; Abraham bargains, with only partial success; Moses pleads with God, who repents and changes His mind. The Bible, then, is both a forward-moving, chronological history and a story of continual return. Two time schemes are at work, one based on narrative sequence and one based on recurrence. In the former, meaning develops through the progressive accretion of new information; in the latter, patterns of repetition determine significance. The point about repetition in both Hebrew scripture and Christian typology is that in each case the layering of history augments meaning.[6]

In both Hebrew and Christian writing the recurrence of

[6]There are, of course, differences between the Hebrew and Christian use of repetition. In the Hebrew scripture later events could not be said to *fulfill* earlier ones in the typological sense, such that, for example, the full meaning of the story of Abraham would become apparent only in light of the story of Moses. Yet, as Auerbach has shown, the past must always be borne in mind in order for the present to mean fully—to understand the Binding of Isaac episode we must be aware that Isaac is not just Abraham's son but the living symbol of God's covenant with him. "Abraham's actions are explained not only by what is happening to him at the moment . . . but by his previous history . . . his silent obedience is multi-layered, has background" (*Mimesis*, 12).

similar events testifies to their participation in the divinely authored story of human history.[7] For repetition assumes the existence of a God writing history's "plot" with a providential purpose outside historical time. As Robert Alter remarks, the fact of recurrence links the specific moment "to a larger pattern of historical and theological meaning." It reproduces "in narrative the recurrent rhythm of a divinely appointed destiny in Israelite history."[8] In turn, if narrative convention expressed a particular way of seeing the universe, the convention itself became one of the elements shaping that view. "The attitude embodied in the figural interpretation," says Erich Auerbach, "became one of the essential elements of the Christian picture of reality, history, and the concrete world in general."[9]

The conviction that repetition expressed the existence of a providential plan in history gave rise to a tradition in Western thought and literature in which, by extension, later secular events could also be seen as reenacting biblical ones. In this way more recent history participates in the typological continuum, gaining special significance by being linked to the overall redemptive scheme. Discussing the early phases of this tradition, Auerbach observes that "the figural view of history was widespread and deeply influential up to the Middle Ages, and beyond," so that for Dante, for example, "the meaning of every life had its place in the providential history of the world."[10] Even in the nineteenth century, Henry Melvill, Ruskin's favorite preacher, believed "that many types are as yet unfulfilled, that they await completion, that man, even

[7]The Victorian scholar of typology Patrick Fairbairn quotes Bishop Marsh on this point: "To constitute one thing the type of another, something more is wanted than mere resemblance. The former must not only resemble the latter, but must have been *designed* to resemble the latter" (*The Typology of Scripture* [1845; Grand Rapids: Zondervan Publishing House, 1952], 46).

[8]Robert Alter, *The Art of Biblical Narrative* (New York: Basic Books, 1981), 60; for a detailed discussion of this topic, see chapters 3 and 5.

[9]Erich Auerbach, "Figura," in *Scenes from the Drama of European Literature: Six Essays*, trans. Ralph Manheim (New York: Meridian, 1959), 53.

[10]"Figura" 60, 70.

man in the time of Queen Victoria, lives within a typologically structured universe."[11] Scripture thus provided both a theoretical framework and a narrative model for subsequent secular writing. Typology was a kind of language, a way of reading and interpreting not only religious texts but history itself.

Autobiographical writing is particularly suited to explore and to exploit typological possibilities, for the story of the individual's life may be shaped to emphasize parallels with biblical events, even as the story of Christ's life was shaped by the Gospel writers to emphasize parallels with Old Testament figures. Thus, the first modern autobiographer, Saint Augustine, set the pattern for later ones, modeling the story of his life on biblical types, from stealing fruit in a garden to an "annunciation scene" in which an angel tells his mother in a dream of his own coming spiritual rebirth.[12] The central event in the *Confessions* is Augustine's conversion, described so as to evoke St. Paul's conversion on the road to Damascus.[13] Augustine links his own experience with Paul's by telling how a

[11]George P. Landow, *The Aesthetic and Critical Theories of John Ruskin* (Princeton: Princeton University Press, 1971), 347.

[12]Augustine, writes Avrom Fleishman, "stands at a watershed in Western autobiography because he begins the active employment of the full range of Christian life models and classical literary devices. He is not the inventor of autobiography but the master of autobiographical figuration" (*Figures of Autobiography: The Language of Self-Writing in Victorian and Modern England* [Berkeley: University of California Press, 1983], 55). See also 53–69 for a fuller discussion of "Augustinian Figures."

[13]As Paul Delany puts it, "The voice which spoke to Paul from Heaven speaks again to St. Augustine" (*British Autobiography in the Seventeenth Century* [New York: Columbia University Press, 1969], 30). The story of Paul's conversion had an immense influence on later autobiographers. Delany points out that in the seventeenth century it "became such a *locus classicus* among the more extreme and Calvinistically-inclined Protestants that, in their autobiographies, they tried to make their early misdeeds seem as heinous as possible, attempting in this way to approximate Paul's dramatic change from a persecutor to a follower of Christ" (30). Tracing the rise of spiritual autobiography, Delany describes the "confident assumption" of Bunyan's *Grace Abounding to the Chief of Sinners* (1666) "that the spiritual experiences of the elect will always conform to a single basic pattern" (88).

heavenly voice instructs him to "take it and read;" when he opens the Bible at random, he reads a passage from Paul's Epistle to the Romans that finally brings about his conversion.[14]

Augustine saw himself, typologically speaking, as a second Paul, not only in his conversion but in his subsequent mission to convert others. His autobiography illustrates the way in which the telling of every life "story" requires a conversion for its climax—otherwise the story has no plot, and the telling of it no point. For in the act of telling, the writer becomes a missionary, influencing others to imitate him: "When others read of those past sins of mine . . . their hearts are stirred so that they no longer lie listless in despair, crying 'I cannot.'"[15] The Christian autobiographer acts therefore as an anti-type, or fulfillment, of Christ, and the autobiographical subject becomes a potential type for all men, a pattern for their redemption.

Whether filtered through Paul or Augustine, the prevalence of biblical motifs and patterns in later spiritual autobiography is unmistakable. In typologically structured autobiographies, certain motifs predominate: Edenic childhoods and lost Edens, fall and exile, journey or pilgrimage, crisis, conversion, renewal and return.[16] More specifically, "the history of the Israelites provides the structure for the personal history of the individual believer, and the significant events of the Exodus— the manna, the water from the rock, the pillars of cloud and fire, the crossing of the Jordan, the entry into Canaan—be-

[14]The distinction between Luke's Paul and the Paul of the Epistles should be borne in mind: the most familiar account of Paul's conversion derives from Luke's Acts, but Paul himself tells the story in Galatians, referring not to his "conversion" but to his "call."

[15]Augustine, *Confessions*, trans. R. S. Pine-Coffin (Harmondsworth: Penguin, 1961), 208.

[16]This list is partially derived from the rubrics Fleishman describes in *Figures of Autobiography*. He observes that "although later writers will focus on one or more of these phases, it is Augustine who most comprehensively assembles them" (58).

[9]

come prefigurations of Christian experience."[17] Such patterns can be traced in spiritual autobiographies of the seventeenth and eighteenth centuries, works that formed the basis of the tradition upon which nineteenth-century autobiographers drew. Thus *Grace Abounding to the Chief of Sinners* (1666), the most influential spiritual autobiography of the seventeenth century, opens with John Bunyan likening his struggle toward salvation to the trials of Moses in the desert, and concludes with his emulating yet surpassing Moses by finding the faith that will bring him "to mount Zion, to the City of the living God."[18]

Although the popularity of typology declined in the eighteenth century, it enjoyed a renaissance among the Victorians as preachers, authors, artists, and historians rediscovered its potential for ethical and artistic expression. As George Landow notes, "the first two-thirds of the nineteenth century saw a great, almost astonishing, revival of biblical typology, which left its firm impress upon Victorian literature, art, and thought."[19]

[17]Linda H. Peterson, "Biblical Typology and the Self-Portrait of the Poet in Robert Browning," in *Approaches to Victorian Autobiography*, ed. George P. Landow (Athens: Ohio University Press, 1979), 237–38.

[18]John Bunyan, *"Grace Abounding to the Chief of Sinners"* and *"The Pilgrim's Progress,"* ed. Roger Sharrock (London: Oxford University Press, 1966), preface and paragraph 264. For useful discussions of pre-Victorian spiritual autobiography, see George A. Starr, *Defoe and Spiritual Autobiography* (Princeton: Princeton University Press, 1965); John N. Morris, *Versions of the Self* (New York: Basic Books, 1966), 87–168; Delany, *British Autobiography*, 27–104; Fleishman, *Figures of Autobiography*, 70–108; Leopold Damrosch, Jr., *God's Plot and Man's Stories: Studies in the Fictional Imagination from Milton to Fielding* (Chicago: University of Chicago Press, 1985), 121–86; and Linda H. Peterson, *Victorian Autobiography: The Tradition of Self-Interpretation* (New Haven: Yale University Press, 1986), 1–28.

[19]Landow, *Victorian Types, Victorian Shadows,* 3. Landow provides a thorough discussion of the Victorians' use of typological symbolism. He also explores aspects of this revival in *Aesthetic and Critical Theories of John Ruskin* and *William Holman Hunt and Typological Symbolism* (New Haven: Yale University Press, 1979). See also Herbert L. Sussman, *Fact into Figure: Typology in Carlyle, Ruskin, and the Pre-Raphaelite Brotherhood* (Columbus: Ohio State University Press, 1979).

Recent scholarship has drawn attention to typology's role as a reservoir of eloquent imagery, particularly for Victorian painters and poets. Less attention, however, has been paid to the role of typology as a source of structural patterns that unfold in time, and hence are of primary importance for narrative. Certain biblical allusions or motifs have been pointed to, such as Newman's use of Pauline military imagery or the metaphor of the Garden of Eden in Ruskin's autobiography. But with the exception of Linda Peterson's *Victorian Autobiography*, there has been no sustained attempt to analyze the influence of typology on nineteenth-century autobiography.[20] Peterson, however, focuses on autobiography as an intertextual genre of self-interpretation, arguing that the emphasis of Victorian autobiography lies in "the understanding of events rather than in the art of narrating them."[21] This book takes a different approach: whereas Peterson's primary stress is on hermeneutics, on typology as an interpretive system, mine is on narrative, on biblical literature as a source of narrative models. As I will show, typology functions as the intrinsic and dynamic basis of Victorian autobiographical narrative.

But how was the conventional Christian pattern able to inspire the Victorian autobiographer, living as he did in an age of scientific revolution and profound religious doubt?[22] In

[20]In *Figures of Autobiography* Fleishman discusses the role of Augustinian, spiritual, and Romantic figuration in an array of autobiographical texts, but his wide-ranging approach does not allow him to linger over any one author.

[21]Peterson, *Victorian Autobiography*, 4.

[22]As Landow writes in *Victorian Types, Victorian Shadows*: "The natural sciences, biblical criticism, and comparative philology all contributed to the realization that the Bible could not be historically true. Geology, which showed that the earth was far older than stated in the biblical accounts, and Darwinism, which much later undermined scriptural accounts of the creation, made it impossible to accept such assumptions about the Bible, while German demonstrations that the scriptures had evolved over a long period of time had the same effect. Similarly, comparisons of Hebrew with other languages revealed that it was not, as many Evangelicals had supposed, a unique tongue designed by God as the medium of His truth" (56).

what way could either history or the individual human life continue to have meaning in the absence of a divine author? Observing that a belief in typology "was obviously an anachronism by the Victorian age," Landow comments that "ultimately, the very historical pressures which made typology so appealing to many Victorians made it intellectually untenable. Like the Evangelical emphasis upon the centrality of the scriptures, typology was based upon a non-canonical belief that God had dictated every word of the Bible."[23] Even for those who remained Christians, faith in the scriptures as the word of God was becoming increasingly difficult to maintain.

Yet while scriptural and scientific models are clearly antithetical on one level, at least for the autobiographer some synthesis was possible. In *Praeterita*, for example, Ruskin could see his childhood self simultaneously as Adam alone in the Garden of Eden and as a tadpole on the evolutionary scale. And while evolution challenges the traditional theocentric view, it still reinforces a sense of meaning, or at least of progress, in the universe. Because typology itself is both end-oriented and yet based on patterns of recurrence, the Victorian loss of faith in a guiding Providence does not necessarily lead to the abandonment of typological narrative structures.

The following pages consider the bizarre and often ironic ways in which Victorian autobiographers adapted and transformed the narrative options that typology afforded them, at a time when literal belief in typology had become "an anachronism." Newman, describing a religious conversion, perhaps comes closest to a conventional use of typology. Typology's emphasis on progressive development enabled him to portray his radical change as a gradual, inevitable process. Chapter 1 shows how in his *Apologia Pro Vita Sua* Newman employs Job and Paul not only as figures of the believer and the convert,

[23]Landow, *The Aesthetic and Critical Theories of John Ruskin*, 352; *Victorian Types, Victorian Shadows*, 54–55.

but as types of the man on trial who turns to autobiography in self-defense. Yet finally, I argue, he longs to transcend typology altogether, to go beyond its figural mediation to achieve a direct face-to-face relationship with God.

Ruskin and Gosse also structure their autobiographies typically around the experience of conversion. But in fact they invoke the familiar model only to undermine it, for it is actually a religious *un*conversion that each describes. My second chapter points out that while Ruskin relies on the traditional Exodus pattern to shape *Praeterita*, at the same time he short-circuits the progression towards salvation through his emphasis on repeated moments of insight rather than on definitive conversion and arrival at a final goal. Yet this motion, too, is subverted by a repressed subtext—a narrative of omission pointing toward Ruskin's true unconversion: not merely from evangelicalism to art, but ultimately from art to disillusioned social prophecy.

In the third chapter I argue that Gosse rebels against the typological roles his intensely evangelical parents expect him to play (the Son, the Lamb, the infant Samuel) by identifying with biblical idolaters and wrongdoers. His struggle to write the "plot" of his own life, rather than living out a preordained typological plan, leads him to an ironic rewriting of scripture. While he does not renounce typology completely, he transforms its terms in such a way that the book becomes a near-parody of typological autobiography.

Finally, in the epilogue I turn to autobiographical fiction, showing how it too relies on typological figuration. Focusing on Charles Dickens's *David Copperfield* and Charlotte Brontë's *Jane Eyre*, I trace their use of the biblical story of David to illuminate the quest for self-knowledge of the authors' fictional counterparts. But, as with the autobiographers, it is their departures from the biblical model that are most revealing.

Thus in the nineteenth century typological forms continue to function—and even flourish—but with a difference. Con-

version remains the structural focal point of autobiography, but the nature of that conversion changes. The experience marks a divide in the life of the individual, a moment in which he comes face to face with himself and obtains a new vision. In this sense, conversion is a metaphor for the act of writing autobiography itself: it represents the intersection of past and present implicit in the autobiographer's necessary encounter with his own past selves. Metaphorically, conversion is a form of symbolic death and rebirth, like the classical journey to the underworld which represents the process of coming to self-knowledge: Aeneas and Dante must confront the past in an attempt to connect their own lives to a larger pattern. For autobiography implies a search for salvation—it is none other than the quest to shape a self, to find (or give) meaning to a life. Finally, because one can never be quite the same afterward, the experience of conversion points toward a central problem for the autobiographer, who must grapple with the meaning of change. How can he assert the continuity of his personality over the course of time? For both Newman and Ruskin, this question—am I the same person, or a new person, or both?—was paramount.

The Victorian loss of faith in the possibility of a literal resurrection was accompanied by a widespread attempt to resurrect the self in autobiography. As we will see most clearly in Gosse, the autobiographer of the later nineteenth century sought to replace lost authority with self-authorship, to father himself to make up for the loss of God the Father.[24] This search for self-understanding through the act of self-creation involves the constructive engagement of traditional solutions or narrative

[24]This metaphor perhaps points to one reason for the conspicuous absence of autobiographies by women in this period. As Sandra M. Gilbert and Susan Gubar have observed in *The Madwoman in the Attic: The Woman Writer and the Nineteenth-Century Literary Imagination* (New Haven: Yale University Press, 1979), "The patriarchal notion that the writer 'fathers' his text just as God fathered the world is and has been all-pervasive in Western literary civilization" (4). Thus, if autobiography meant fathering a self, women were inevitably excluded.

models, for these offer a way in which one's personal past can interact with the literary past. For this reason, typology's assertion of a providentially directed continuity between past and present was crucial for the autobiographer, imaginatively recreating the past through memory and language. But the Victorian employment of typological analogies to biblical characters and events—themselves newly discovered to be fictitious—inevitably raises questions about the degree of "truth-telling" which is possible in autobiography. While I would not agree that "all autobiography is essentially fiction,"[25] in this book I am exploring the creative dependence of factual narratives on fictive patterns. For to study the role of typology in Victorian autobiography is to study the emergence of a new concept of the authored self, one based on what Wallace Stevens calls the "necessary fictions" essential to imaginative life in an Authorless world.

[25]Burton Pike, "Time in Autobiography," *Comparative Literature* 28 (1976): 327; Pike is expressing a popular contemporary view of autobiography.

Newman's *Apologia*: Autobiography as Self-Defense

If I justify myself, mine own mouth shall condemn me.

—Job 9:20

W HAT IS human identity if it can change, or be changed? This fundamental question confronts every autobiographer, for the mere passage of time alters him. The question perplexed John Henry Newman in writing the *Apologia Pro Vita Sua*: "For who can know himself, and the multitude of subtle influences which act upon him? And who can recollect, at the distance of twenty-five years, all that he once knew about his thoughts and his deeds?"[1] For the autobiographer who has experienced a radical break with his own past, such as Newman did when he converted to Catholicism, these crucial issues of continuity and change arise in an even more acute form. Given the obvious disjuncture in his life, how can he be said to have remained the same person? And how can he demonstrate the integrity of his character so that others may understand how and why he has changed?

[1]John Henry Newman, *Apologia Pro Vita Sua: Being a History of His Religious Opinions*, ed. David J. DeLaura (New York: Norton, 1968), 81. Subsequent citations to this edition are noted parenthetically. I have also consulted Martin J. Svaglic's edition and his helpful notes (Oxford: Clarendon, 1967). The *Apologia* was first published serially in 1864, in seven pamphlets.

As we will see, John Ruskin deals with the problem by denying it: "I find myself in nothing whatsoever *changed*," he claims in *Praeterita*, written as he approached the age of seventy.[2] In contrast, Newman in old age wrote, "I can look back at the end of seventy years as if on another person."[3] The notorious circumstances under which Newman composed his autobiography, as a response to the allegations of Charles Kingsley, meant that he was concerned precisely to prove that he had indeed changed. For in calling Newman's sermon "Wisdom and Innocence" (preached in 1843, before his conversion) "not a Protestant, but a Romish sermon," Kingsley implied that Newman had *not* changed, that he had been all along a Catholic in disguise.[4] To Newman, it seemed that Kingsley had, in effect, asserted that "Father Newman and the Vicar of St. Mary's are one and the same: there has been no change of mind in him; what he believed then he believes now, and what he believes now he believed then. To dispute this is frivolous; to distinguish between his past self and his present is subtlety."[5] Newman needed to convince his audience that his position while a member of the Anglican church had not been a false one, and that his change of heart and church had been genuine. Thus, he had first to prove that the self can and does change, and further, to justify himself for having done so. In his *Essay on the Development of Christian Doctrine*, written in 1845 when he was in the final stages of the process of conversion, Newman had already argued that "in a

[2]John Ruskin, *Praeterita, The Works of John Ruskin*, 39 vols., Library Edition, ed. E. T. Cook and Alexander Wedderburn (London: George Allen, 1903–12), xxxv, 220.

[3]Letter to Anne Mozley, February 28, 1885. *Letters and Correspondence of John Henry Newman*, ed. Anne Mozley, 2 vols. (London: Longmans, Green, 1891), I, 22.

[4]Charles Kingsley, *"What, Then, Does Dr. Newman Mean?" A Reply to a Pamphlet Lately Published by Dr. Newman*, rpt. in the DeLaura edition of the *Apologia*, 312.

[5]John Henry Newman, *The True Mode of Meeting Mr. Kingsley*, rpt. in the DeLaura edition of the *Apologia*, 357. Originally the second pamphlet, it was dropped in the 1865 edition of the *Apologia*.

higher world it is otherwise, but here below to live is to change, and to be perfect is to have changed often."[6] In writing his autobiography, Newman set out to demonstrate the truth of this maxim.

Newman was anxious to show that his conversion was not an abrupt, discontinuous change, a betrayal of friends, followers, and church, but rather a natural, almost inevitable, organic process. Earlier he had claimed that "a gradual conversion from a false to a true religion, plainly, has much of the character of a continuous process, or a development, in the mind itself."[7] The frequent images of growth in the *Apologia* reinforce this contention.[8] "My opinions in religion were . . . the birth of my own mind," Newman writes (82); "I will state the point at which I began, in what external suggestion or accident each opinion had its rise, how far and how they developed from within, how they grew, were modified" (12). For, Newman argues repeatedly, the progress of his ideas "was necessarily the growth of time" (66).[9] His method of argument, a gradual and careful accumulation of evidence, contributes to the impression of a nearly imperceptible but irreversible movement.

But it was not merely his own life that Newman saw in terms of organic process; the concept also illuminated his

[6]John Henry Newman, *An Essay on the Development of Christian Doctrine* (London: Longmans, Green, 1906), 40. Brian Martin suggests that it was the writing of this essay that "finally led him across. His exploration of the history of Christianity persuaded him to believe that all things develop and change in time including the Church" (*John Henry Newman: His Life and Work* [London: Chatto & Windus, 1982], 75).

[7]Newman, *An Essay on the Development of Christian Doctrine*, 200.

[8]In *John Henry Newman* (Hamden, Conn.: Archon Books, 1966) C. F. Harrold writes: "Like Darwin, Newman was not the inventor of a hypothesis, but a bold and illuminating applier of the general nineteenth-century idea of 'growth' and 'development' to a particular field. The idea of organic continuity and growth is of comparatively modern origin" (73).

[9]And, citing the influence upon him of the evangelical clergyman Thomas Scott, Newman writes: "For years I used almost as proverbs what I considered to be the scope and issue of his doctrine, 'Holiness rather than peace,' and 'Growth the only evidence of life'" (17).

entire understanding of divine history. Newman believed that "Revelation is . . . a process of development: the earlier prophecies are pregnant texts out of which the succeeding announcements grow; they are types." He adds that "the whole Bible, not its prophetical portions only, is written on the principle of development."[10] For Newman, typology is a form of annunciation: through typology God communicates his truths to man in a partial form, adapted for their understanding. Biblical writing is thus a kind of procreation where "pregnant texts" give birth to "succeeding announcements." The language Newman used to describe the self ("the birth of my own mind") is here applied to texts, which give birth and are born, grow and develop. It is also the language he uses to describe the making of his own texts: "The composition of a volume is like a gestation and child-birth"; it is "a mental child-bearing" which reminds him of Eve's punishment, " 'in sorrow shalt thou bring forth children.' "[11]

Typology, then, would appear to offer Newman just the organic, developmental model of both sacred and individual history he needs to account for his own conversion as a natural process. Typology's paradoxical assertion of divine continuity despite temporal change enables him to make sense of his life and provides him with a way to answer Kingsley.[12] Indeed,

[10]Newman, *An Essay on the Development of Christian Doctrine*, 64, 65.

[11]The first quotation is from a letter written to his biographer, Wilfred Ward, and is quoted in Martin, *John Henry Newman*, 143. The second is from a letter to Richard Holt Hutton of March 3, 1864 (*The Letters and Diaries of John Henry Newman*, 31 vols., ed. C. S. Dessain et al. [London: Thomas Nelson, 1961–77], xxi, 69).

[12]In *Victorian Types, Victorian Shadows* George Landow points out that "since typology is essentially a system of progressive revelation, any attempt to apply it to the natural world inevitably leads to some sort of theory of evolution" (11). But this was not a problem for Newman. Brian Martin writes in *John Henry Newman*: "When Darwin's *On the Origin of Species* was published in 1859, it came as no particular surprise to Newman. His idea of history, with change and development implicit in it, enabled him to comprehend Darwin's claims" (76). According to Martin, Newman "confided to a friend that he was willing 'to go the whole hog with Darwin' " (144). References to Darwin in Newman's letters support

Newman's entire outlook is profoundly typological. He tells us in the *Apologia* that Keble's religious poetry "brought home to me . . . the doctrine that material phenomena are both the types and the instruments of real things unseen" (28).[13] For Newman, typology provides the visible evidence of an invisible guiding hand, of providence working itself out in history.[14]

Such a mode of thought imbues Newman's consciousness. In his sermon "The Gospel Feast" he sets forth his belief in the divine interweaving of biblical and modern times: "Now the Old Testament, as we know, is full of figures and types of the Gospel; types various, and, in their literal wording, contrary to each other, but all meeting and harmoniously fulfilled in Christ and His Church. Thus the histories of the Israelites in the wilderness, and of the Israelites when settled in Canaan, alike are ours, representing our present state as Christians. . . . our state altogether is parallel to that of the Israelites, as an antitype to its type."[15] This sermon was written in 1838, while Newman was still a Protestant. But it speaks of a way of viewing the universe, and this perspective did not change when he became a Catholic. As Jaak Seynaeve says, "Newman's approach to the Bible, his fundamental attitude of mind in biblical matters and consequently his method of biblical

this; for example, his letter of June 5, 1870 to E. B. Pusey analyzes Darwin's claims in relation to scripture and theism and finds nothing objectionable or irreconcilable (*Letters and Diaries*, xxv, 137–38).

[13]Newman repeatedly stresses his conviction of the reality of things unseen. He writes of "my mistrust of the reality of material phenomena" (16) and "my feeling of separation from the visible world" (19). Ruskin also remarks that his mother's "unquestioning evangelical faith in the literal truth of the Bible placed me, as soon as I could conceive or think, in the presence of an unseen world" (*Praeterita*, 128).

[14]As Northrop Frye puts it, "What typology really is as a mode of thought, what it both assumes and leads to, is a theory of history, or more accurately of historical process: an assumption that there is some meaning and point to history" (*The Great Code: The Bible and Literature* [New York: Harcourt, 1982], 80–81).

[15]May 20 and 27, 1838. *Parochial and Plain Sermons*, 8 vols. (London: Rivingtons, 1868), vii, 163–65.

interpretation remained to a large extent the same during great part of his Catholic career as they were during his Anglican period."[16]

Nonetheless, writing a typologically structured autobiography to justify his conversion proved to be a problematic enterprise for Newman. Traditionally, the spiritual autobiographer has relied on typological motifs of lost Eden and exile, journey and crisis, to assert that the Bible's divinely planned continuity of past and present belongs to the individual life as well. Such motifs produce a recurrent pattern of imagery linking private events to providential acts. In particular, the Exodus account frequently underlies the story of conversion, with the autobiographer's spiritual confusion or despair seen as analogous to the Israelites wandering in the wilderness, and his spiritual peace analogous to finding the Promised Land.

Such patterns are indeed present in the *Apologia*, but they are muted. Linda Peterson has argued that in the nineteenth century "typology was so intricately bound to the tradition of the evangelical conversion narrative that Newman could not have used it without seeming to acquiesce in the theology with which it was associated."[17] Contending that "the most telling evidence of Newman's rejection of evangelical patterns of autobiography . . . is the absence of a specific set of allusions: allusions to the Exodus," Peterson proposes that he instead substitutes "ecclesiastical hermeneutics," finding in the conflicts of the early church—rather than in the Bible—the metaphors through which he comes to understand his own situation.[18]

[16]Jaak Seynaeve, *Cardinal Newman's Doctrine on Holy Scripture* (Oxford: Blackwell, 1953), 200. Seynaeve's book, particularly Part II, "Newman's Hermeneutics," offers a detailed analysis of Newman's frequent use of typology and his attitudes toward typological interpretation.

[17]Peterson, *Victorian Autobiography*, 104–5. She admits that Newman "did not object to typological interpretation in itself" (104), but given its pervasiveness in his sermons, and even in his private letters and journals, this seems to be a serious understatement.

[18]*Victorian Autobiography*, 105–6, 108.

In fact, Newman does suggest analogies between his own life and Exodus.[19] Moses was a figure particularly rich in typological associations for Newman, for as Moses led the Hebrew people out of bondage in Egypt, so Newman felt himself called to save the English church from the threat of Liberalism. During a near-fatal illness in Sicily in 1833, Newman felt a profound conviction that he would not die, for he had "a work to do in England" (40). In the *Apologia* he recounts how, while waiting impatiently for a boat to take him home to begin his great mission, he wrote his famous poem "Lead, Kindly Light." The poem—originally titled "The Pillar of the Cloud"—illuminates the way in which Newman felt himself to be another Moses, led by God to the rescue of his people.

Peterson acknowledges that Newman uses "the Exodus frequently in the verse of the *Lyra Apostolica*, especially in his best-known autobiographical poem, 'Lead, Kindly Light,'" yet insists that in the *Apologia* "he does not cast his account as a spiritual pilgrimage."[20] But in part 3, when the thought that "the Church of Rome will be found right after all" comes as a "sudden visitation" (99–100), Newman describes his persistent sense that his life is a journey. He tells of his "habitual notion . . . that my mind had not found its ultimate rest, and that in some sense or other I was on journey" (100).[21] And at this crucial stage in his narrative he again mentions "Lead, Kindly Light," making the connection to Moses in the wilderness unmistakable.

Strengthening the typological identification even further,

[19]Avrom Fleishman also notices that "Newman has recourse to the time-honored language of exile, journey, and return" (*Figures of Autobiography*, 167).

[20]Peterson, *Victorian Autobiography*, 106.

[21]Nor is this an isolated reference to the idea of life as a pilgrimage or journey. Later Newman writes: "As well might you say that I have arrived at the end of my journey, because I see the village church before me, as venture to assert that the miles, over which my soul had to pass before it got to Rome, could be annihilated, even though I had been in possession of some far clearer view than I then had, that Rome was my ultimate destination" (136).

Newman quotes a letter he had written on December 31, 1841, concerning his determination to remain in the Church of England as long as possible, despite his attraction to Rome: "I am content to be with Moses in the desert, or with Elijah excommunicated from the Temple" (127). Newman deliberately links the period of spiritual uncertainty he experienced prior to his conversion with Moses wandering in the wilderness. And if Newman identified with Moses both during his years as a leader of the Oxford Movement and later during his years of religious quest, the analogy would be no less appropriate after he became a Catholic. For Moses is the quintessential outsider: raised by an Egyptian princess, he had very little of the Hebrew about him. To Newman, who continued to look like a "foreigner" to Catholics throughout his post-conversion years, that sense of not quite belonging in either camp must have seemed particularly poignant.[22]

Yet Peterson maintains that those biblical allusions that do appear in the *Apologia* are "not typological in intention"; they resemble "allusions to classical myths or historical events" in that their use "is primarily rhetorical, not hermeneutic." Thus she sees Newman's comparison of himself to Samuel "before 'he knew the word of the Lord'" as intended only "to explain a psychological state, not to establish a typological link between the prophet's life and his own." But I would argue that the reference to Samuel is too rich, too resonant with Newman's own life, to be dismissed. For Newman is explaining how, like Samuel and like Moses, he was called and led by God. The quotation, then, does not merely help the audience understand Newman's "indecision before his conversion."[23] More importantly, it reinforces the motif of Moses being blindly led

[22]I am indebted to Barry Qualls for pointing this out. The ironies of Moses' situation are apparent from the very beginning of Exodus: driven out of Pharaoh's land for defending "an Hebrew, one of his brethren" (2:11), Moses is called "an Egyptian" (2:19) when he arrives in the land of Midian.

[23]Peterson, *Victorian Autobiography*, 105.

and demonstrates how Newman conceived of his own life typologically.

Clearly, then, Peterson's claim that "quite distinctly, he avoids allusions to exile, exodus, or wilderness wandering" needs to be modified.[24] Yet it is true that the familiar motifs of conversion autobiography were troubling for Newman in a variety of ways. Lost Edens, for example, so prominent a theme in Ruskin's autobiography, would clearly have led Newman into difficulties: how could he suggest that Protestant Oxford had been Eden, without implying that his conversion to Catholicism had been a kind of Fall? And how could he pursue the parallel with Moses to its conclusion, without implying that he too had been denied entrance into the Promised Land? Whatever Newman may have felt privately about the disappointments of his life as a Catholic, he hardly wanted to convey such an impression of failure to the readers of his *Apologia*.

Yet Newman was undeniably writing out of and certainly against an overwhelming sense of defeat. His letters and journals of the years immediately preceding the writing of the *Apologia* are almost despairing. In one letter he speaks of "thirty years disappointment. And so it is—everything seems to crumble under my hands, as if one were making ropes of sand."[25] A journal entry is even more revealing: "O my God, I seem to have wasted these years that I have been a Catholic. What I wrote as a Protestant has had far greater power, force, meaning, success, than my Catholic works—& this troubles me a great deal."[26] As Newman reviewed his life, the fear that he had *not* reached the Promised Land must have been uncomfortably close to home.

The implications, then, of some of the types traditionally

[24]*Victorian Autobiography*, 106.

[25]April 18, 1861. Quoted by Meriol Trevor in *Newman: Light in Winter* (London: Macmillan, 1962), 238.

[26]January 8, 1860. *Autobiographical Writings*, ed. Henry Tristram (New York: Sheed and Ward, 1957), 253.

used by spiritual autobiographers were fraught with danger for Newman in ways other than—or at least in addition to—their evocation of a Protestant theology. But Newman does not "shun typology."[27] For, as we have seen, typology is far more than a rhetorical tool for Newman; it is a fundamental way of understanding the nature of history and the relations between God and man. Typology is a form of divine communication—it is how God imparts a portion of his mystery to man. Thus, far from abandoning typology completely, Newman necessarily continued to search for the appropriate types through which to understand and portray his own situation.

And, in the stories of Job, the long-suffering innocent, and Paul, the Christian convert, Newman found striking prefigurations of his own life. Both Job and Paul were placed on trial and forced to defend themselves for no other reason than having changed dramatically. Even more significantly, Job and Paul respond to their accusers with a kind of "autobiography." Recognizing the insufficiency of a point-by-point rebuttal, each offers instead the story of his life, a portrayal of what Newman would call "the whole man." Of course, Job and Paul can no more be called autobiographers, strictly speaking, than Odysseus and Aeneas can—Job didn't write Job, Paul didn't write Acts.[28] Yet each of them, if not an author, is certainly the teller of his own life story. Odysseus is an autobiographer in the same sense that David Copperfield and Stephen Daedalus are novelists. For the purposes of providing later writers with literary models, the figure of the autobiographer may be just as influential as the historical autobiographer; Job and Paul are "types" of the autobiographer as surely as Saint Augustine.[29]

[27]Peterson, *Victorian Autobiography*, 104.

[28]Elsewhere Paul does write autobiographically. In his Epistle to the Galatians he defends his apostolic authority by telling the story of how God called him and gave him a mission to the Gentiles. In Acts, however, "Paul" must be regarded as a literary artifice of the author.

[29]In describing the scriptural origins of spiritual autobiography, Paul Delany points to both Job and Paul as primary sources: "After *Psalms*, the books of Job and the major prophets probably had the most influence on

In resorting to autobiography as their method of self-defense, they provided Newman with the solution he needed to answer Kingsley's charges.

Newman, then, is not breaking decisively with the tradition of Protestant spiritual autobiography, but rather taking up an important aspect of it, the religious autobiographer's comparison of himself with Job and Paul on trial. In the preface to *Grace Abounding*, for example, Bunyan observed that "it was Pauls accustomed manner, Acts 22, and that when tried for his life, Acts 24, ever to open before his Judges, the manner of his Conversion." Paul Delany points out that "Bunyan himself had been imprisoned for several years when he wrote these words, and a remarkable number of seventeenth-century spiritual autobiographers seem to have shared his experience; so that Paul's behaviour in front of his accusers provided a dramatic example to those who had good reason to identify with his predicament." He adds, "*Acts* xxii suggested to later autobiographers both a means of justifying their works and a style of self-presentation."[30] The following pages will explore Newman's own adaptation of this convention, suggesting specific ways in which Job and Paul worked—and did not work—for Newman as types of the autobiographer on trial.

The Autobiographer on Trial

"It may easily be conceived how great a trial it is to me to write the following history of myself" (14). The opening sentence of

religious autobiography. . . . For the religious autobiographer, St. Paul was the great exemplary figure of the New Testament" (*British Autobiography*, 28, 29).

[30]Delany, *British Autobiography*, 29–30. Delany provides several examples, then argues that "these attempts to imitate Paul by seventeenth-century autobiographers undoubtedly cramped the development of religious autobiography. Autobiographers commonly distorted the true pattern of their lives by trying to fit every detail into the Pauline archetype" (30).

the *Apologia* sounds one of the keynotes of the entire work: while some autobiographers write because they think it will afford them or their readers some pleasure to review the past, Newman repeatedly stresses the pain it gives him to expose his private self to public gaze.[31] The double meaning of the word "trial" brings out the connection between Newman's situation, being accused, and his response to it—the writing of his autobiography. Being "on trial" forces him to become an autobiographer, but being an autobiographer is itself another kind of trial. The figure of the trial dominates the work, and Newman sustains it throughout as he describes the gradual process of his conversion to Catholicism and the subsequent misunderstanding and rejection to which it exposed him.

The very title reminds us that this was no calm record for its own sake, but rather an impassioned plea to be judged fairly; as Newman explains in the preface, the *Apologia* originated as a form of self-defense. For "more than twenty years," he complains, "a vague impression to my disadvantage has rested on the popular mind, as if my conduct towards the Anglican Church, while I was a member of it, was inconsistent with Christian simplicity and uprightness" (1). Never before had he felt the moment was ripe to attempt to justify himself. Now, however, "I unexpectedly found myself publicly put upon my defense, and furnished with an opportunity of pleading my cause before the world, and, as it so happened,

[31]Letters written during and shortly after the composition of the *Apologia* confirm this. On April 23, 1864, for example, he wrote to R. W. Church, "I am in one of the most painful trials in which I have ever been in my life" (*Letters and Diaries*, xxi, 100). And Father Ignatius Dudley Ryder wrote that Newman found the "effort of writing the weekly parts . . . overpowering. On such occasions he wrote through the night, and he has been found with his head in his hands crying like a child over the, to him, well-nigh impossibly painful task of public confession" (Wilfred Ward, *The Life of John Henry Cardinal Newman*, 2 vols. [London: Longmans, Green, 1912], II, 23). In a letter to W. J. Copeland (April 19, 1864) Newman writes: "I am very low—it is one of the most terrible trials that I have had. . . . When you see it, you will see what a trial it is. In writing I kept bursting into tears" (*Letters and Diaries*, xxi, 97–98).

with a fair prospect of an impartial hearing" (1). Legal language dominates this preface: "defence," "pleading my cause," "impartial hearing," and "acquit myself."[32] It is clear that Newman had felt himself to be under attack for decades before Kingsley's accusation, and that although "taken by surprise" he was not wholly unprepared to defend himself.[33]

Newman then summarizes the events that spurred him to write the *Apologia*, beginning with Charles Kingsley's accusation, published in 1864, that "Truth, for its own sake, had never been a virtue with the Roman clergy," and that "Father Newman informs us that it need not, and on the whole ought not to be" (2). Despite Newman's protest, Kingsley would not fully retract the charge, and Newman responded by publishing their correspondence. He appended, however, some satiric reflections that surely helped to goad Kingsley into his wild and impolitic reply, the pamphlet *What, Then, Does Dr. Newman Mean?* In this pamphlet, Newman writes, Kingsley "professed to do that which I had called upon him to do; that is, he brought together a number of extracts from various works of mine, Catholic and Anglican, with the object of

[32]A fuller list includes: accusation, accuse, Accuser, allegations, case, charge, confess, crime, exculpation, impeachment, imputations, incurred, judgment, justice, offence, penalty, provocation, and proof. Even Newman's letter of February 10, 1864 to Alexander Macmillan uses terms such as "assailant," "defence," and "unprovoked attack," providing additional evidence that Newman saw the situation in terms of being on trial (*Letters and Diaries*, XXI, 46–47).

[33]On January 15, 1864 Newman wrote to Edward Badeley actually regretting that Kingsley's initial charge did not go far enough, for then "I could have written what would have been *worth* writing, both as regards the doctrine of Truth, and my own history" (*Letters and Diaries*, XXI, 18–19). And two months later (March 8, 1864) another letter to Badeley attests to Newman's state of preparedness: "I never have had an opening to defend myself as to various passages in my life and writings, and I have always looked forward to the possibility of that opening being presented to me. I have for a long time been attempting to arrange my letters and papers with a view to it" (*Letters and Diaries*, XXI, 73–74). Thus it is clear that Newman had had some thoughts of writing an autobiographical defense of himself, and Kingsley's words provided him with the opportunity and the impetus he needed.

showing that, if I was to be acquitted of the crime of teaching and practising deceit and dishonesty, according to his first supposition, it was at the price of my being considered no longer responsible for my actions" (3). Calling Kingsley "my accuser" and speaking of himself as needing to be "acquited" of a "crime," Newman again casts the quarrel in terms of a legal trial.

Anticipating a reply from Newman, Kingsley had written "I am henceforth in doubt and fear, as much as an honest man can be, concerning every word Dr. Newman may write. How can I tell that I shall not be the dupe of some cunning equivocation?" (6). As Newman immediately perceived, this was an "unmanly attempt . . . to cut the ground from under my feet;—to poison by anticipation the public mind against me" (6). For how can anyone reply to a charge of lying if anything he may say in his own defense will be dismissed as more lies? As Newman saw, "if my accuser is able thus to practise upon my readers, the more I succeed, the less will be my success. . . . The more triumphant are my statements, the more certain will be my defeat" (7).[34]

Furthermore, Newman's judges—the English public—already mistrusted him:

> It is not my present accuser alone who entertains, and has entertained, so dishonourable an opinion of me and of my writings. It is the impression of large classes of men;

[34]In fairness to Kingsley, it should be noted that Newman's advocacy of the idea of economy, or reserve—the position that difficult religious truths can and should be adapted to the understanding of the audience or even, if necessary, concealed—was easily liable to misinterpretation. Newman tried to explain what he meant by "economy" in the *Apologia*: "The exterior world, physical and historical, was but the manifestation to our senses of realities greater than itself. Nature was a parable: Scripture was an allegory" (34). For a fuller discussion, see "The Idea of Economy" in Lee H. Yearley, *The Ideas of Newman* (University Park: Pennsylvania State University Press, 1978), 32–37. See also G. Egner's *Apologia pro Charles Kingsley* (London: Sheed & Ward, 1969) for a detailed analysis of Kingsley's allegations and Newman's replies to them.

the impression twenty years ago and the impression now. There has been a general feeling that I was for years where I had no right to be; that I was a "Romanist" in Protestant livery and service; that I was doing the work of a hostile Church in the bosom of the English Establishment, and knew it, or ought to have known it. (8–9)

For people regarded Newman's conduct prior to conversion as highly suspicious: Why had he converted at all? Or rather, why had he waited so long? It almost seemed like a "conspiracy" (9). Newman believed that the public saw him and other converts to Catholicism as fifth columnists, conducting a secret "plan of operations . . . meant gradually to leaven the minds of the rising generation, and to open the gates of that city, of which they were the sworn defenders, to the enemy who lay in ambush outside of it" (9).

It is this prejudice, Newman argues, "which is the strength of the case of my Accuser against me;—not the articles of impeachment . . . which I shall easily crumble into dust, but the bias of the court" (10). What possible defense could he offer? Newman's solution was autobiography: "I recognized what I had to do, though I shrank from both the task and the exposure which it would entail. I must, I said, give the true key to my whole life; I must show what I am, that it may be seen what I am not. . . . I will vanquish, not my Accuser, but my judges. . . . I will draw out, as far as may be, the history of my mind" (11–12). Such a solution is perhaps not an immediately obvious one: how will the specific charge of being a liar be refuted by the general undertaking of autobiography?

The answer is that it will persuade the sympathies and imagination of an audience, as no laborious arguments could do.[35] Autobiography is the best defense because it erodes the

[35]Sixteen years earlier, Newman had attempted such persuasion in the form of an autobiographical novel, *Loss and Gain* (1848). Like the *Apologia*, *Loss and Gain* interweaves the ideas of conversion and trial, sympathetically tracing the religious difficulties of an Oxford undergraduate named

distinction between accuser and accused. Just as it is necessary to step outside the self in order to be an autobiographer—to gain the necessary distance from which to see and write about oneself—so the act of reading autobiography forces us to step outside ourselves and see the world from the point of view of another, figuratively reliving his experience. Autobiography succeeds by making the reader the judge; we identify with the accused, and so acquit him.

For Newman was only superficially writing to answer the charge of dishonesty; far more important was to vindicate himself for having converted to Catholicism many years earlier. It was this which he really needed to explain; he longed to acquit himself and his church, not before Kingsley, but before all of England. The focus of the *Apologia*, then, is not Newman's honesty but his conversion.

This conversion was the central event of his life: Newman's autobiography is the story of a dramatic change.[36] But change must be justified, as Newman well understood. Autobiography, as a record of progressive development, tries to demonstrate the essential unity of the self. Explaining how continuity can exist between two very different selves poses a problem for all autobiographers, for the passage of time alone ensures

Charles Reding. The novel illustrates the degree to which Newman regarded himself as having been on trial long before Kingsley's attack. Newman writes of Charles that a "tangible trial was coming on him;" when he attended a tea-party "he was on his trial;" it was "an inquisition" (rpt. in Geoffrey Tillotson, *Newman: Prose and Poetry* [Cambridge: Harvard University Press, 1970], 241). The novel also evokes the Exodus pattern of conversion autobiography, providing further evidence of Newman's typological identification with Moses. During his period of spiritual wandering in the wilderness, Charles felt "the pillar of the cloud before him and guiding him" (240). Having made up his mind to join the Church of Rome, Charles contemplates the irrevocable separation from home, family, and friends: "I am like Moses seeing the land" (300).

[36]As Walter Houghton says, the *Apologia* "is centered upon Newman's changing beliefs to the exclusion of everything else." This, he adds, explains the omission of Newman's undergraduate years and Catholic years—his beliefs were not changing then (*The Art of Newman's Apologia* [New Haven: Yale University Press, 1945], 91).

change, even where no conversion has taken place. Memory seems to promise continuity, but can memory be trusted? At times, Newman himself seems perplexed as to how to account for his own change: "It is the concrete being that reasons; pass a number of years, and I find my mind in a new place; how? the whole man moves; paper logic is but the record of it" (136).

Yet Newman was forced to try to answer the question *how*, though he scarcely knew himself: "How was I any more to have absolute confidence in myself? . . . how was I to be sure that I should always think as I thought now?" (79). He had foreseen that his changing ideas would amount to a betrayal of his friends, and of the Oxford Movement: "The most oppressive thought, in the whole process of my change of opinion, was the clear anticipation, verified by the event, that it would issue in the triumph of Liberalism. . . . I was breaking the *Via Media* to pieces. . . . Oh! how unhappy this made me!" (160). The friends whom he has thus misled are compared to a "poor sailor whose legs were shattered by a ball, in the action off Algiers in 1816, and who was taken below for an operation. The surgeon and the chaplain persuaded him to have a leg off; it was done and the tourniquet applied to the wound. Then, they broke it to him that he must have the other off too. The poor fellow said, 'You should have told me that, gentlemen,' and deliberately unscrewed the instrument and bled to death" (160). Newman portrays himself as having played the role of the surgeon and the chaplain for his friends. "How," he asks, "could I ever hope to make them believe in a second theology, when I had cheated them in the first? . . . Would it not be plain to them that no certainty was to be found any where?"

This powerful simile illustrates how serious it is to undergo a change, how difficult to persuade others that you have acted in good faith.[37] The man who has changed may not be a liar, or

[37]Newman's profound awareness of the implications of change emerges forcefully in *Loss and Gain*. Charles Reding's most sympathetic friend warns him of the danger of conversion: "If you take this step, you will find yourself in the hands of a Circe, who will change you, make a

even a hypocrite, but he cannot blame his friends for requiring reassurance. Yet he finds it impossible to provide any that will be convincing, for the very act of changing has already undermined his credibility. As Newman puts it in his preface, "How am I now to be trusted, when long ago I was trusted, and was found wanting?" (10).

Once again, it is typology that provides the answer. Situating himself typologically, in relation to Job and Paul, enables Newman to make sense of his own past, as well as his current circumstances. Similarly, if Newman's readers could be made to see him as another Job, another Paul, they could more easily understand and forgive him. For indeed, Newman is on trial precisely because others have not seen his actions typically, have not been able to see his life as anything but an appalling anomaly in the providential scheme. If, as the ghastly image of the sailor suggests, Newman saw his conversion to Catholicism as a kind of dismemberment, then typology became a way of re-membering himself. Ultimately, to persuade his Protestant audience, Newman needs to show how, despite the appearance of having cut himself off from them, he is still typologically connected to God's work in England.

Newman and Job

NEWMAN RECOGNIZED clear parallels with his own situation in the stories of Job and Paul. Both figures underwent radical transformations and were called upon to account for them. Like Newman, they were accused indirectly, accused of other crimes such as wickedness and lying and false teaching. But in each case the underlying issue was the startling reversal that

brute of you" (Tillotson, *Newman*, 303). At the first hint of his uncertainties, his sister Mary cries, "Oh, Charles . . . how changed you are!" (253). To her, "it was as if Charles had lost his identity, and had turned out some one else. It was like a great breach of trust" (257).

had taken place in their lives. Job went from prosperity, a sign that he enjoyed the favor of God, to misery; proof, his "comforters" argued, that he must have committed some secret crime for which he was being punished. Paul changed from an enthusiastic persecutor of Christians to their most ardent exponent; his conversion aroused mistrust as much among his new allies as among his forsaken ones.

Like Newman, they are acutely aware of the difficulty of a successful defense. As Job complains, "If I justify myself, mine own mouth shall condemn me" (Job 9:20). What can Job reply to the accusation that if he weren't wicked, God would not have punished him so terribly? Both Job and Paul turn to autobiography as self-defense. The extent of Newman's typological identification with their example is suggested even by the language of the *Apologia*: his courtroom rhetoric sets up strong verbal echoes with the books of Job and Acts.[38] As Michael Ryan notes, "using terms like 'Accuser' and 'avenger,' Newman creates a scenario whose pre-text is the Book of Job."[39] And Newman's choice of the word "Accusers" also points unmistakably to Acts, where the words "accusers," "accuse," and "accused" recur again and again.[40]

In adopting this strategy, Newman is also participating in a classical tradition at least as old as Socrates. His choice of title echoes the *Apology*, in which Socrates' self-defense consists of

[38]These books employ an extensive repertory of legal terms. In Job we find the following: acquit, arguments, cause, condemn, crime, defense, dispute, injustice, judge, judgment, justice, justify, offend, plead, prove, testify, trial, and witness; while in Acts the list includes: accusation, accused, accusers, cause, charge, complaints, council, defence, examined, informed against, judge, judgment hall, judgment seat, just, law, lawful, offence, offender, prove, sedition, testified, uncondemned, unjust, and witness.

[39]Michael Ryan, "A Grammatology of Assent: Cardinal Newman's *Apologia pro vita sua*," in *Approaches to Victorian Autobiography*, ed. Landow, 132.

[40]Indeed, almost half of their appearances in the Bible are in Acts, so they cannot but be strongly associated with it.

[37]

an endeavor to explain who he is, in the most profound sense.[41] But Socrates was not required to justify any major change in his life, and perhaps as a result was not as autobiographical as Job and Paul. For it is not only as men on trial but also as figures of the autobiographer that Job and Paul provide Newman with typological models.

It may seem that Jesus himself would be an ideal type of the innocent man brought to trial on vague and unanswerable charges: as he says when asked if he is Christ, "If I tell you, ye will not believe" (Luke 22:67). Yet no more than Socrates is Jesus on trial for having changed. And while the fundamental issue of his trial, as of Newman's, is one of identity—Who is he?—he does not respond to his accusers with autobiography; indeed, he hardly answers them at all. Jesus merely asserts that victory will ultimately be his, but in another, transcendent sphere: "Hereafter shall the Son of man sit on the right hand of the power of God" (Luke 22:69). But Newman wants vindication, not in the next world, but in this one; he is determined to vanquish his accusers now. In this respect, then, Jesus does not offer such an appealing model for Newman as do Job and Paul. As Paul Delany observes, "To imitate Christ was an undertaking which only the deranged or the mystic could undertake in full literalness." Analyzing the influence of both Job and Paul on religious autobiographers, Delany points out that "Paul, unlike Jesus at *his* trial, was ready with an articulate and systematic defence of his beliefs."[42]

[41]The similarities go beyond Newman's choice of title. Socrates also refers to his "accusers" and faces the difficulty of answering accusations before a public long since prejudiced against him: "I want you to realize too that my accusers are of two kinds: those who have accused me recently, and the old ones I mention; and to think that I must first defend myself against the latter, for you have also heard their accusations first, and to a much greater extent than the more recent" (Plato's *Apology*, in *The Trial and Death of Socrates*, trans. G. M. A. Grube [Indianapolis: Hackett, 1975], 23).

[42]Delany, *British Autobiography*, 29.

Newman's sermons, letters, and journals reveal a lifelong sense of kinship with Job. In an 1839 sermon describing the blessings of marriage, family, and friends, Newman writes that God "takes away to give again. . . . Job lost all his children, yet his end was more blessed than his beginning."[43] And in a sermon called "The Parting of Friends," preached in September 1843 as Newman's farewell address to the congregation of Littlemore, Newman compares Christ's feelings of grief at parting from the disciples at the Last Supper to those of Job: "He calls His friends around Him, though He was as Job among the ashes."[44] In a post-conversion sermon (1849) Newman says that Christ suffers when the three apostles appear before him, "not as comforters, but as accusers, like the friends of Job . . . heaping curses" on his head.[45]

In each case, Newman associates Job with friendship, particularly the sorrow of losing friends. As Martin Svaglic remarks, "the one criticism he could not reconcile himself to even with great effort . . . was the one never uttered in words: it was the silence, with all it implied, of his oldest and closest friends."[46] The Book of Job dramatizes how Job's worst sufferings are inflicted by his so-called friends. He can bear everything but the isolation their betrayal brings: "My kinsfolk have failed, and my familiar friends have forgotten me. They . . . count me for a stranger: I am an alien in their sight. . . . All my inward friends abhorred me: and they whom I loved are

[43]Newman, "Present Blessings," *Sermons and Discourses*, ed. C. F. Harrold, 2 vols. (London: Longmans, Green, 1949), II, 8–9.

[44]Newman, *Sermons and Discourses*, II, 122.

[45]*Sermons and Discourses*, II, 243. And on August 18, 1856, describing the strong attachment to their oratory felt by various fathers and lay brothers, Newman quotes "the beautiful passage in the Book of Job, 'Dicebam, in nidulo meo moriar,'—'I used to say, I shall die in my dear nest.'" ("Remarks on the Oratorian Vocation," *Newman the Oratorian: His Unpublished Oratory Papers*, ed. Placid Murray [Dublin: Gill & Macmillan, 1969], 331.)

[46]Svaglic, Introduction to the *Apologia*, xi.

turned against me" (19:14–15, 19). Several months before he was received into the Catholic church, Newman wrote an emotional, almost despairing letter, expressing a passionate identification with Job: "No one has spoken well of me. My friends who have had means of knowing me have spoken against me. . . . Others have kept silent in my greatest trouble. . . . It is over—my spring, my summer, are over, and what has come of it? . . . my prime of life is past and I am nothing. . . . There is no redress, no returning, and I say with Job, 'O that it were with me as in years past, when the candle of the Lord shone on me.'"[47]

The figure of Job spoke particularly strongly to Newman during such periods of near-despair. In the late 1850s and early 1860s Newman's anguish over the frustrations of his Catholic career found expression in his journal. These entries reveal much about Newman's state of mind in the years immediately preceding the *Apologia*.[48] On December 15, 1859, for example, Newman writes, "Job, Moses, and Habacus felt as I feel thousands of years ago."[49] His biographer, Meriol Trevor, quotes a letter Newman wrote in 1858: "I am like Job with one trouble after another."[50] And a few months later he wrote to his friend Ambrose St. John: "I don't speak to the whole world, but to

[47]Letter of April 27, 1845 to Henry Wilberforce; quoted in Wilfred Ward's *Life*, I, 81–82.

[48]A long entry written on January 21, 1863 illustrates Newman's Job-like wretchedness as he searches for a way to make sense of his trials: "O how forlorn & dreary has been my course since I have been a Catholic! here has been the contrast—as a Protestant, I felt my religion dreary, but not my life—but, as a Catholic, my life dreary, not my religion." He adds, "I do not wonder at trials; trials are our lot here; but what saddens me, is that, as far as one can see, I have *done* so little, *amid* all my trials. My course has been dreary, because, to look back on it, it is so much of a failure" (Newman, *Autobiographical Writings*, ed. Henry Tristram [Sheed & Ward, 1957], 254, 256).

[49]*Autobiographical Writings*, 250.

[50]Letter of February 1858 to Stanislas Flanagan; quoted in Trevor, *Newman: Light in Winter*, 175. Trevor even titles the chapter on the years 1858–59 "The Trials of Job."

you, Stanislas, and Henry. Job too had three friends—and he let out to them—yet he was 'the most patient of men.' "[51]

Newman, then, frequently saw in Job a precursor of his own suffering, both at the time of his conversion when his friends dropped away and later during this terrible period of self-doubt. What more natural than to turn to Job as a model for the autobiographical response of the *Apologia*? The story of Job provides him with a solution to the paradox: he *cannot* consider that his conversion was a mistake, yet his Catholic life has been a failure. Job offers a model of inexplicable suffering—and of suffering eventually rewarded.

Newman's initial difficulty in responding to the insidious charge of lying echoes Job's situation. Job insists that this is a "trial of the innocent" (9:23). But if, as his three comforters claim, God punishes only the wicked, then somehow Job must have deserved his suffering. As Bildad says: "Doth the Almighty pervert justice? . . . Behold, God will not cast away a perfect man" (8:3, 20). Job stands prejudged, for to defend himself is to accuse God.

Job argues his case from the standpoint of faith: he is not wicked, nor is God unjust (the only two alternatives his accusers can imagine). Rather, God is beyond human comprehension, ultimately mysterious. There can be no questioning such immense, inscrutable power: "Who will say unto him, What doest thou? . . . How much less shall I answer him, and choose out my words to reason with him? . . . Though he slay me, yet will I trust in him" (9:12, 14; 13:15). Similarly, Newman's confidence in his own secure relationship with God never wavered: "Ten thousand difficulties do not make one doubt" (184). Both Newman and Job believe that the real trial

[51]June 13, 1858; quoted in Trevor, *Newman: Light in Winter*, 181. Newman closes this long litany of complaint with the quotation "the words of Job are ended." Ambrose St. John replies: "Truly you are Job and truly we are Job's comforters thinking of self and not of their friend" (182).

must take place before God, where all will be well: as Job says, "When he hath tried me, I shall come forth as gold" (23:10). For Newman, as we shall see, the ultimate trial of the human soul takes place when it finds itself face to face with God.

Job, however, not only displays absolute faith—he demands it for himself. He tells his friends that they can never know why this misfortune has befallen him but must take on trust his assertion of innocence. And he is right, for as readers we have been privileged to know why Job suffers—God's wager with Satan—yet this explanation can never be made available to Job and his friends.

Essentially, then, Job asks his friends to believe in him, as he believes in God. Yet the practical problem remains: how to create such belief? Having exhausted every other argument, Job turns in his long final speech to autobiography: he tells the story of his blameless life as the only possible demonstration of his innocence. Nothing less than autobiography will evoke the necessary faith on the part of the audience. Like Job, Newman demands an act of faith on the part of his audience equivalent to that he offers God; the autobiographer is to the reader as God is to the convert.

Job begins with a nostalgic plea: "Oh that I were as in months past . . . as I was in the days of my youth" (29:2–4). Wistfully he recalls his former prestige and power, painting a vivid, poetic picture of himself at the height of his prosperity: "My glory was fresh in me, and my bow was renewed in my hand. Unto me men gave ear, and waited, and kept silence at my counsel. . . . I chose out their way, and sat chief, and dwelt as a king in the army, as one that comforteth the mourners" (29:20–21, 25). Newman, too, was acutely conscious of having lost his role as a leader: "If there ever was a case, in which an individual teacher has been put aside and virtually put away by a community, mine is one" (171).[52] Even the hint of egotism

[52]Later he adds that "as soon as I turned my face Romeward, I gave up, as far as ever was possible, the thought of in any respect and in any shape acting upon others" (169).

in Job's words may remind us of Newman, but we forgive him for it, as we forgive Newman, because of the suffering that was to follow. Our forgiveness is a crucial element in our "conversion" to belief in the integrity of the autobiographer.

Abruptly, Job turns to the painful description of his present position: "But now they that are younger than I have me in derision, whose fathers I would have disdained to have set with the dogs of my flock. . . . They abhor me, they flee far from me, and spare not to spit in my face" (30:1, 10). The narrative becomes a cry of anguish as Job complains bitterly to God: "I am become like dust and ashes. I cry unto thee, and thou dost not hear me: I stand up, and thou regardest me not" (30:19–20). His alienation from the entire human community is forcefully conveyed in the Lear-like metaphor: "I am a brother to dragons, and a companion to owls" (30:29). Newman's journal expresses the same desolation: "I am nobody. I have no friend at Rome, I have laboured in England, to be misrepresented, backbitten, and scorned. I have laboured in Ireland, with a door ever shut in my face."[53]

In closing, Job reasserts his innocence, asking only that "the Almighty would answer me" (31:35). It is a challenge to God to give him justice, and he signs his name with simple dignity: "The words of Job are ended." Although his autobiographical self-defense does not convince his hearers, who merely bring out all their old arguments once more, Job gains his objective: God pronounces in his favor and condemns his accusers. He rewards Job's faith by giving him "twice as much as he had before," blessing "the latter end of Job more than his beginning" (42:10, 12).

The pattern of Job's story thus provides a model for Newman: he begins the *Apologia* by recounting his former happiness among his friends at Oxford, where his influential position enables him to accomplish much; his fortunes then undergo a dramatic reversal as his conversion brings him into

[53]Journal entry dated January 8, 1860. Newman, *Autobiographical Writings*, 251.

disrepute; and finally, like Job, he endures loneliness and persecution. Eventually, suspicions culminate in accusations that, because of their nature, he can answer only through autobiography. His autobiography succeeds in gaining him an acquital and vanquishing his accusers (for the *Apologia* was an instant success, not only defeating Kingsley utterly but regaining for Newman a portion of his former recognition and respect). The work closes on a happy note, the dedication to his friend Ambrose and the new home he has found.

The structure and language of the *Apologia*, then, suggest the depth of Newman's affinity with Job. Newman himself made the parallel explicit when he resumed his journal in 1867: "I will put myself under the image of the Patriarch Job. . . . He first strenuously resisted the charges of his friends, then he made a long protest of his innocence, & then we read, 'The words of Job are ended.' Mine are ended too."[54]

Newman and Paul

As a man who suffered unjustly yet remained steadfastly faithful, as a man who lost everything but was rewarded in the end, as a man who responded to being on trial with a kind of autobiography, Job offered Newman a partial solution to the problem of how to justify himself. But Job is a man who, despite outward appearances, remains essentially unchanged; ultimately, then, he is inadequate as a model for Newman in writing his *Apologia*. Yet if Job's unexpected fall from prosperity could provide an approximate "type" of Newman's life, how much more could the story of Paul, the man who experienced such a spectacular but perplexing conversion.

This conversion made a powerful impression on Newman. As early as 1831 Newman had preached a vivid description of it in a sermon entitled "The Feast of the Conversion of St.

[54]Journal entry dated October 30, 1867. Newman, *Autobiographical Writings*, 262.

Paul": "His awful rashness and blindness, his self-confident, headstrong, cruel rage against the worshippers of the true Messiah, then his strange conversion, then the length of time that elapsed before his solemn ordination, during which he was left to meditate in private on all that had happened, and to anticipate the future,—all this constituted a peculiar preparation for the office of preaching to a lost world, dead in sin."[55] These words could be describing Newman himself, so eerily do they foreshadow his own experience.

Paul's conversion made him suspect, yet although he was persecuted, brought to trial, and forced to defend himself, the authorities could never quite decide what to charge him with. Like Newman, Paul was accused of conspiracy to teach against and subvert the established religion. Paul's conversion prefigures Newman's in being seen as a total repudiation of all he had been known to stand for. As Paul had been outspoken against Christians, so Newman had been outspoken against Catholics: as a boy he had written vile epithets after the word "Papa" (101), and had been "most firmly convinced that the Pope was the Antichrist" (18). Newman explains that he had "felt it to be a duty to protest against the Church of Rome" (55), and he quotes at length from a virulent article he had published in 1840, which slandered Catholics who attempted to convert Englishmen (105).[56]

Paul's conversion changed him completely: the same man who went to Damascus to round up Christians "straightway . . . preached Christ in the synagogues" (Acts 9:20). But could he really be the same man? "All that heard him were amazed and said; Is not this he that destroyed them which called on

[55]Newman, *Parochial and Plain Sermons*, II, 100–101.

[56]The self-righteous blustering tone of the passages Newman quotes sounds oddly like Kingsley himself. But Newman forestalls our revulsion by frankly acknowledging—and deploring—the likeness: "No one ought to indulge in insinuations; it certainly diminishes my right to complain of slanders uttered against myself, when, as in this passage, I had already spoken disparagement of the controversialists of that religious body, to which I myself now belong" (106).

this name in Jerusalem?" (9:21). How could such a complete transformation be interpreted? Even if sincere, it represented a betrayal of those whom he formerly supported so vigorously. And so the reaction was swift and severe: "the Jews took counsel to kill him" (9:23). Paul's newfound associates help him escape, but are hardly less mistrustful: "They were all afraid of him, and believed not that he was a disciple" (9:26).

For the remainder of Acts, Paul is on trial, and legal terms such as "crime," "prisoner," "clemency," "confess," and "appeal" prevail. As Newman would be, Paul is publicly accused by those whom he had abandoned. But the accusations are unspecific: "And some cried one thing, some another, among the multitude: and . . . he could not know the certainty for the tumult" (21:34). Paul requests permission to defend himself, asking to speak, not just to his accusers, but to the people—as Newman would do.

Like Job, Paul realizes that his only hope is to persuade his accusers to believe in him, and Paul undertakes to tell who he is: "I am verily a man which am a Jew, born in Tarsus" (22:3). Paul tells the story of his life, focusing on the details of his conversion.[57] This first attempt at autobiography succeeds in buying him time, but animosity continues to grow. Just as the general murmurings against Newman were finally given voice by Kingsley, so an individual antagonist emerges in Acts. The mob's hatred of Paul finds expression through "a certain ora-

[57]Delany writes that "Paul's influence on Protestant autobiographers may be considered under three heads: his use of autobiographical testimony in the *Acts* and elsewhere, his conversion (which became the archetype for later narratives of spiritual awakening), and his contribution to Christian doctrine" (*British Autobiography*, 29). He describes Paul's response to being brought to trial as "autobiographical statements" that had an enormous influence on generations of subsequent autobiographers (30). (Once again, it should be stressed that it is Luke's portrayal of Paul-as-autobiographer that has shaped autobiographical tradition, as opposed to Paul's self-imaging in his own writings.)

tor named Tertullus" (24:1), who charges that "we have found this man a pestilent fellow, and a mover of sedition among all the Jews throughout the world" (24:5). The accusation amounts to no more—and no less—than an *ad hominem* attack. Mere denial will not suffice when a man's character has been attacked. As Newman put it, "We all know how our imagination runs away with us, how suddenly and at what a pace;—the saying, 'Caesar's wife should not be suspected,' is an instance of what I mean" (6).

Paul spends two years in prison, awaiting a retrial. Finally King Agrippa grants him a hearing, and once again Paul's self-defense consists of autobiography. He describes "my manner of life from my youth" (26:4), recounts his avid persecution of the Christians, and tells the story of his conversion. He tells his judge, King Agrippa, what happened on the road to Damascus: "At midday, O king, I saw in the way a light from heaven, above the brightness of the sun, shining round about me and . . . I heard a voice speaking unto me, and saying in the Hebrew tongue, Saul, Saul, why persecutest thou me?" (26:13–14). He repeats the Lord's words charging him to open the eyes of the Gentiles and "to turn them from darkness to light" (26:18). "Whereupon, O king Agrippa," he explains, "I was not disobedient unto the heavenly vision" (26:19). In his account of his subsequent missionary activity and harassment by the Jews, Paul appeals directly to Agrippa, trying to win him over to his side against the governor Festus: "King Agrippa, believest thou the prophets? I know that thou believest" (26:27).

Paul thus blurs the boundary between prosecutor and prisoner to the extent of nearly converting his hearer, for Agrippa replies, "Almost thou persuadest me to be a Christian" (26:28). This remark epitomizes the power of autobiography to make the audience identify with the teller, vividly illustrating why autobiography is the best defense. Agrippa affords us a rare instance of "reader response," illustrating how conversion

autobiography does not merely record a conversion, but seeks to produce one in its audience.[58]

Paul provided Newman with an important typological model, not only in the fact of conversion and of autobiographical self-defense, but also in his stress on divine call and mission. Paul's narrative highlights his faith and reliance on God, and thus his own passivity: events happened to him, he did not choose. In telling his story to Agrippa, Paul has God declare a specific intention with regard to him: "I have appeared unto thee for this purpose, to make thee a minister and a witness" (Acts 26:16). By depicting himself as God's agent, Paul both diminishes his own responsibility for having converted, and increases his authority.

Paul's emphasis on mission appealed strongly to Newman, for he too felt directed by God: in the *Apologia* he insisted that he had been "led on by God's hand blindly" (100). During his illness in Sicily he first became convinced that God had a great work for him to do:[59] "I began to think that I had a mission. . . . I said, 'I shall not die.' I repeated, 'I shall not die, for I have not sinned against light, I have not sinned against light.'. . . My servant, who had acted as my nurse, asked what ailed me. I could only answer him, 'I have a work to do in England'" (40). As we have seen, Newman's sense of having been singled out

[58]The classic example is, of course, Saint Augustine, whose own conversion came about through hearing and reading of other conversions. The *Confessions* attempt to perpetuate the cycle by recording this experience for future readers. Newman recognizes the parallel between his own conversion and Augustine's: his horrified realization that the Anglican church was in schism crystallizes when he hears Augustine's words, "Securus judicat orbis terrarum." Newman writes: "Who can account for the impressions which are made on him? For a mere sentence, the words of St. Augustine, struck me with a power which I never had felt from any words before. . . . they were like the 'Tolle, lege,—Tolle, lege,' of the child, which converted St. Augustine himself" (98–99).

[59]Newman's sense of the importance of this illness was so great that in 1834 he wrote a detailed memoir describing it, "My Illness in Sicily" (*Autobiographical Writings*, 121–38). He was still meditating on its significance in his journal in 1869 (*Autobiographical Writings*, 268).

by God for an urgent purpose found expression in the poem he wrote at this period, "Lead, Kindly Light." But Newman had Paul as well as Moses in mind, for in June 1833 he also wrote a poem called "St. Paul."[60] It describes a dream in which "I wish'd me born amid God's deeds of might" when "a stranger met my sight / . . . / Then came a voice,—'St. Paul is at thy side.' "[61]

Back in England, Newman recounts in the *Apologia*, "I had the consciousness that I was employed in that work which I had been dreaming about. . . . I felt as on board a vessel, which first gets under weigh" (47). The choice of the voyage image to portray his embarking on the mission for which God has chosen him evokes Paul, whose voyages took him all over the Mediterranean, and resonates with Augustine as well.[62] Newman again associates the voyage with his mission in life when he writes that leaving Anglicanism and Oxford "is like going on the open sea" (182). In contrast, becoming a Catholic "was like coming into port after a rough sea" (184). The "rough" and

[60]Paul was an important source, as Martin Svaglic has shown, for Newman's "conception of life as a drama in which Christians were the warriors of the God of Revelation." ("The Structure of Newman's *Apologia*," *PMLA* 66 (1951): 143; rpt. DeLaura, 447). The imagery of the *Apologia* is frequently military, in keeping with the metaphor Newman uses to describe his conflict with Kingsley: "I am at war with him" (5).

[61]John Newman, *Verses on Various Occasions* (London: Burns, Oates, 1880), 164. In yet another poem written during this same month, Newman again associates Paul with vocation and mission; the notion that a Christian life must be an active one emerges clearly:

> If toilsome Paul had stayed
> In cot or cloister's shade,
> With the priests' white attire
> And the Saints' tuneful choir,
> Men had not gnashed their teeth, nor risen to slay;
> But thou hadst been a heathen in thy day.
> ("Warfare," *Letters and Diaries*, III, 318)

[62]Martin Svaglic also traces the source of the voyage motif in Newman to Paul, pointing to Paul's letter to Timothy: "From St. Paul's warning against 'those, who, having "rejected a good conscience," had "made shipwreck of their faith"' the imagery of the sea appears to take its origin" ("The Structure of Newman's *Apologia*," 148; rpt. DeLaura, 452).

"open" sea may remind us of the tempest Paul endured, and perhaps also of Aeneas, another voyager with a divine mission that led him to Rome.[63]

If Newman identified strongly with the Pauline model of vocation during the early, optimistic years of the Oxford Movement, he later identified with the way in which Paul was misunderstood and drawn into controversy. In the period of disillusionment before the writing of the *Apologia*, Newman compared his own sufferings to those of Saint Paul: "Do you think the *sollicitudo omnium Ecclesiarum* did not waste St. Paul! . . . The wounds which one bears speechlessly, the dreadful secrets which are severed from the sympathy of others, the destruction of confidences, the sense of hollowness all around one, the expectation of calamity or scandal, this was a portion of St. Paul's trial."[64]

Yet while Newman continued to feel his resemblance to Paul, a divergence in their respective paths must have been becoming clear to him. For though Paul's trials were all in the service of fulfilling his great mission, Newman's trials had come to seem increasingly futile. In 1863 he wrote in his journal, "What is the good of living for nothing? . . . I look back on my years at Oxford & Littlemore with tenderness—and it was the time in which I had a remarkable mission—but how am I changed even in look!"[65]

[63]As Robert A. Colby has observed, "the frame of the action of the *Apologia* is the two journeys to Rome" ("The Poetical Structure of Newman's *Apologia pro Vita Sua*," *The Journal of Religion* 33 [1953]: 51–52; rpt. DeLaura, 459). The second journey, following Newman's conversion, balances the original journey during which he first realized that he had a mission to perform. Newman highlights this correspondence by comparing his final departure from Oxford to a voyage. Thus, if the pattern of loss, ordeal, trial, and triumph can be traced to Job, so the pattern of a trial framed by two voyages can be traced to Paul.

[64]Letter of April 18, 1861; quoted in Trevor, *Newman: Light in Winter*, 238.

[65]January 21, 1863; Newman, *Autobiographical Writings*, 254. And, describing "the failure of his successive endeavours" to found a Catholic University in Ireland, to translate the Scriptures, to edit the *Rambler*, and to found an Oratory at Oxford, Wilfred Ward writes: "His career as a

Given the apparent failures of his life, Newman must have found it more and more difficult to sustain the certainty of having received a divine call such as Paul's. While being summoned by God places Newman squarely in the tradition of Abraham, Moses, Samuel, and Paul, and enables him to justify the fact of having changed, the question must have continued to trouble him: what had he been chosen to do? If in 1833 his mission had been clear—to save the Church of England from the rising tide of Liberalism—in 1864 his mission was no longer self-evident.

Ultimately, then, there were dangers for Newman implicit in setting up too close a typological parallel between himself and Paul. The very aspect of the story of Paul that works so effectively to justify dramatic change—Paul's divine call to perform a task for God—also works against Newman. He could not pursue the notion of mission in the *Apologia* without openly confronting his own failures—which might seem to cast retrospective doubt on the meaning of his conversion.

Even Paul's conversion, apparently so compelling a model for change, was finally too extreme for Newman. So troubling was its abruptness that Newman once preached a sermon called "Sudden Conversions" in which he distorted the biblical account of Paul's conversion almost beyond recognition. He argued that Paul's change of heart only appeared sudden to others; in reality, it was merely the culmination of a long, slow process:

> When men change their religious opinions really and
> truly, it is not merely their opinions that they change, but

Catholic had been in one respect at least—he could not deny it—a supreme disappointment. The desire of his heart had been that he should speak with the whole weight of the great historic Church and of the Holy See unmistakably at his back. . . . But to speak with her authority was just what appeared to be denied him. His critics still whispered that he was not to be trusted" (*Life*, I, 13).

their hearts; and this evidently is not done in a moment—
it is a slow work; nevertheless, though gradual, the
change is often not uniform, but proceeds, so to say, by
fits and starts. . . . This we see in the growth of plants, for
instance; it is slow, gradual, continual; yet one day by
chance they grow more than another, they make a shoot,
or at least we are attracted to their growth on that day by
some accidental circumstance, and it remains on our
memory. So with our souls.[66]

As in the *Apologia*, Newman introduces an organic metaphor
to describe the experience of conversion as a gradual process.
But such a reading of Saint Paul's conversion is so unconven-
tional, so opposite to the words of scripture, which depict a
sudden stroke from heaven, that it vividly illustrates how
important it was to Newman to be able to see his own conver-
sion as a course of inevitable and divinely guided natural
development. In effect, Newman is trying to recreate Paul to
accord with his own ideas; he wants to use scriptural prece-
dent to legitimize his own sense of what conversion is, but he
has to rewrite scripture in order to do so.

In the *Apologia* Newman implies a further analogy between
his own behavior prior to conversion, and Saint Paul's: "For is
it not one's duty . . . to throw oneself generously into that form
of religion which is providentially put before one? . . . Were
those who were strict and conscientious in their Judaism, or
those who were lukewarm and sceptical, more likely to be led
into Christianity, when Christ came? Yet in proportion to their
previous zeal, would be their appearance of inconsistency"
(161–62). "Their appearance of inconsistency"—Newman is
anxious to have it both ways, to assert that conversion means a
complete change of heart, and yet to maintain that any incon-
sistencies are only apparent. There is thus a conflict in the text
between Newman's need to tell the story of a change (indeed,

[66]January 1832. *Parochial and Plain Sermons*, VIII, 225–26.

his need to convince his audience that he *has* changed), and at the same time his desire to suggest that he has not really changed after all.

"Face to Face"

As an autobiographer, then, Newman is confronted with the dilemma of portraying change within a framework of permanence. While Newman "recognized change as an essential quality of the visible world," as George Levine puts it, he also "insisted on change only to get as close as possible to the unchanging. His theory of development, though it would seem to have been in harmony with theories of biological evolution that were developing at the time, was in fact a quest for permanence."[67] The most memorable image of the *Apologia*, the snapdragon that ironically came to symbolize Newman's farewell to Oxford, illustrates how his own change frustrated his longing for stability:

> Trinity had never been unkind to me. There used to be much snap-dragon growing on the walls opposite my freshman's rooms there, and I had for years taken it as the emblem of my own perpetual residence even unto death in my University.
>
> On the morning of the 23rd I left the Observatory. I have never seen Oxford since, excepting its spires, as they are seen from the railway. (182–83)

The snapdragon may remain forever, but Newman has been painfully uprooted. His paradoxical and poignant choice of flowers as an emblem of constancy beautifully captures the tension between transience and permanence in Newman's own life.

[67]George Levine, *The Boundaries of Fiction: Carlyle, Macaulay, Newman* (Princeton: Princeton University Press, 1968), 187.

For Newman, finally, permanence could be achieved only in a direct, unmediated relationship with God. Indeed, it was his fear that the Catholic church would interpose between them that had initially formed one of the chief obstacles to his conversion. But eventually he had realized that "the Catholic Church allows no image of any sort, material or immaterial, no dogmatic symbol, no rite, no sacrament, no Saint, not even the Blessed Virgin herself, to come between the soul and its Creator. It is face to face, 'solus cum solo,' in all matters between man and his God" (154). "Face to face"—this metaphor for an unobstructed connection between the human and the divine reveals that Newman's quest is a textual as well as doctrinal one, a quest to get beyond images "of any sort." Seeking to overcome the problems posed by inexact typological models, such as Moses, Job, and Paul, the autobiographer turns to a self-effacing metaphor that can transcend time-bound typology and terminology to convey the immediacy and purity of a relationship existing on the plane of eternity.

The phrase itself alludes unmistakably to Paul: "When I was a child, I spake as a child, I understood as a child, I thought as a child: but when I became a man, I put away childish things. For now we see through a glass, darkly; but then face to face" (I Cor. 13:11–12). The transition from blindness to sight evokes Paul's own conversion, and with it the notion of change: Paul's metaphor for gaining full knowledge of God is the process of growth and maturation ("when I became a man"), the essential subject matter of autobiography. The autobiographer looks back through time at an earlier self ("when I was a child"), and measures the changes that have taken place by comparing his different selves. As we will see, Ruskin called his earlier self "a little floppy and soppy tadpole,"[68] yet remained convinced that no essential changes had occurred. Newman, too, asserts a fundamental continuity in spite of that great change, his conversion. For Newman, as for Paul,

[68]Ruskin, *Praeterita*, 279.

the goal of development is finally to get beyond time and change, to arrive "face to face" with God.

The figure has its source in the Hebrew Bible, specifically in Moses' direct converse with God as described in Exodus, where "the Lord spake unto Moses face to face" (33:11). Elsewhere God affirms that "with him will I speak mouth to mouth, even apparently, and not in dark speeches; and the similitude of the Lord shall he behold" (Num. 12:8).[69] But if it is granted to Moses to see God, it is because of his role as mediator between God and the Israelites. As he explains to them, "The Lord talked with you face to face in the mount out of the midst of the fire, (I stood between the Lord and you at that time, to shew you the word of the Lord)" (Deut. 5:4–5). Newman, however, wants to be face to face with God, not in his capacity as priest and intermediary, but simply as an individual Christian—once again, Moses is not quite the ideal type for Newman.

Ezekiel gives the image a slightly different turn when he conveys God's message to the Israelites: "I will bring you into the wilderness of the people, and there will I plead with you face to face" (20:35). "Face to face" still refers to direct confrontation between God and man, but here the notion of pleading emerges, preparing the way for the adaptation of the expression in a legal setting in Acts. By the time the phrase is used during Paul's trial, when Festus tells Agrippa, "It is not the manner of the Romans to deliver any man to die, before that he which is accused have the accusers face to face" (Acts 25:16), it has become weighted with resonance from its earlier biblical appearances. Here the words apply, not to the confrontation between man and God, but to the confrontation

[69]The Anchor Bible commentary on "face to face" notes that "the phrase is probably not to be taken in a general sense but is to be referred to direct knowledge of God. . . . Moses' *face to face* communication with God marks his unique prophetic role" (*The Anchor Bible: I Corinthians*, introduction and commentary by William F. Orr and James Arthur Walther [Garden City, N.Y.: Doubleday, 1976], 292).

between the accused and his accusers. The analogy is appropriate, however: Paul was on trial for his life, and the implied consequence of seeing the face of God is death.

"Face to face," however, is an image not only for seeing God or being on trial but also for the autobiographical act itself. One thinks of Wordsworth's metaphor for autobiography: it is like looking at his own reflection in a lake where, "crossed by gleam / Of his own image," the poet "often is perplexed and cannot part / The shadow from the substance."[70] Similarly, Ruskin speaks in *Praeterita* of "the effect on my own mind of meeting myself, by turning back, face to face."[71] Here the dialogue between man and God has become a dialogue of the self with itself—as in Proverbs, where we read that "in water face answereth to face" (27:19).

Newman uses the metaphor of coming face to face with oneself to announce a powerful experience of self-recognition. When his course of summer reading in 1839 led him to identify the Anglican church with the Monophysites, a heretical Christian sect of the fifth century, he wrote, "I saw my face in that mirror, and I was a Monophysite" (96). This unlooked-for discovery badly shook Newman's "supreme confidence" in the Anglican church; it was the first step in "that great revolution of mind," his conversion (81). The terrible implications of the nineteenth century's re-enactment of the fifth forced Newman to a new understanding of his times and himself.[72] Thus, it is not just the process of writing autobiography that requires coming face to face with the self, but conversion itself: Newman's conversion begins when he gains a frighteningly new

[70]William Wordsworth, *The Prelude* (1850) IV, 267–68; 263–64.
[71]Ruskin, *Praeterita*, 279.
[72]Newman writes: "There was an awful similitude, more awful, because so silent and unimpassioned, between the dead records of the past and the feverish chronicle of the present. . . . It was like a spirit rising from the troubled waters of the old world, with the shape and lineaments of the new" (97).

perspective on the face he is accustomed to seeing in the mirror.[73]

"Face to face," then, evolves from an expression of the unique relation between Moses and God into an image for trial, for autobiography, and for conversion. One may see the face of one's accuser, the face of another, younger, self, or one's own face from a new angle. But it is seeing the face of God that represents the ultimate trial of the human soul. When Jacob wrestles with the angel in a scene of testing and trial, he exclaims, "I have seen God face to face, and my life is preserved" (Gen. 32:30). His "baptism" with a new name, Israel, symbolizes a transformation that parallels conversion, for the confrontation with death is closely linked to the discovery of a new identity.

For Newman, "face to face" represents the fundamental situation of the Christian soul, on trial throughout life, but supremely so when it must confront God at the last judgment. To be prepared to face that final trial is, in the end, the goal of Newman's life and writing. This emerges most clearly in his long poem "The Dream of Gerontius," written "in the midst of the Kingsley controversy."[74] The poem describes a soul approaching the throne of God to receive judgment. The soul

[73]As Avrom Fleishman writes, "The discovery of one's face in a mirror is well established as an origin both of identity and of alienation" (*Figures of Autobiography*, 165). At one point in writing his autobiography, Ruskin says that "as I look deeper into the mirror, I find myself a more curious person than I had thought" (*Praeterita*, 243). For Jacques Lacan's discussion of the "mirror stage" of psychological development, see *Ecrits: A Selection*, trans. Alan Sheridan (New York: Norton, 1977), 1–7. In "Conditions and Limits of Autobiography" (in *Autobiography*, ed. James Olney [Princeton: Princeton University Press, 1980], 28–48), Georges Gusdorf has a useful discussion of "the encounter of man with his reflection" (32).

[74]C. F. Harrold, *John Henry Newman*, 277. Harrold suggests that "perhaps because of the strain imposed by the writing of the *Apologia* . . . Newman was seized with a vivid apprehension of impending death. . . . After the Kingsley affair was over . . . he set down 'on small bits of paper' a dramatization of the vision of a Christian's death, on which his mind had been dwelling."

hears the angels singing: "Father, whose goodness none can know, but they / Who see Thee face to face," and an angel explains that "for one moment thou shalt see thy Lord" when "thou art arraign'd / Before the dread tribunal."[75]

The radical transformation undergone by the soul in death approximates conversion; in fact, Newman had linked both ideas with the sight of God in his sermon "Sudden Conversions." Asking how Paul could bear "to be spurned and spit upon as a renegade, a traitor," Newman answered that it was "the Face of Jesus Christ" that sustained him: "One sight of that Divine Countenance, so tender, so loving, so majestic, so calm, was enough, first to convert him, then to support him on his way amid the bitter hatred and fury which he was to excite in those who hitherto had loved him." The sermon ends with the claim that looking upon the face of God will be eternal bliss: "And if such be the effect of a momentary vision of the glorious Presence of Christ, what think you, my brethren, will be their bliss, to whom it shall be given, this life ended, to see that Face eternally?"[76] Newman's preoccupation with the joy and awe of this sight leads him to meditate upon those biblical figures who had already experienced it during their lives.[77] In

[75]"The Dream of Gerontius" first appeared in January 1865, and is reprinted in *Newman: Prose and Poetry*, selected by Geoffrey Tillotson (Cambridge: Harvard University Press, 1970), 812–42. The lines quoted may be found on pages 836 and 830.

[76]*Parochial and Plain Sermons*, VIII, 229. The magnitude of this event was so vivid to Newman that in a sermon "Neglect of Divine Calls and Warnings" he described its opposite, the horror of a careless Christian when he discovers he must go to hell: "Oh what a moment for the poor soul, when it comes to itself, and finds itself suddenly before the judgment-seat of Christ! Oh what a moment, when . . . the sinner hears the voice of the accusing spirit. . . . And, oh! still more terrible, still more distracting, when the Judge speaks, and consigns it to the jailors." (*Discourses Addressed to Mixed Congregations* [London: Burns & Oates, 1849], 38).

[77]Job, too, apparently saw God: "I have heard of thee by the hearing of the ear: but now mine eye seeth thee" (42:5). Northrop Frye points out that this statement "makes the shattering claim to a direct vision of God that the Bible, even in the New Testament, is usually very cautious about expressing" (*The Great Code*, 197).

his sermon "Moses the Type of Christ," Newman says that "before Christ came, Moses alone saw God face to face." But he adds that only "Christ really saw, and ever saw, the face of God."[78]

Yet Christ, Newman suggests, gave up his vision of God's face in making his great sacrifice. Newman makes a fascinating analogy between the Pisgah sight vouchsafed to Moses (when he was allowed to see but not to enter the Promised Land) and the sight of God given to Christ: "Rather than Israel should forfeit the promised land, he [Moses] here offered to give up his own portion in it, and the exchange was accepted. He was excluded, dying in sight, not in enjoyment of Canaan. . . . This was a figure of Him that was to come. Our Saviour Christ died, that we might live: He consented to lose the light of God's countenance, that we might gain it."[79] The face of God is like the Promised Land; Moses and Christ each sacrifice the sight of what he loves best. By comparing the Pisgah sight, with its paradoxical combination of possession and loss, to the sight of God, Newman suggests an even more complex aspect of the "face to face" metaphor: he reveals its connection to sacrifice and absence as well as fulfillment.[80] Thus in "The Dream of Gerontius" Newman depicted an individual soul that, after one glimpse of God, was consigned to Purgatory, to long for what it had seen and lost.

Newman's own conversion brought both loss and gain; he gave up the sight of his beloved Oxford when he converted to Catholicism, and in a journal entry he actually speaks of his conversion as "the great sacrifice."[81] But for whom did Newman make his sacrifice? For God, of course: he loses the sight

[78]April 15, 1832; Newman, *Parochial and Plain Sermons*, VII, 122, 124.

[79]Newman, *Parochial and Plain Sermons*, VII, 128.

[80]The Pisgah sight was, as George Landow has pointed out, a widely used typological motif in the nineteenth century, a double-edged symbol for both fulfillment and failure (*Victorian Types, Victorian Shadows*, ch. 7).

[81]January 21, 1863; Newman, *Autobiographical Writings*, 255. And in the *Apologia* Newman quotes a letter he wrote on November 16, 1844: "How much I am giving up in so many ways!" (177).

of Oxford to gain the sight of God. But unlike Moses and Christ, leaders who sacrifice themselves for their people, Newman abandoned his followers in the Oxford Movement and the Anglican church.[82] In converting to Catholicism, Newman had apparently renounced the role of Moses leading pilgrims in the wilderness. As he writes in the *Apologia*, "How could I in any sense direct others, who had to be guided in so momentous a matter myself?" (169).[83]

Once again, potential typological identifications become problematic for Newman. His ambivalence about his own lost position as a leader, his guilt over betraying his friends, and his search for a new role to play in the Catholic church all meant that Paul, Moses, and Christ could be but imperfect analogies. "Face to face" represents Newman's attempt to get beyond these mediations, to be free of typological figuration. Yet how can he achieve that primary, direct relationship with God, as elusive and unattainable as the Pisgah sight? Searching for the true face—or "figure"—of God behind the figuration, Newman is nonetheless forced back into analogy, for the only way to capture God's face is to present his own, through autobiography.

[82]Indeed, it could be argued that it is Newman himself who accepts a symbolic substitute sacrifice. For conversion has traditionally been imaged as the death of the old self and the birth of the new, an image Newman evokes in calling himself "on my death-bed, as regards my membership with the Anglican Church" (121). Newman uses the fatal illness of a close friend to mark a clear turning point, even a crisis, in his own path towards Rome (175–77). The death of his friend enables Newman to rise, reborn, from his own metaphoric deathbed.

[83]Yet others still wanted to be guided by him, as he makes clear in the *Apologia*, describing an account of his conduct written by a lady. She portrays "a singularly graphic, amusing vision of pilgrims, who were making their way across a bleak common in great discomfort" when they discover " 'the most daring of our leaders . . . suddenly stop short, and declare that he would go on no further' " (170). Newman's inclusion of this passage in his autobiography, while intended to convey a humorous, self-deprecating attitude toward his renunciation, suggests a deeper anxiety about his own leadership.

The words "face to face" imply a certain equality; their very appearance on the page forms a balanced equation, almost a mirror image. And earlier Newman spoke of himself and God as "two and two only absolute and luminously self-evident beings" (16)—they might almost be interchangeable. Yet in a passage ostensibly affirming his certainty of the existence of God, Newman seems to undo the whole equation: "If I looked into a mirror, and did not see my face, I should have the sort of feeling which actually comes upon me, when I look into this living busy world, and see no reflexion of its Creator" (186). The extraordinary thing about this analogy is that Newman *does* see his own face in the mirror—but does *not* see God reflected in the world.[84] Despite the attempt to make "face to face" serve as a metaphor for his unmediated relation to God, Newman is caught in a self-reflective circle. With what Thomas Vargish calls "breathtaking egocentricity" Newman reaffirms the primacy of the self, while God almost drops out of the picture.[85] The "face to face" image has made possible a bizarre role reversal, perfectly symbolizing the paradoxes implicit in the autobiographical act of self-creation.

Meditating upon his own quest for self-knowledge and knowledge of God, Augustine too uses the words of Paul, saying that "at present I am looking at a confused reflection in a mirror, not yet face to face."[86] The metaphor is central in the tradition of spiritual autobiography: Bunyan tells us that the looking glass desired by Mercie "would present a man, one

[84]As Fleishman puts it: "Without malice be it said, there arises some doubt from the *Apologia* about the priority as between the two 'luminously self-evident beings' of Newman's world" (*Figures of Autobiography*, 169). He adds, "it is God's being that comes into question, never his own" (170).

[85]Thomas Vargish, *Newman: The Contemplation of Mind* (Oxford: Clarendon, 1970), 184. Vargish calls it an "essentially Cartesian argument," whereby Newman infers the existence of God from his own existence (183).

[86]Augustine, *Confessions*, 211.

way, with his own Feature exactly, and turn it but an other way, and it would shew one the very Face and Similitude of the Prince of Pilgrims himself."[87] In both instances, the mirror has a double function: it reflects the self, yet it also has the potential to show the face of Christ.[88] The mirror may thus serve as an analogy for typology itself, for just as "now we see through a glass, darkly; but then face to face," so types are the shadows of a reality to come. Bunyan's marginal note on the mirror reads, "It was the Word of God," suggesting that vision and language are one, both transparent media enabling the seeker to gain knowledge of self and God.

Newman's mirror confines him to his earthly vision of a fallen world rather than showing him the face of God. Yet his inner conviction of God's existence survives his own undercutting analogy: for Newman, God's devastating absence implies only that language and images are but imperfect conductors, to be transcended entirely in that final moment when the soul comes face to face with God. But the irony persists: Newman has sacrificed everything in order to see the face of God, but is finally denied that ultimate vision. He remains trapped in self, able to see only his own face in the mirror.

[87]Bunyan, *The Pilgrim's Progress*, 378. In *The Puritan Origins of the American Self* (New Haven: Yale University Press, 1975) Sacvan Bercovitch analyzes the Puritans' concept of the mirror, saying that "the mirror radiated the divine image. They never sought their own reflection in it, as did Montaigne and his literary descendants through Rousseau. They sought Christ. . . . The Puritans felt the less one saw of oneself in that mirror, the better; and best of all was to cast no reflection at all, to disappear" (14). For Newman, it seems, his own face in the mirror is a constant; it is God who has disappeared.

[88]In "Through a Glass Darkly: A Note on 1 Corinthians 13,12," David H. Gill contends that to see God through a mirror means to see him as mirrored in his creatures (*Catholic Biblical Quarterly* 25 [1963]: 429). Gill writes that D. J. Behm "establishes quite conclusively by the citation of numerous parallels that *di' esoptrou* [through a mirror] is to be interpreted in the sense of through the medium of creatures: . . . 'die Erscheinungswelt ist das Medium für die Erfassung des überweltlichen Gottes, Gottes Wesen wird im Spiegel der Welt erkannt, die er geschaffen hat und regiert'" ("Das Bildwort von Spiegel I Korinther 13,12" in the *Rheinhold Seeburg Festschrift* [Leipzig, 1929], I, 341).

"Things unseen" may be real, but they remain unseen, at least in "this living busy world."

By weaving a deliberately unliterary textual self, suppressing allusions to Moses, Job, and others, Newman tries to achieve a position from which he can celebrate a moment of linguistic, figural purity. The closing scene of Newman's autobiographical novel, *Loss and Gain*, provides a striking example of this desire to overcome the tension between rhetorical figure and divine *figura*. After spiritual trials and a glimpse of the Promised Land, Charles Reding arrives "face to face" with God. He has just been received into the Catholic church.

> He went on kneeling, as if he were already in heaven, with the throne of God before him, and Angels around. . . . "Oh," said Charles, "what shall I say?"—the Face of God! As I knelt, I seemed to wish to say this, and this only, with the Patriarch, 'Now let me die, since I have seen Thy Face.' "[89]

Newman attempts to create for his hero a near-speechless moment—"what shall I say?"—in which all earthly language, all self-justification and self-explanation resolve themselves in a direct vision of God. But the quotation of the Patriarch Jacob's exclamation to his long-lost son Joseph betrays the inescapability of typology.[90] The absence of a comparable scene in the *Apologia* signals Newman's realization of the impossibility of finding an unmediated language to describe this unmediated moment. He omits entirely any description of his actual reception into the Church. The conversion that has been prospective through four long chapters is silently accomplished in the turning of a page.

[89]Tillotson, *Newman*, 351.
[90]See Gen. 46:30. The gospel of Luke provides Charles Reding with a typological precedent for his use of this quotation, for the Holy Ghost promises the aged Simeon that he shall not die before looking upon Christ (2:29–30).

For Newman, then, "face to face" is an ideal image to transcend all images, types, and time. But it is still an image, still typologically and textually bound to tradition: the very Pauline resonances that appear to guarantee Newman the confident immediacy of Paul's relation to God also illustrate that even this seemingly transparent image cannot be genuinely unmediated. The moment of purity dissolves back into the intertext, becoming one more over-figured expression of an experience that can never be named. Newman's attempt to allow "no image . . . between the soul and its Creator" is doomed to failure, for the Face he seeks can only appear textually as one more figure in the literary construct of his religious life.

"That there should be time no longer": Revelation and Recurrence in Ruskin's *Praeterita*

She began with the first verse of Genesis, and went straight through, to the last verse of the Apocalypse; hard names, numbers, Levitical law, and all; and began again at Genesis the next day.

—John Ruskin, *Praeterita*

So Ruskin describes the daily Bible readings with his mother, "the long morning hours of toil, as regular as sunrise . . . year after year."[1] They began at the beginning, but did not stop at the end. In their method of reading they merged opening and closing, as Revelation itself does in the words "I am Alpha and Omega, the beginning and the end" (Rev. 21:6). And, just as Revelation simultaneously marks the conclusion of the Bible and yet re-evokes its beginning, recreating an Eden in which "there shall be no more curse" (Rev. 22:3), so Ruskin's *Praeterita* ends with a return to its own beginning, to the childhood garden of "Eden-land." In the Bible's own narrative structure, both linear and cyclic— and particularly in Ruskin's repetitive manner of reading it— we can see the pattern of sequence and recurrence with which Ruskin shaped *Praeterita*.

[1]Ruskin, *Praeterita*, *The Works of John Ruskin*, Library Edition, ed. E. T. Cook and Alexander Wedderburn, 39 vols. (London: George Allen, 1903– 12), xxxv, 40. Subsequent page references to *Praeterita* are given paren- thetically. *Praeterita* was first published serially between 1885 and 1889.

Although following in part the traditional, end-oriented model of autobiographical narration—the journey, the quest, the pilgrimage—*Praeterita* also traces, as Elizabeth K. Helsinger has said, "a history of continual return, of constant circling."[2] There is, on one level of narration, a linear progressive development based on Christian autobiographies of conversion and classical narratives of journeying, while on another level there is a pattern of repetition and return. For example, the two central chapters, "Rome" and "Cumae," are subtly modeled on the conversion experience of Christian autobiography and the visit to the underworld of classical epic. They tell of Ruskin's trip to Italy as a young man and his recovery from a dangerous illness as he turns northward with renewed energy and purpose (the parallel with Newman's first chapter is striking). Ruskin treats his recovery in a climactic manner, as though it were the turning point in his life. However, as the rest of *Praeterita* illustrates, this experience was only one of many: like Edens, Pisgah sights, and glimpses of Revelation, which should by their very nature be once-in-a-lifetime, unrepeatable events, conversion in *Praeterita* becomes plural, as Ruskin transforms the supposed climax into a recurrent episode. Moreover, such moments are treated as recurrent not only because they are repeated during the course of Ruskin's own lifetime but also because they are seen as reenacting similar occurrences in history and literature. Thus Ruskin, in describing his experience at Cumae, evokes the stories of Moses and Christ, of Aeneas and Dante. In narrating a single event of his own life, Ruskin connects it to many similar events in the past, creating a vision of history as patterned through significant repetition.

Typology provided Ruskin with a means of resolving the conflict between these two narrative models, the linear developmental one in which a unique episode such as a climactic conversion or revelation can occur and the cyclic one in which

[2]Elizabeth K. Helsinger, "The Structure of Ruskin's *Praeterita*," in *Approaches to Victorian Autobiography*, ed. Landow, 90.

history is seen as layered and events continually reenact the past.[3] For typology is not only an end-oriented system of progressive revelation, in which Adam, Moses, and David are believed to foreshadow Christ, but a means of linking similar events across time, in defiance of chronology. The full meaning of particular occurrences is not to be found within their own limited historical context, but in their transcendent relation outside time. Typology thus depends upon the perception of a similarity between two events, and the assumption that the latter in some sense repeats the former (even as it prefigures a yet later fulfillment). It is this pattern of repetition that establishes a relationship between often distant events, and connects them to a larger framework of religious and historical significance.[4]

We can see Ruskin uniting both sequence and recurrence in the opening pages of the "Cumae" chapter, where the autobiographer, by calling attention to his presence, insists on the period of time separating him from his subject. By analyzing "the effect on my own mind of meeting myself, by turning back, face to face" (279), Ruskin emphasizes the existence of two selves, young and old, subject and author, at different points in time. This image of two selves contributes to our sense of a development over time, especially in the evolutionary metaphor that follows, in which he says his earlier self "was simply a little floppy and soppy tadpole,—little more than a stomach with a tail to it, flattening and wriggling itself up the crystal ripples and in the pure sands of the spring-head of youth" (279–80). Presumably the adult self has since be-

[3]For a discussion of Ruskin's attitudes toward typology, including the effects of his childhood immersion in sermons and the Bible, see ch. 5 of Landow, *The Aesthetic and Critical Theories of John Ruskin.*

[4]As Carlyle—one of Ruskin's "Masters"—wrote, history "is a looking both before and after; as, indeed, the coming Time already waits, unseen, yet definitely shaped, predetermined and inevitable, in the Time come; and only by the combination of both is the meaning of either completed" ("On History," *The Works of Thomas Carlyle,* Centenary Edition, ed. H. D. Traill, 30 vols. [London: Chapman & Hall, 1896–1901], xxvii, 83).

come a full-grown frog, almost a different creature altogether, though it has grown, progressively, out of its own embryonic past. But the image of two selves meeting one another also creates a sense of identity outside time that is further illustrated when Ruskin gets "a sudden glimpse of myself, in the true shape of me" (280), through seeing his own profile carved in cameo. Thus, the young Ruskin had the experience of meeting himself face to face, through the medium of a portrait, just as the autobiographer Ruskin did, by painting a portrait in words. This passage creates a kind of layering effect, as one self meets an earlier self meeting *it*self. Ruskin's insistence on the identity of his two selves over an interval of forty years—"I find myself in nothing whatsoever *changed*. . . . I am but the same youth" (220)—achieves, like typology, a continuity that transcends mere chronology.

Typological autobiography locates itself in the midst of a continuum, linked to the past through repetition, and to the future through chronological progression towards salvation. In "Cumae" Ruskin uses typology in a fairly traditional way to describe a key experience, a kind of conversion. But ultimately it is not this end-oriented aspect of typology that Ruskin finds most congenial. For in addition to the finely poised tension between the two narrative strategies I have been describing (apparent development through turning points or moments of insight such as that at "Cumae," and simultaneous assertion of changelessness through patterns of repetition and return), there is also a third movement in the text. This consists of those passages leading up to and culminating in the "unconversion" of "The Grand Chartreuse" chapter, passages focusing on Ruskin's attitudes toward religion, especially Catholicism, and toward social conditions. The notion of an unconversion rather misleadingly suggests a conversion to Art, as Ruskin sheds the inhibitions of his Evangelical training first through sketching on a Sunday and later by contrasting an Evangelical sermon with a sensuous painting. But in fact, although Ruskin largely suppresses this in *Praeterita*, the unconversion signals

the greatest turning point of all in his life, the virtual abandonment of his career as an art critic to take up the role of social critic or "prophet."[5]

Praeterita ends with the events of 1864, and so includes almost no allusion to this second career.[6] As John D. Rosenberg writes, "We catch no glimpse of Ruskin's embattled, embittered years of social criticism or of the still darker years of his decline. . . . As the past encroached too closely and too painfully upon the present, he lost control of his material and had to abandon the book."[7] In fact, Ruskin forewarns the reader that this will be the case, for his self-proclaimed narrative strategy is one of omission: "I have written . . . speaking, of what it gives me joy to remember, at any length I like . . . and passing in total silence things which I have no pleasure in reviewing" (Author's Preface, 1885). This confession of selectivity lies at the heart of any understanding of the structure of *Praeterita*.[8] Such an extraordinary announcement, coming as it

[5]Although, as George Landow reminds us, "even this new fervent interest in political economy turns out to be not such a radical departure as it might first appear. Not only did Ruskin never entirely cease writing about art but he also had earlier always been concerned with the effects of art upon its audience" (*Ruskin* [Oxford: Oxford University Press, 1985], 17).

[6]In "The Feasts of the Vandals" Ruskin describes the visits of the aristocratic Domecq family as having given him "the first clue to the real sources of wrong in the social laws of modern Europe" (409). But as Kenneth Clark writes in his introduction to *Praeterita* (1949; reprint, Oxford: Oxford University Press, 1978), "Throughout there is hardly a mention of social or economic conditions. . . . It is evident that the memory of what Ruskin . . . calls 'the political work which has been the most earnest of my life,' was emphatically not among those things which it gave him joy to remember; but was, on the contrary, all too likely to evoke the savage and tormented state of mind which he wished to avoid: and so it is excluded" (xvi).

[7]John D. Rosenberg, *The Darkening Glass: A Portrait of Ruskin's Genius* (New York: Columbia University Press, 1961), 217.

[8]And it raises, of course, questions about the reliability and accuracy of the work. Ruskin entirely omits, for example, any mention of his marriage. But as John Dixon Hunt writes, "In essence it is, despite factual errors and omissions, often symbolically true" (*The Wider Sea: A Life of John Ruskin* [New York: Viking Press, 1982], 1–2).

did after decades of suffering and despair,[9] reveals how funda-
mentally at odds with any conventional autobiographical
structure *Praeterita* must be. For the typologically based auto-
biography of conversion, like Augustine's, records an experi-
ence of radical change, of how I became what I am now from
what I once was. It is a passage from error to truth through
conversion. Indeed, the conversion motivates the autobio-
graphical form itself, for as Jean Starobinski observes,

> One would hardly have sufficient motive to write an auto-
> biography had not some radical change occurred in his
> life—conversion, entry into a new life, the operation of
> Grace. If such a change had not affected the life of the
> narrator, he could merely depict himself once and for all,
> and new developments would be treated as external (his-
> torical) events. . . . It is the internal transformation of the
> individual—and the exemplary character of this transfor-
> mation—that furnishes a subject for a narrative discourse
> in which "I" is both subject and object.[10]

Ruskin, however, trying to argue that there has *been* no
change, suppresses nearly everything concerning the post-
conversion years of his life, which he had come to regard as
years of defeat and failure. This has immense consequences
for the autobiographical structure, which traditionally—like
typology itself—relies upon the ending to endow all that has
gone before with its ultimate significance. The ending for the
autobiographer is always a problem, for the natural stopping
point of the biographer, death, is not available to him.[11] But in

[9]Kenneth Clark calls it "an admission of defeat" (Clark, Introduction to
Praeterita, vii).

[10]Jean Starobinski, "The Style of Autobiography," in *Autobiography*, ed.
Olney, 78.

[11]Some autobiographers, notably Charles Darwin and Mark Twain,
adopt the stance of writing as if they were already dead: "I have at-
tempted to write the following account of myself, as if I were a dead man
in another world looking back at my own life" (*The Autobiography of*

conversion autobiography the discovery of some "truth" provides the solution, for it means that the autobiographer has found a fixed resting place of certainty and authority from which to look back, judge, and write about his former self. For Augustine, this truth was Christianity. But what, then, are the implications for an autobiography that wishes to exclude its own ending?

The problem of *Praeterita* is the problem of authorship without authority. Ruskin denies, even to himself, any consciousness of the ending—thus denying the very basis from which traditional autobiography is written. Elizabeth Helsinger suggests that in *Praeterita* Ruskin tries, unsuccessfully, to impose a progressive structure upon the random events of his life: "In spite of the pressure of the genre to select a single line of development, he cannot make his own life conform to that pattern."[12] Yet it seems, rather, that Ruskin is trying to escape progression in order to avoid the ending, those years which it will give him no pleasure to recall. *Praeterita* is not an unrealized narrative but a repressed one, in which the cycles of repetition and return are, at least partially, escape attempts. For if the ending represents not triumph but defeat, then the impulse of the narrative will be, not to push forward, but to linger, "gathering visionary flowers in fields of youth" (Author's Preface).

To Ruskin the ending, at least in his own case, seemed to signify the absence of meaning, not the revelation of it. Yet he continues to utilize typological structures, which are deeply directional and end-oriented, in order to write an autobiography in which the ending, quite literally, cannot be faced. The contrast between the unavoidably progressive structure and the effaced conclusion is poignant, even tragic. Yet finally this use of typology becomes, I believe, part of an unconscious

Charles Darwin, ed. Nora Barlow [1887; reprint, New York: Norton, 1969], 21). See Moshe Ron, "Autobiographical Narration and Formal Closure in *Great Expectations*," *Hebrew University Studies in Literature* 5 (1977): 39–40.

[12]E. Helsinger, 94–95.

strategy of duplicity. It asserts an apparent progression through turning points (moments of aesthetic insight), misleading the reader with the hopeful delusion that Art will be the goal.[13] These are, in a sense, red herrings, deceptive signposts that do not tell how Ruskin's story will really end, as despairing social prophet, not inspired art critic. Similarly, the patterns of repetition and return are a means of taking refuge from the real movement of the story towards social criticism and failure. It is this repressed narrative of omission that ultimately undermines the other two.

Only in the last chapter of *Praeterita* does Ruskin appear to transcend the dilemma of the entire narrative. He has made a gigantic leap, skipping over the dark decades separating the present moment from the unconversion. It is typology's vision of history as reenactment that enables Ruskin to defeat time and repossess the past by organizing his remembrances, not chronologically, but in patterns of significant recurrence. In merging the end into the beginning, he deprives the end of its terrors. Through repetition Ruskin transforms the end itself into a form of return, coming full circle, as Revelation recreates Eden.

Typology as Progression

ALTHOUGH *Praeterita* as a whole portrays the gradual weakening of Ruskin's evangelical beliefs, culminating in the unconversion of "The Grande Chartreuse," the "Rome" and

[13]An example, one of many possible ones, would be Ruskin's description of a discovery he made while drawing in the woods at Fontainebleau: "That all the trees of the wood . . . should be beautiful—more than Gothic tracery, more than Greek vase-imagery, more than the daintiest embroiderers of the East could embroider, or the artfullest painters of the West could limn,—this was indeed an end to all former thoughts with me, an insight into a new silvan world" (315). Such moments of revelation, so very visual, imply strongly that his future work will take place in the artistic, not the social, realm.

"Cumae" chapters depict a conversion experience similar to those that structure traditional Christian autobiography. One of the primary sources for spiritual autobiography, as Linda Peterson has pointed out, was the Exodus account: "The autobiographer's description of his unrepentant ways corresponds to the Egyptian bondage; the dramatic conversion, to the flight from Pharaoh and the crossing of the Red Sea; the period of confusion or backsliding, to the wilderness wandering; and the final peace, to the entry into Canaan."[14] Ruskin does employ allusions to Exodus to describe a period of physical and spiritual crisis and reemergence. But the episode is also portrayed as a classical journey to the underworld: like Dante, whose *Divine Comedy* links Aeneas's visit to Hades with Christ's death and resurrection, Ruskin mingles biblical and classical sources.[15]

"Rome" and "Cumae" tell of the Ruskin family's 1840–41 trip to Italy, where they sought to restore the twenty-one-year-old Ruskin's health, severely strained by overwork at Oxford. If his childhood in the garden at Herne Hill had been Eden,[16] then Oxford, where he spent three years at work in which he "took not the slightest interest" (188), may be seen as the captivity in Egypt. During this period of forced labor, which finally culminated in a physical breakdown, he felt a dimming of religious feeling: "It had never entered into my head to doubt a word of the Bible . . . but the more I believed it, the less it did me any good. . . . I had virtually concluded from my general Bible reading that, never having meant or done any harm that I knew of, I could not be in danger of hell" (189–90).

[14]Peterson, "Biblical Typology," 238.

[15]Similarly, Saint Augustine relies upon the stories of both Paul and Aeneas in his *Confessions*.

[16]For further discussion of the motif of a lost and found Eden, see "Ruskin's *Praeterita*: The Enclosed Garden," in Avrom Fleishman's *Figures of Autobiography*, 174–88. See also Pierre Fontaney, "Ruskin and Paradise Regained," *Victorian Studies* 12 (1969): 347–56, and Bruce Redford, "Ruskin Unparadized: Emblems of Eden in *Praeterita*," *Studies in English Literature, 1500–1900* 22 (1982): 675–87.

Like the young Augustine he explicitly rejected any typological connection between his life and the Bible, saying that "if I had lived in Christ's time, of course I would have gone with Him up to the mountain, or sailed with Him on the Lake of Galilee; but that was quite another thing from going to Beresford Chapel, Walworth, or St. Bride's, Fleet Street" (189).[17] Yet it is precisely in this inability to link his individual religious existence with the larger pattern of providential history that he most clearly reveals himself to be in the same state of spiritual isolation as the Israelites in Eygpt, who forgot even the name of their God (Exod. 3:13).

Though Ruskin may have felt confident that he "could not be in danger of hell," he was soon to travel to the very gate of hell itself, Cumae. In Ruskin's narration the journey southward takes on aspects of the Red Sea crossing and the wandering in the wilderness. Nightmarish visions of deluge and desert succeed one another: "The journey by Valence to Avignon was all made gloomy by the ravage of a just past inundation . . . slime remained, instead of fields" (263), and the landscape at Genoa was like an infernal wasteland, revealing only "what uglinesses of plants liked to grow in dust, and crawl, like the lizards, into clefts of ruin" (264). Finally, the Ruskins are forced to cross swollen rivers in their heavy carriage so that "in windy weather, with deep water on the inside of the bar, and blue breakers on the other, one really began sometimes to think of the slackening wheels of Pharaoh" (265).

Ruskin reports his first sight of Florence where "the Newgate-like palaces were rightly hateful to me" (269)—the first of several references to Italy itself as a prison. Then, in Rome, he despises St. Peter's and finds most of the art "entirely useless"

[17]He also rejected the traditional prototype for spiritual autobiography, saying "though I felt myself somehow called to imitate Christian in the *Pilgrim's Progress*, I couldn't see that either Billiter Street and the Town Wharf, where my father had his cellars, or the cherry-blossomed garden at Herne Hill, where my mother potted her flowers, could be places I was bound to fly from as in the City of Destruction" (189).

(273). In the midst of his despondency, however, was one ray of light: his occasional glimpses at church of "a fair English girl" with "the kind of beauty which I had only hitherto dreamed of as possible, but never yet seen living" (277). He never spoke a word to her, "but she was the light and solace of all the Roman winter to me, in the mere chance of glimpses of her far away" (277). With this Beatrice-like vision, the chapter "Rome" ends.

The "Cumae" chapter recounts the story of a brush with death and a spiritual crisis as a metaphorical journey to the underworld. As the home of the priestess of Apollo and the place where Aeneas descended to Hades, Cumae represents not only the location of prophecy and divinity but also the entrance to hell. Thus for Ruskin it functions beautifully as a double symbol: for him, as for Aeneas and Dante, it was necessary first to reach an absolute spiritual nadir before obtaining some sort of prophecy concerning his future life.

The central passage begins with his visit to Vesuvius, at which, Ruskin says, his feelings were "of being in the presence of the power and mystery of the under earth, unspeakably solemn." Here is the gateway to the underworld, and in these "volcanic powers of destruction" he saw, "if not the personality of an Evil Spirit, at all events the permitted symbol of evil, unredeemed" (288). This Dantesque landscape of "under earth" and mountain sets the scene for Ruskin's encounter with death and evil. Throughout, the episode owes much to Dante's conception of Purgatory as a mountain upon whose summit is an Earthly Paradise, toward which the penitent climbs. "The object of all Purgatory," John Sinclair says, "is the reversal of the fall . . . the re-entering of Eden."[18] For Ruskin, any landscape had always a symbolic significance, so that in "the same literal way in which the snows and Alpine roses of Lauterbrunnen were visible Paradise, here, in the valley of

[18]Note to Canto I of *Purgatorio* in Sinclair's translation of Dante, *The Divine Comedy* (1939; reprint, New York: Oxford University Press, 1980), 28.

ashes and throat of lava, were visible Hell. If thus in the natural, how else should it be in the spiritual world?" (288).

Ruskin is also awed by the classical associations of the landscape before him. He recalls the lines from *Purgatorio* in which Virgil tells Dante that his mortal remains are buried in Naples, saying that

> From the moment when I knew the words,—
> > "It now is evening there, where buried lies
> > The body in which I cast a shade, removed
> > To Naples from Brundusium's wall,"
> not Naples only, but Italy, became for ever flushed with the sacred twilight of them. (288)

Yet lurking in this tribute to Dante and Virgil may be a deeper anxiety on Ruskin's part about the lack of guides in his own life. For the context of the passage Ruskin quotes is that Dante, seeing only one shadow, is anxious that his guide, Virgil, may have abandoned him. In the previous line, which Ruskin does not quote, Virgil reassures Dante, saying, "Believest thou not that I am with thee and guide thee?"[19] But, like Moses, Virgil is a guide who will not be able to accompany those he leads into the Promised Land, or Paradise.

Ruskin continues, remembering how the scene made the *Aeneid* come alive:

> What pieces I knew of Virgil, in that kind, became all at once true, when I saw the birdless lake; for me also, the voice of it had teaching which was to be practically a warning law of future life:—
> > "Nec te
> > Nequidquam lucis Hecate praefecit Avernis."
> The legends became true,—*began* to come true, I should have said,—trains of thought now first rising which did not take clear current till forty years afterwards; and in

[19]Dante, *Purgatorio*, Canto III, line 24; Sinclair translation.

this first trickling, sorrowful in disappointment. "There *were* such places then, and Sibyls *did* live in them!—but is this all?"

Frightful enough, yes, the spasmodic ground—the boiling sulphur lake—the Dog's grotto with its floor a foot deep in poisoned air that could be stirred with the hand. Awful, but also for the Delphi of Italy, ignoble. And all that was fairest in the whole sweep of isle and sea, I saw, as was already my wont, with precise note of its faults. (288–89)

Ruskin's quotation from Virgil's *Aeneid* introduces another guide, the Sibyl, who not only conducts Aeneas into Hades but also reveals portions of his future to him. Disappointed that there are no sibyls now, Ruskin nonetheless takes Aeneas's words to the Sibyl, "not for nothing has Hecate assigned Avernus' woods to your safekeeping,"[20] as addressed to himself, "a warning law of future life." Ruskin dimly foreshadows his own later sibylline role as social prophet, condemning the popular view of Naples as a Paradise and taking "precise note of its faults." He writes with indignation of "the horror of neglect in the governing power, which . . . [has] made the Appenines one prison wall, and all the modern life of Italy one captivity of shame and crime" (289–90).[21] In this context of prophecy and leadership Ruskin realizes that a choice is before him: to continue in his present state of useless nervous depression and ennui, or to make something of himself by beginning the work of his life. The

[20]Virgil, *The Aeneid*, trans. Allen Mandelbaum (New York: Bantam, 1971), VI, 163–65.

[21]Raymond D. Fitch also regards Ruskin's experience at Cumae as central to his spiritual development and linked to the later unconversion. It was an "apocalyptic moment that he recollects in *Praeterita* to dramatize the spiritual crisis . . . toward which he was moving in the forties and fifties, and that would determine the whole course of his work after the mid fifties" (*The Poison Sky: Myth and Apocalypse in Ruskin* [Athens: Ohio University Press, 1982], 44–45).

realization at the cave of the prophetess is a turning point in his life, a "stroke of volcanic lightning" after which "the chrysalid envelope began to tear itself open here and there to some purpose," so that he leaves Naples with "notions of bettering my ways in future" (290).[22]

But the return with a divinely inspired message for the future is only half of the experience of a descent into hell; the other half must clearly be a confrontation with the past, like the autobiographical act itself. Aeneas meets his dead father Anchises, while Ruskin, after all, writes *Praeterita* as "a dutiful offering at the grave of parents . . . in the hope of being soon again with them" (Author's Preface). Similarly, the young Ruskin had to find some means of reintegrating himself with the history, religion, and literature from which he felt cut off. He had rejected the Bible during his Oxford years, and asserted his "total ignorance of Christian history" (250). Like Saint Augustine, who denounces the *Aeneid* only to pattern central portions of his autobiography on it, Ruskin claims "I had nominally read the whole *Aeneid*, but thought most of it nonsense" (271). Yet now, suddenly, what he knew of Virgil "became all at once true." Three times in this section he emphasizes the notion of literature becoming true for him. Earlier, while he may have enjoyed it, he could never feel it to be real:

> I rejoiced in all stories of Pallas and Venus, of Achilles and Aeneas, of Elijah and St. John: but, without doubting in my heart that there were real spirits of wisdom and beauty, nor that there had been invincible heroes and inspired prophets, I felt already, with fatal and increasing sadness, that there was no clear utterance about any of them—that

[22]It may also be possible to see in this warning, particularly since he adds that he only realized its full import "forty years afterwards," an allusion to his later bouts of madness, almost literal descents into hell. The warning, which set him about his life's work, thus alludes to the fact that "the night cometh, when no man can work" (391).

there were for *me* neither Goddess guides nor prophetic teachers; and that the poetical histories, whether of this world or the next, were to me as the words of Peter to the shut up disciples—"as idle tales; and they believed them not." (149)

But now "the legends became true,—*began* to come true" rather, for the process was not complete until forty years afterwards, that is to say, the present moment, that of the old man seeing his past and shaping his autobiography in terms of those very legends of "invincible heroes and inspired prophets." The quotation sets up typological pairs: Venus protects Aeneas as Pallas Athene protected Achilles, and the New Testament prophet John the Baptist patterns his life upon the Old Testament prophet Elijah. For the individual life gains meaning through becoming part of a typological continuum. As Saint John took Elijah for his model and Dante took Virgil for his, so Ruskin takes them all, linking his story to a whole series of reenactments. Thus the realization at Cumae concerns not just the future but the past, as Ruskin begins to see his own life acting out what once seemed merely literary history.

In any journey to the underworld one must confront not only the past but death itself. Ruskin goes on to tell how his cough returned, worse than before, and his father had to hurry to Rome for a doctor. But he recovers, appropriately, at Easter,[23] and having reached Naples, the southernmost point

[23]These chapters frequently allude to events in the Christian calendar. Thus, in Rome we learn that it was "towards the Christmas time" (280), and then again that it was "under the birth-star" (284). The sentence "it was the last time the cough ever troubled me" flows directly into the next, "the weather was fine at Easter" (291). The progress of the chapter, with its metaphorical descent to the underworld and literal brush with death, is closely linked to the Christian year, as is Dante's journey through the Inferno, which begins on Good Friday and ends on Easter. Thus Ruskin, like Dante, typologically ties this account of spiritual crisis to Christ's birth, death, and resurrection.

of their travels, the Ruskins head north again. Nevertheless, he says, "there was no sign, take all in all, of gain to my health from Roman winter. My own discouragement was great" (292). Then, following a chance encounter with a dying Scottish youth of about his own age, Ruskin "recovered heart" (293). It seems as though a kind of sacrifice has been offered and accepted in this substitute death, coming as it does soon after the return from the "Inferno" at Cumae. And, if Ruskin's own discouragement corresponds to the period of wandering in the wilderness that followed the flight from Pharaoh, then the death of the youth corresponds, not only to Christ's death, but to Moses' death, after which his people cross into Canaan without him.[24]

For indeed the very next sentence describes a kind of Pisgah sight, such as that vouchsafed to Moses on the mountaintop just before his death (Deut. 34:1–4).[25] Beautiful in the distance, "the enchanted world of Venice" rises before Ruskin, so lovely he can scarcely believe it: "That the fairy tale should come true now," he says—in the third mention of literature or legend coming true—"seemed wholly incredible . . . Venice, asserted by people whom we could not but believe, to be really over there, on the horizon, in the sea! How to tell the feeling of

[24]The *Apologia* provides a parallel, in that Newman rises, newly converted, from his metaphoric deathbed shortly after the death of a dear friend. A source for both Newman and Ruskin may be the *Confessions*, where the death of a friend is described in conjunction with Augustine's illness (at Rome, no less) which, he says, "all but carried me off to hell" (*Confessions*, 101). And Augustine perhaps echoes the *Aeneid*, for Aeneas loses his friend Misenus after his conversation with the Sibyl and before his visit to Hades. The death of a substitute seems to be a necessary component of every journey to the underworld.

[25]Moses' Pisgah sight was widely used as a typological motif in the nineteenth century. The notion of a divinely granted vision that is at once the symbol of reward and failure, fulfillment and denial, seems particularly appropriate for *Praeterita*. George Landow, who discusses this motif in *Victorian Types, Victorian Shadows*, suggests that all of *Praeterita* can be seen as structured around a series of Paradises lost and Pisgah sights, in which Ruskin is compensated for the many losses of his life by his ability to see so clearly (230).

it!" (293). He recalls his joy, "when everything . . . was equally rich in rapture, on the morning that brought us in sight of Venice: and the black knot of gondolas in the canal of Mestre, more beautiful to me than a sunrise full of clouds all scarlet and gold" (294).[26] In a sense, this retrospective vision of "absolute happiness" represents the ultimate Pisgah sight for the autobiographer, too, writing forty years later of his past life as the unattainable Canaan of *temps perdu*. For the Pisgah sight symbolizes not only fulfillment, but frustration and failure, the ability of the autobiographer to see but not to enter the childhood Eden of his past.

If this sight of Venice corresponds to the Pisgah sight, a glimpse of the Promised Land, it is also a vision of the New Jerusalem in Revelation, for Ruskin concludes his account of Venice with a quotation from his diary, "Thank God I am here; it is the Paradise of cities" (296). Throughout *Praeterita* Ruskin organizes his remembrances around particular places and landscapes, primarily gardens (Edens), mountains (Pisgah sights), and cities (New Jerusalems). He says that there were "three centres of my life's thought: Rouen, Geneva, and Pisa" (156). Like Venice, each of these cities is an earthly paradise, both a heavenly city and a garden recreated.

Yet despite his love for Venice, Ruskin ultimately rejects it, saying, "Venice I regard more and more as a vain temptation" (296). Like Aeneas, who was tempted to remain in Carthage but was finally forced to resume his quest, Ruskin's journey continues to his true "home," the Alps, in sight of which his health improves even further. The chapter closes with a return to the mountains which, since his first glimpse of them, had been both Eden and Revelation to him (116). He describes

[26]There are further parallels to the *Aeneid* and *The Divine Comedy* in that, after the return from the underworld, all three books describe dawn and the sea: "And now the sea was red with sunrays, saffron / Aurora shone in her rose chariot" (Virgil, *Aeneid*, VII, 31–32); "The dawn was overcoming the morning breeze, which fled before it, so that I descried far off the trembling of the sea" (Dante, *Purgatorio*, I, 115–17).

getting up early in the morning and running outside to look at the mountains in the dawn: "I had found my life again;—all the best of it. What good of religion, love, admiration or hope, had ever been taught me, or felt by my best nature, rekindled at once; and my line of work, both by my own will and the aid granted to it by fate in the future, determined for me. I went down thankfully to my father and mother, and told them I was sure I should get well" (297).

This ecstatic mountaintop revelation is the climax of the chapter, in which the tentative realizations at Cumae about his past and future are enthusiastically reaffirmed. It is a kind of resurrection—"I had found my life again"—and a renewal of faith and energy. The last paragraph of "Cumae" provides a final confirmation that the new and productive course of Ruskin's life was set. Appending a diary entry from more than a year later, he takes pains to show that a renewal of the "resolutions" first felt on this trip was the origin of his work on Turner—*Modern Painters*.

Israel in bondage in Egypt, then in the wilderness, and finally in the Promised Land, forms a series of events which find their typological fulfillment in the story of Christ's arrest, death and descent to hell, and final resurrection—itself a version of the classical journey to the underworld. Ultimately, these become metaphors not only for the young Ruskin's spiritual crisis, but also for the autobiographical act being performed by the older Ruskin. The autobiographer, like the classical visitor to the underworld, reviews his own past, juxtaposing past and present, in order to integrate the individual moment or life into a larger historical and religious pattern of meaning.

Typology as Recurrence

IN THE "Rome" and "Cumae" chapters the subtle presence of the pilgrimage and journey pattern creates the strongest sense

of progressive development in *Praeterita*. Nevertheless, the following chapter opens with another recurrence of Ruskin's illness, so that the alternative pattern, the "history of continual return," reasserts itself once more. Even the turning point described in "Cumae" proves to be only one of many, for as Elizabeth Helsinger notes, "on at least seven different occasions between 1845 and 1882 he thought he had achieved religious conversion, only to discover, in retrospect, that the turning had not been definitive."[27] Climactic moments thus become habitual, and it is this sense of repeated action that is so characteristic of *Praeterita*.

Individual journeys, for example, are narrated in what Gérard Genette has called the "iterative" mood, that is, what used to happen, on more than one occasion, as opposed to what happened uniquely, the "singulative."[28] Ruskin explicitly acknowledges this nonchronological method as his own, most notably in "The Col de la Faucille," where he says "the reader must pardon my relating so much as I think he may care to hear of this journey of 1835, rather as what *used* to happen, than as limitable to that date; for it is extremely difficult for me now to separate the circumstances of any one journey from those of subsequent days, in which we stayed at the same inns, with variation only from the blue room to the green, saw the same sights, and rejoiced the more in every pleasure—that it was not new" (158).

Genette points out that in literature the iterative is usually subordinate to the singulative; it provides the descriptive framework out of which the singulative action may be launched.[29] But in Proust, he shows, the proportion of iterative to singulative is reversed—so much so that the singulative itself is transformed in various ways into the iterative, a phenomenon Genette calls "pseudo-iterative," where scenes that

[27]E. Helsinger, 96.
[28]Gérard Genette, *Narrative Discourse: An Essay in Method*, trans. Jane E. Lewin (Ithaca: Cornell University Press, 1980), 114–16.
[29]Genette, 116–17.

could logically only have happened once are presented as habitual.[30] Like so many supposedly distinctive Proustian characteristics, this use of the iterative can be traced back to *Praeterita*—which Proust claimed to know by heart.[31]

The iterative use of verbs and adverbs occurs frequently in *Praeterita*: "We used to hire the chaise regularly for the two months out of Long Acre" (16); "Anne would observantly and punctiliously put it always on the other [side]" (31); "I never thought of doing anything behind her back" (36). Very few things happen only once; occurrences are always regular, routine, predictable. This is true not only for activities that are performed every day—reading the Bible, watching his father shave, playing in the garden, setting out on their travels at six each morning—but for activities that recur at weekly intervals—"the horror of Sunday used even to cast its prescient gloom as far back in the week as Friday" (25)—or at annual intervals—"my father's birthday was the tenth; on the day I was always allowed to gather the gooseberries for his first gooseberry pie of the year" (32). As Ruskin says, "the routine of my childish days became fixed, as of the sunrise and sunset to a nestling," and it was this very routine that made him happiest: "I remember with most pleasure the time when it was most regular" (131). If in Proust, as Genette writes, "the *return* of the hours, the days, the seasons, the circularity of the cosmic movement, remains both the most constant motif and the most exact symbol of . . . *Proustian iteratism*,"[32] the same can certainly be said of Ruskin.

The point about repetition, however, is its paradoxical nature, for time both enables repetition and frustrates it. Like memory itself, which recreates the past and yet separates us from it, the passage of time marks the past as forever irrecover-

[30]Genette, 121.

[31]In *Proust: The Early Years* (Boston: Little, Brown, 1959), George D. Painter writes that "Proust knew *Praeterita* well: it was one of the works of Ruskin which in his letter to Mlle. Nordlinger of 8 February 1900 he claimed to know by heart" (346).

[32]Genette, *Narrative Discourse*, 139.

able. It is the situation of every autobiographer, able to recapture the past through his art, but *only* through his art. For Ruskin, though, the pain of this unsolvable paradox was unusually acute, for as an adult the focus of his desires remained his childhood. Desire, normally directed toward the future, and memory, necessarily directed toward the past, merged. The problem for Ruskin was that as he grew older, the objects of memory—little girls and childhood gardens—became themselves the objects of desire, and it is this which gives the book its pervasive feeling of loss and frustration. If in childhood Ruskin experienced the frustration of desire by being deprived of toys, rich food, and freedom, in later years he experienced the frustration of memory, by being unable to return to the past.[33] In typological terms the first may be symbolized by the Pisgah sight, the vision of the Promised Land into which one is denied entrance, and the second by the image of lost Edens, so frequent in *Praeterita*. When the two become identified, the longing for repetition becomes almost compulsive, translating into a desire to defeat time itself, to recapture the past.

Typology, like iteration, evidences a view of reality and time as a succession of states, of connected events that are separate in time, not a causal progression. Christ doesn't evolve out of Moses; he is subsequent to him. Relationships are seen to exist on a transcendent level, where only discontinuity exists on the everyday, historical level. It is this transcendent connection of apparently disjunct experiences that both Ruskin and Proust are seeking when they group their memories around symbolic landscapes, rather than arranging them along the ultimately more random lines of mere chronology, which can so easily

[33]In *Ruskin's Poetic Argument* (Ithaca: Cornell University Press, 1985) Paul Sawyer writes: "To an obsessive degree, Ruskin experienced life in terms of a past that was serene and intact, a future fulfillment that was forever about to be, and a present forever embodying the gap betweeen fulfillment and desire" (27). For an excellent discussion of the patterns and themes of *Praeterita* see Sawyer's last chapter, "Time Present and Time Past," 309–32.

imply a developmental connection where none may exist. Chronology is seen as superficial, arbitrary, something to be overcome by the act of memory that arranges events "in an order not theirs, but its own."[34] Ruskin confessed to privileging memory over chronology in composing *Praeterita*: "I think my history will, in the end, be completest if I write as its connected subjects occur to me, and not with formal chronology of plan" (128). Typology, like iteration, groups events on the basis of a perceived similarity, helping the autobiographer to defeat the tyranny of chronology. The search for similarity, if not identity, between separate events is perhaps in essence a desire to assimilate the new, to regularize it and make it familiar. The strength of this desire for iteration can be seen in Ruskin, as in Proust, by his ability to make even the singular event part of the pattern.

This recurrence of key experiences, which ought by their very nature to be unique, best illustrates the role of repetition in *Praeterita*. For Ruskin such experiences were primarily those of a new vision or realization, in which he suddenly had an insight into the nature of form, such as the Norwood ivy or the tree at Fontainebleau, or saw for the first time a landscape, such as the Alps at Schaffhausen. In fact, Ruskin's series of Pisgah sights or visionary moments can be regarded as one of the primary structuring devices of *Praeterita*. Certainly it is true that Ruskin, from an early age, sought out the view to be had from heights, whether it was his seat in the "dickey" of the traveling carriage from which his "horizon of sight [was] the widest possible" (32) or the view of the Alps from the Col de la Faucille which, he says, "opened to me in distinct vision the Holy Land of my future work and true home in the world. My eyes had been opened, and my heart with them, to see and to possess royally such a kingdom!" (167).[35]

[34]Genette, *Narrative Discourse*, 156.
[35]Liking heights and especially the Alps so much, he even transforms Herne Hill, in simile, into Mont Blanc, the highest point in Western Europe (34).

Throughout Ruskin focuses more on the similarities among these experiences than on the difference he claims they have made in his life. He finds meaning in patterns of recurrence, not in dramatic development over time. For Ruskin, the self is essentially unchanging because it contains in embryo all that it will later be.[36] At quite a young age, in fact, Ruskin had decided that he "already disliked growing older,—never expected to be wiser, and formed no more plans for the future than a little black silkworm does in the middle of its first mulberry leaf" (103). He likes things precisely because they *are* familiar:

> I can scarcely account to myself, on any of the ordinary principles of resignation, for the undimmed tranquillity of pleasure with which, after these infinite excitements in foreign lands, my father would return to his desk opposite the brick wall of the brewery, and I to my niche behind the drawing-room chimney-piece. But to both of us, the steady occupations, the beloved samenesses, and the sacred customs of home were more precious than all the fervours of wonder in things new to us. (134)

It is the *return* to the routine that delights Ruskin, the quality of sameness and familiarity: "After all the furious excitement and wild joy of the Continent, the coming back to a Yorkshire streamside felt like returning to heaven" (221).[37] And to Geneva, he says, they returned "again and again . . . knowing,

[36]The conception of an essential and fixed basis of the self that the process of life gradually reveals dates back to Aristotle and before him to Pindar, who paradoxically advised, "Become what thou art." See Georg Misch, *A History of Autobiography in Antiquity*, 2 vols., 3d. ed., trans. E. W. Dickes (London: Routledge & Kegan Paul, 1950), 1: 62–63, 289–95.

[37]As John Dixon Hunt puts it, "Recurrent pleasures are especially acute when no change at all is apparent; therefore no revision of the past is required, and the living self of the present and the lived self of the past whose patterns are already constructed are happily one" (*The Wider Sea*, 2).

and, in their repetitions twice, and thrice, and four times, magnifying, the well-remembered joys" (320). This love of repetition and return accounts for the recurrence of Pisgah sights in *Praeterita*: Ruskin thus achieves the transformation of the singular, unique moment—which he claims has altered the course of his life—into the almost habitual one. The similarity that characterizes the description of such formative visions illustrates his pleasure in returning to the familiar, rather than an inability to get on with the narrative by making each event entirely new and special, different from all preceding ones. This is the ultimate tour de force of the iterative in *Praeterita*, the metamorphosis of these necessarily singular visions into the recurrent, the incorporation of variation itself into the routine.

For routine and repetition, finally, are the absence of event. The Fall itself was the first event; previous to it there were no events in the garden, no human history. It is a fall *into* time and history. For primitive people who perceive "the universe in terms of archetypal, ever-recurring processes and rituals," George Landow says, "to be different—to be *individual*—is to fall."[38] In the same vein, Octavio Paz comments that "primitives distrust history because they see in it the beginning of the separation, the beginning of the exile of man adrift in the cosmos."[39] It is precisely this separation and exile Ruskin seeks to overcome; he wants to regain the stasis of prehistory, before time and event began, in the Garden of Eden. Through a narrative structured around repetition he tries to frustrate change. The act of writing autobiography is itself an attempt to defeat time,[40] and this no doubt was one of the reasons for the

[38]Landow, *Approaches to Victorian Autobiography*, xvi.

[39]Octavio Paz, *Claude Lévi-Strauss: An Introduction*, trans. J. S. and M. Bernstein (Ithaca: Cornell University Press, 1970), 85.

[40]In his essay "Conditions and Limits of Autobiography," Georges Gusdorf suggests that the genre of autobiography has emerged "only in recent centuries," for the "conscious awareness of the singularity of each individual life is the late product of a specific civilization." Only when humanity "enters into history" does autobiography become possible (*Au-*

popularity of the genre among Victorians, who lived in an age of rapid, disconcerting change.[41] Where Newman's goal as an autobiographer was to justify change, Ruskin's is to deny that there has been any.

Ruskin professes to be unchanged, but clearly we must read this as expressive more of his desire than of the reality. For Ruskin was all too aware of time passing, and feared it, as the many deaths and transformations in the book amply illustrate. People and landscapes around him were always changing— little girls grew up, railroads defaced the countryside, aunts and cousins died, and streams turned into sewers. When he writes of the assembled congregation in Christ Church choir, "none of us then conscious of any need or chance of change" (192), it is with a nostalgic accent on the word "then." Since the very concept of a journey or pilgrimage asserts change, it is perhaps inevitable that the notion of typology as recurrence should come to dominate *Praeterita*.

The Repressed Text

DESPITE ITS apparent structure of development through moments of aesthetic insight, formulated as turning points or conversions, and despite the patterns of repetition and return that characterize even these key moments, another more fundamental structure governs *Praeterita*. It is a narrative of omis-

tobiography, ed. Olney, 31). In a sentence that could have been written of Ruskin, Gusdorf adds that "recalling of the past satisfies a more or less anguished disquiet of the mind anxious to recover and redeem lost time in fixing it forever" (37).

[41]In *Design and Truth in Autobiography*, Roy Pascal writes: "What is new in the nineteenth century is the historical consciousness that the time described has now altered, gone beyond recall. Countless autobiographies set out to describe circumstances that are altogether vanished. The fantastically rapid transformation of Western society, above all through industrialisation, has affected everything" (56–57). Thus Ruskin was hardly alone in his nostalgia for lost Edens, but was rather an important representative of a larger nineteenth-century longing for a simpler life.

sion, of vague allusion to those things that Ruskin has "no pleasure in reviewing," but that lead inexorably toward the true unconversion—not simply from Evangelicalism to Art, as the text misleadingly implies, but from artist to prophet.[42] Though it may take detours, get sidetracked, and return upon itself, the narrative, however reluctantly, moves gradually toward the climactic unconversion of "The Grande Chartreuse." The chapters that participate in this progression examine Ruskin's attitudes toward religion, particularly Catholicism, and hint at his awakening social conscience; for Ruskin's religious history is closely linked to his career as a social critic. Yet he approaches this material in a glancing way, rarely admitting its crucial importance for his later, post-conversion years.

Thus the appearance of confusion in *Praeterita* results from the tension between two narratives, the overt narrative concerned with Ruskin's vocation as an artist and the covert narrative concerned with his vocation as a prophet. The latter is present as an undercurrent whose significance only becomes evident in "The Grande Chartreuse." Consequently, there are really *two* kinds of turning points in *Praeterita*, the aesthetic, and the religious or social. The series of visions and revelations that he believes to be turning points are always moments of artistic insight, and in fact run contrary to the deeper current of his life, which was to lead him toward social commitment and attempts at leadership and reform. Although art

[42]Ruskin's career may be said, broadly speaking, to fall into two parts, art critic and social critic, with the turning point coming at or near the time of the unconversion in 1858. As Rosenberg says, "It is tempting to take 1860—the year *Modern Painters* was completed and the precise midpoint of Ruskin's life—as the dividing line on one side of which falls his career as art critic and on the other, with the publication of *Unto This Last* also in 1860, his career as a critic of society. But the change is of emphasis only, not of direction" (*The Darkening Glass*, 41). Obviously the divide was not absolute; Ruskin's concern with social issues predates his unconversion, and he continued to write about art during the years that followed it. As Raymond Fitch observes, "It would be difficult and probably unnecessary to set a precise date for the awakening of Ruskin's social conscience" (*The Poison Sky*, 115).

was a delight to Ruskin, social reform was an unshirkable duty to which he felt called.[43] The unconversion signifies not merely a rejection of Evangelical principles, but also the failure of Ruskin's art, although this is nowhere explicitly stated. It is this unwilling, inevitable progression toward social awareness and action that I am calling the repressed subtext of *Praeterita*. The chapters most concerned with this process are "Cumae," "The Campo Santo," and "The Grande Chartreuse." Together they illustrate the hidden motion of his life, which was leading him in a direction quite different from what he imagined. It is a motion that the stress placed on moments of aesthetic insight works to conceal from both reader and narrator.

In Italy Ruskin had felt an intense distaste for both the landscape and the art, a feeling which may, at least partly, be attributed to his anti-Catholic sentiments.[44] He had found all sacred art a "mere zero" (269) and "all the great religious paintings . . . entirely useless" (273). Yet he left Rome "bearing with me . . . many thoughts that ripened slowly afterwards, chiefly convincing me how guiltily and meanly dead the Protestant mind was to the whole meaning and end of medieval Church splendour" (291). These remarks follow the conversion episode at Cumae, and anticipate important later stages in his religious development, described in "The Campo Santo" and "The Grande Chartreuse." In each case, turning points in his life are linked with the gradual reception of new ideas about Catholicism, often coupled, as in "Cumae," with glimmerings of a new social awareness. Two years after Cumae, and "the flash of volcanic lightning at Naples," he was in "a

[43]"Despite his claim of tenfold greater interest in social issues, undoubtedly Ruskin preferred collecting Turners, classifying minerals at Denmark Hill, or sketching the Alps, to the labors of social reconstruction he was about to undertake" (Rosenberg, *The Darkening Glass*, 102).

[44]For example, his tutor Osborne Gordon surprised Ruskin by avoiding his "favourite topic of conversation, namely, the torpor of the Protestant churches, and their duty . . . to trample finally out the smouldering 'diabolic fire' of the Papacy, in all Papal-Catholic lands" (250).

deeper and more rational state of religious temper" (344). He had begun to realize "what a blind bat and puppy I had been, all through Italy" (340) and decided to revisit the country before continuing *Modern Painters*.

Yet despite the increasing religious tolerance that this decision shows, the strict Evangelical teaching of Ruskin's youth had not lost its force. Until this trip to Italy, he writes, "I never . . . had thought of travelling, climbing, or sketching on the Sunday: the first infringement of this rule by climbing the isolated peak above Gap . . . remains a weight on my conscience to this day. But it was thirteen years later before I made a sketch on Sunday" (346). Making this sketch in 1858 was the incident that finally set the unconversion in motion. "The Campo Santo" is thus an important preparation for and foreshadowing of the later chapter.

It is here in the Campo Santo of Pisa that Ruskin finds "the entire doctrine of Christianity, painted so that a child could understand it." He sees the "total meaning" of Christianity expressed in painting in "the gospel of the Campo Santo" (351–52). In particular, "the stories of Abraham, Job, and St. Ranieri" made a profound impression, and Ruskin describes the conversion of Saint Ranieri in some detail: "He is playing, evidently with happiest skill, on a kind of zithern-harp, held upright as he stands, to the dance of four sweet Pisan maids, in a round, holding each other only by the bent little fingers of each hand. And one with graver face, and wearing a purple robe, approaches him, saying—I knew once what she said, but forget now; only it meant that his joyful life in that kind was to be ended. And he obeys her, and follows, into a nobler life" (354–55). Significantly, we are told twice of the happiness of Saint Ranieri's life *before* his conversion, yet nothing whatsoever of his life *after* it, except that it was "nobler." He must abandon music, or art, for a life more serious and committed. Saint Ranieri thus serves as an image or type for Ruskin himself, whose own conversion would mark his transition from artist to prophet. Ruskin's attitude toward his new vocation

may be gleaned from his sympathy with Saint Ranieri, for he writes "of the conversion of St. Ranieri, for which I greatly pitied him" (354). Ruskin even forgets the Pisan maid's words—in short, the very reason for the conversion—recording only what they "meant": that his joyful life "was to be ended." This selective amnesia characterizes the repressed subtext of *Praeterita*, those passages that might hint at what his own unconversion really meant.

Conversion traditionally marks the divide between error and truth, before and after. Thus the conversion model of autobiography describes the experience of radical change, after which the autobiographer is able to judge and write about his former self from a new perspective of authority, as in Augustine's *Confessions*. But in Ruskin's account of Saint Ranieri there is a striking difference: the pleasures of his early life are not presented as errors to be condemned from a post-conversion standpoint, but as innocent, delightful, and worthwhile occupations, which must be laid aside regretfully to follow a call to higher things (in contrast to Augustine, who rejects *his* early pleasures with loathing and shame). Paralleling Saint Ranieri's story, *Praeterita* too is a history, not of error and sin, but of those things that it gives Ruskin pleasure to recall. Just as Ruskin stresses the joyfulness of Saint Ranieri's pre-conversion life, so the joyfulness of much of his own pre-conversion life forms the avowed subject of his book. In this very passage he writes of his "extremely happy fortnight" of drawing in Pisa, where his work was "pure delight" (354). Nothing like this can be said, apparently, of his post-conversion life—and so, nothing *is* said. The pity Ruskin feels for Saint Ranieri is the pity he feels for himself,[45] for his own

[45]For a discussion of self-pity in autobiography see Barbara Charlesworth Gelpi, "The Innocent I: Dickens' Influence on Victorian Autobiography," in *The Worlds of Victorian Fiction*, ed. Jerome H. Buckley (Cambridge: Harvard University Press, 1975), 57–71. Of *Praeterita* she says, "Ruskin's self-pity makes him see his life as failed and indeed does frustrate the full effectiveness of what is nonetheless a towering achievement" (66–67).

conversion will be, not an exchange of error for truth, but a reluctant putting aside of the pleasures of art to take up the "nobler" duty of social reform.

But unlike Ranieri's, Ruskin's was an unconversion, a change from a position of certainty—his youthful Evangelical conceit—to a position of doubt. Indeed, it was almost a reverse conversion, from truth to error, for he frequently observes that the best work of his life was his early work. He writes his autobiography not from the authoritative vantage point of an Augustine, secure in the conviction that he has at last "arrived" at truth, but from a conviction that his life has been wasted, particularly the post-conversion portion, since all his efforts to reform society seemed to fail.[46] He wrote of his plans for the St. George's Guild: "The doctors said that I went mad . . . from overwork. . . . But I went mad because nothing came of my work."[47] Thus if the traditional autobiography winds down after the conversion because nothing more can be said to happen, this one concludes because everything more that happens is, or is believed to be, failure, too painful to recount in an autobiography devoted to recalling only the pleasurable memories.

Yet Ruskin's exclusion of "error" is strangely at odds with the theory that the events of autobiographical narrative are necessarily those that involve error, that once truth is achieved there can be no more events. Moshe Ron writes: "There could be no narrative whatever without the possibility and fact of error. It is a fundamental necessity of any story that the meaning of the events should be, on their first appearance, obscure or deceiving. It is when the self recognizes itself as having been mistaken that it has a story to tell, and it is when it has a

[46]From the public's hostile reception of *Unto This Last* to the absurdities of the St. George's Guild, from the disastrous road-building episode at Oxford to the tea shop that never made any money, his many endeavors appeared to be failures, for he was never to know of the lasting influence his social philosophy would have. See Rosenberg, *The Darkening Glass*, 131ff., 178–79, 188ff., 195ff.

[47]Ruskin, *Works*, xxix, 386.

story to tell that it becomes a self." Ron adds that "when the narrator of autobiography runs out of misdeeds which need to be explained or justified or rectified he runs out of a story."[48] Yet in what sense the pre-conversion events of Ruskin's life, as told in *Praeterita*, can be said to involve error, is not immediately clear. Perhaps it is in the disparity between what the young Ruskin thinks will be his future life's work, and what the narrator knows was in fact his later work. Every moment of aesthetic revelation is taken by the narrated self as a step on the way to becoming a better artist and art critic—while the narrating self knows all along that the real truth lies in the apparent digressions about the state of the Italian peasantry and about Catholicism. For example, noting the crowd's interest when he sketches in public, the young Ruskin feels pleased "that my really watchful delineation . . . had a quite unusual power of directing the attention of the general crowd to points of beauty . . . to which they had never before lifted eyes" (357). He calls attention not merely to the objects he sees and his own ability to reproduce them, but to his role as guide and teacher.

In itself this remark might suggest no new sensibility beyond that of *Modern Painters I*, but what follows reveals a difference: he pities his audience's wasted lives, "never one effort made to teach them, to comfort them, to economize their industries, animate their pleasures, or guard their simplest rights from the continually more fatal oppression of unprincipled avarice, and unmerciful wealth" (357). Passages such as these, apparently tangential to the main story, foreshadow the climax of the autobiography. Unlike Saint Augustine, the former self is not so much in error for what it does wrong as for what it believes about itself and its purpose in life. This, too, accords with the story of Saint Ranieri's conversion: if he could be said to be in error prior to his conversion, it could only be in

[48]Ron, "Autobiographical Narration," 42. For example, *The Autobiography* of Benjamin Franklin is at least partially the story of what he calls, in printer's terminology, his "errata."

the sense of not knowing what lay in store for him, for there was obviously nothing wrong with his joyful life as a harpist.

In "The Campo Santo" as in "Cumae," a description of the powerful impression made upon Ruskin by a particular event is closely followed by observations about social conditions. The same three elements link these two chapters: opinions about Catholicism; an important event in his personal development; and sympathy for the peasants. Once again, his religious, artistic, and social concerns are intermingled. "The Campo Santo" offers a glimpse of Ruskin's future role as social prophet, which is only rarely made explicit in *Praeterita*, as when he notes: "The world has for the most part been of opinion that I entered on the task of philanthropy too soon rather than too late" (358).

If in "The Campo Santo" Ruskin provides an image of a conversion that he "greatly pitied" as a foreshadowing of his own, and takes a step toward unconversion by climbing on a Sunday, in "Macugna" he describes a religious experience on the way home from Italy that he thought at last was a real conversion. In many ways this episode parallels the story told in "Rome" and "Cumae": once again a period of overwork is followed by illness, depression, fear of dying, and even the death of a substitute, this time his Croydon cousin, John. News of John's death reached him at Nyon, where he wondered if he would ever get home again. The situation seemed so serious that he "fell gradually into the temper, and more or less tacit offering, of very real prayer." On the third day, he says, "the consciousness of answer came to me; and a certainty that the illness . . . would be taken away" (377). At last he had found "that happy sense of direct relation with Heaven" (378). But, as during the aftermath of Cumae, he is unable to sustain the revelation: "Little by little . . . it passed away from me. I had scarcely reached home in safety before I had sunk back into the faintness and darkness of the Under-World." In *Praeterita*'s catalogue of losses, Ruskin calls this loss of relation with Heaven "the gravest of all" (378).

Shortly afterward, in "The State of Denmark," Ruskin con-

firms his permanent residence in the underworld, referring to himself as Pirithous, the friend of Theseus who was imprisoned in Hades and whom Theseus and Herakles could not rescue (385).[49] This marks a seeming recognition that such conversions as he thought and hoped to have undergone at Nyon were not for him. He adds that he had "no mind whatever to win Heaven at the price of conversion like St. Ranieri's, or mortification like St. Bruno's" (389). He doesn't want to be called as Saint Ranieri was, doesn't want conversion at that price, doesn't want to give up *his* art for God. Yet, as the narrating self well knows, this is an image of what will indeed happen to him, though with an ironic twist: *his* conversion, though it will take the same form as Ranieri's (sacrificing art for duty), will be a conversion away from religion.

Praeterita follows the form of conversion autobiography, but really traces the stages by which Ruskin lost rather than found his faith. It records a breakdown of authority—that of his father, of Evangelicalism, and finally of reason itself—but discovers nothing to put in its place. It is an autobiography with an absent center, for there is no conversion to truth and authority, only a lifelong search for guides and kings. Thus there is an overabundance of potential models for Ruskin's life, despite his early realization that "there were for *me* neither Goddess guides nor prophetic teachers" (149). In "The State of Denmark" Ruskin claims Saint Anthony of Padua as the most typical of all his models, calling him "my prototype and patron saint" (391). Saint Anthony was famous for his retirement from the world, his deep seclusion and sufferings "par la malice du démon"—strikingly similar to Ruskin's own desperate battles with the demons of nightmare and madness. God rewards Saint Anthony as he rewards Ruskin, by making him "puissant en oeuvres et en paroles" (392). But Ruskin quickly changes this potentially painful subject: "I must not,

[49]As the chapter title suggests, Hamlet too is a double for Ruskin: he is in contact with the underworld; he searches for a "conversion" to certainty and a position of authority; he is alternately mad and sane; and the woman he loves dies insane.

however, anticipate the course of this eventful history so far as to discuss at present any manner of the resemblance in my fate, or work, or home companionships, to those of St. Anthony of Padua" (392). Thus, in Saint Anthony we have as clear an image as the repressed text allows of the unmentionable future, the post-conversion decades.

Saint Anthony and Saint Ranieri, like Abraham and Job, are men called to the harder course, called to abandon their private lives and accept sacrifice and suffering. Each responds to the call instantly and unquestioningly. Ruskin identifies with them, seeing them as types of his own life, especially since each is a man alone, without goddess guides or prophetic teachers such as Achilles, Aeneas, Saint John, and Dante had. Forever seeking a guide and teacher, Ruskin tries to cast everyone he knows in this role: Turner, Charles Eliot Norton, Thomas Carlyle, and most of his friends and tutors. The quest to anchor himself in a fixed authoritative tradition begins with the invocation of both his father and Homer in the opening lines of *Praeterita*. In the end, Ruskin forces himself to take up the role, becoming that prophet and teacher for whom he has been searching.[50] Yet there is always a painful irony in Ruskin's typological identifications, for if Abraham, Job, and Saint Ranieri abandoned their personal lives to serve others, they also did it to serve God. Each is thus less alone than Ruskin who, although he seeks real religious conversion all his life, never achieves Job's "direct converse with God" (353).

The Unconversion

"THE GRANDE CHARTREUSE" opens with Ruskin's poem, "Mont Blanc Revisited," which he has already mentioned in "The Campo Santo" as being among "the last serious exer-

[50]For an analysis of the rhetorical techniques that Ruskin and other Victorian sages derived from the biblical prophets, see George P. Landow, *Elegant Jeremiahs: The Sage from Carlyle to Mailer* (Ithaca: Cornell University Press, 1986).

tions of my poetical powers" (344). The poem, then, symbol-
izes another aspect of Ruskin's farewell to art, and its subtitle,
"(Written at Nyon in 1845)," reminds us once again of the
connection between these two periods of his life. The journey
of 1845 prepared the way for that of 1858, including as it did
the first step in Sabbath breaking, the image of Saint Ranieri's
conversion, and the experience of near conversion at Nyon.

The poem begins with an apostrophe to the mountain, the
traditional location of religious inspiration or revelation.[51]
One thinks of Moses on Mount Sinai or Mount Pisgah, of
Christ's Sermon on the Mount, of Saint John's Revelation on
Patmos and his vision of the New Jerusalem as set upon a
mountaintop. It was in the mountains, Ruskin says, that the
best work of his life was always done: "Whatever might be my
common faults or weaknesses, they were rebuked among the
hills; and the only days I can look back to as, according to the
powers given me, rightly or wisely in entireness spent, have
been in sight of Mont Blanc, Monte Rosa, or the Jungfrau"
(474).

The lines of the poem that Ruskin singles out for comment
are these:

> O Mount beloved, thy frontier waste
> I seek with a religious haste
> And reverent desire.
>
> They meet me, 'midst thy shadows cold,—
> Such thoughts as holy men of old

[51]See Fontaney, "Ruskin and Paradise Regained," 347–56. Focusing on
"The Simplon" chapter of *Praeterita*, which he sees as being, in mythic
terms, an experience of trial and descent to the underworld, Fontaney
points out the ancient aura surrounding the idea of the mountain: "In
many religious cosmogonies the world is ordered from a *centre*, the *axis
mundi* . . . [which] is often a sacred *cosmic mountain*. . . . by ascending it
man can literally communicate with the gods or reach heaven" (349).
Fontaney cites Dante's Delectable Mountain, Milton's Paradise on a Hill,
and Bunyan's Heavenly Jerusalem on a hill. He notes that the mountain
"stands [as] a gate to the underworld as well as to heaven" (350).

> Amid the desert found;—
> Such gladness, as in Him they felt
> Who with them through the darkness dwelt,
> And compassed all around. (473)

Ruskin explains that "the claim of being able to find among the rock-shadows thought such as hermits of old found in the desert, whether it seem immodest or not, was wholly true" (474). Like John the Baptist, Ruskin believes himself to be a prophetic voice crying in the desert, listening for other voices that speak from Heaven. He identifies with the isolation of hermits in the desert as with the isolation of monks in the mountains. Throughout *Praeterita* Ruskin expresses this identification in the metaphoric allusions to himself as a monk: he calls himself a "young novice . . . virtually convent-bred" (179) and talks of his "monastic poverty" (20) and "mossy cell" (368).[52] Ruskin continually emphasizes his love of solitude, only beginning to see his monkishness in a new light after his visit to the monastery of the Grande Chartreuse.

Having written of "the power of mountains in solemnizing the thoughts and purifying the hearts of the greatest nations of antiquity, and the greatest teachers of Christian faith" (475), Ruskin is horrified by his discovery that mountains, so magical in their effect upon himself and the prophets of the past, have lost their power over his contemporaries. He complains that in recent times religious men were "lost,—or even degraded, if they ever went up to the mountain to preach, or into the wilderness to pray" (475). Ruskin's growing awareness of this contemporary Fall was finally confirmed for him during his visit to the Grande Chartreuse in May 1849. There, "a word was said, of significance enough to alter the courses of religious thought in me, afterwards for ever" (475). The word was spoken by a monk who acted as guide to Ruskin and his

[52]In "Ruskin's *Praeterita*: The Enclosed Garden" (chap. 7 of *Figures of Autobiography*), Avrom Fleishman discusses these metaphors of "religious seclusion" (185).

father during their tour of the monastery. Ruskin describes their conversation:

> We came to a pause at last in what I suppose was a type of a modern Carthusian's cell, wherein, leaning on the window sill, I said something in the style of *Modern Painters*, about the effect of the scene outside upon religious minds. Whereupon, with a curl of his lip, "We do not come here," said the monk, "to look at the mountains." Under which rebuke I bent my head silently, thinking however all the same, "What then, by all that's stupid, do you come here for at all?" (476)

In itself the monk's reply might seem trivial enough, but in the context of Ruskin's description of the mountains' effect on him and on "the greatest teachers of Christian faith," the monk's fall into modern-day insensibility acts as a validation of the entire current of Ruskin's present thought.

Modern monks, in short, don't *see*. In this landscape, which has been the ancient and mythic location of vision, the monks aren't even looking. Their blindness to their surroundings is both literal and metaphoric, for if they don't look at the view, neither do they receive religious inspiration from it. The monk's chance reply symbolizes for Ruskin the religious temper of his age: Carthusians are no longer being sent forth into the world to do good, conversions are not taking place, and the entire missionary, socially oriented thrust of the order is gone. The role of the mountains as a focal point, a place of germination followed by a going forth (into Canaan, to give the commandments, to write *Modern Painters*) has been lost. They are now no more than a place of refuge, of escape from the world and its problems, of weakness, uselessness, and self-indulgence.

The monk who showed them around, with his "ungraciously dull manner, showing that he was much tired of the place, more of himself, and altogether of my father and me"

(475–76), represents the modern decline. His assertion of indifference shocks and horrifies Ruskin—if the monks are insensitive to the mountains, why do they retreat to them? And why, Ruskin wonders, should their "delight in solitude" be considered a virtue? Ruskin, who has loved solitude all his life, observes: "I sympathize with them in their love of quiet—to the uttermost; but do not hold that liking to be the least pious or amiable in myself, nor understand why it seems so to them" (476). In comparing himself with the monks (as metaphors throughout the autobiography have implicitly done), Ruskin questions not only their sequestered way of life but his own.[53] In particular, he seems anxious about his potential similarity to Saint Bruno, the founder of the Carthusian order. Saint Bruno had been "a man of the brightest faculties in teaching, and exhorting, and directing," as well as "a teacher and governor in the exact centre of European thought and order, the royal city of Rheims." Why, Ruskin demands, should he "think it right to leave all that charge, throw down his rod of rule, his crozier of protection, and come away to enjoy meditation on the next world by himself"? (476). As Saint Ranieri was a type whom Ruskin admired, pitied, and hoped he would not be called to imitate, so Saint Bruno seems to be a type whom he disdains and resists, precisely because he fears the resemblance, and feels the temptation to imitate Bruno by seeking the solitude he loves so much.

This is the crux of Ruskin's conversion. He is torn between two opposite paths, as represented by Ranieri and Bruno. Their similarity is only superficial: each leaves his worldly life for his religious vocation, but one gives up his beloved music for a nobler life of duty and self-sacrifice while the other gives up his useful service in the world for a life of solitude and

[53]In "Ruskin's *Praeterita* as Thanatography," Claudette Kemper Columbus suggests that the monk "is also an unacknowledged alter ego" (in *Approaches to Victorian Autobiography*, ed. Landow, 113). Focusing on the Grande Chartreuse chapter, her essay finds in the silences and repressions of *Praeterita* "the triumph of the death instinct" (118).

meditation in the Alps—precisely that life Ruskin would most happily choose for himself. So, torn between duty and pleasure, Ruskin rejects Bruno as too tempting. He pities Ranieri, as he pities himself, for his is the course Ruskin will compel himself to follow.[54] In effect, Ruskin is rejecting the monkish side of himself. Although he "loved or envied the monks," his reading gradually convinced him that both "in the world and the Church, the hearts of men . . . were alike disobeying the laws of God when they withdrew from their direct and familiar duties, and ceased, whether in ascetic or self-indulgent lives, to honour and love their neighbor as themselves" (481).

This concern for his fellow man determines the second half of Ruskin's career. The only really good and dutiful life, he comes to believe, is one of service to others, not of self-indulgent pleasure in lonely contemplation of nature and beauty. Thus the only Carthusians he can admire are those medieval ones who, though "reared in their mountain fastnesses," were "sent out to minister to the world." Most notable was Hugo of Lincoln, "to my mind," Ruskin writes, "the most beautiful sacerdotal figure . . . in history" (482). For such as these the mountains were a source of inspiration to action, just as they had been for Ruskin himself at the end of "Cumae," when the Alps gave him new determination to go forth and begin his life's work. If before his unconversion Ruskin identified with monks and hermits, after it he identifies with prophets and leaders. It is a significant shift of typological focus, for this was ultimately what the unconversion really meant: though he longs to be a Bruno, he gives up his solitary monastic way of life to go forth into the world, like Hugo, to reform and lead.

[54]As Rosenberg suggests, "Ruskin's social criticism is in part an atonement for pleasures which his large means and exquisitely refined senses enabled him to afford, but which his conscience never allowed him wholly to enjoy." The reason is that "one precept of the Evangelical ethic retained an extraordinary hold upon Ruskin long after his unconversion. The cardinal virtue of that ethic was self-denial; the cardinal vice, self-indulgence" (*The Darkening Glass*, 109, 112).

Ruskin next tells of a visit he made to the Convent of St. Michael at Le Puy, another remote and inaccessible pinnacle. The nun who acts as guide presents a complete contrast to the Carthusian monk. She is pleased with her visitors, not bored by them, and courteous where he was ungracious and supercilious. Nevertheless, Ruskin perceives that she can no more furnish a model for him than the monk could: "it has always seemed to me that there was no entering into that rest of hers but by living on the top of some St. Michael's rock too, which it did not seem to me I was meant to do, by any means" (478). Yet, though her isolation offers no adequate example for Ruskin's imitation, she is a positive example of Catholicism, providing another step in the process by which his Puritan insularity was being worn away.

Through these accumulating experiences and reflections about Catholicism and solitude, Ruskin grew "daily more sure that the peace of God rested on all the dutiful and kindly hearts of the laborious poor; and that the only constant form of pure religion was in useful work, faithful love, and stintless charity" (481). Work, love, and charity—rather than a specific set of narrow sectarian principles—were to be the basis of Ruskin's religion in the future.[55] And, since none of these could be accomplished alone in the mountains or by contemplating beauty, Ruskin's course was becoming increasingly clear to him.

At this point in the chapter Ruskin alludes to his approaching unconversion, mentioning the "fading away of the nobler feelings in which I had worked in the Campo Santo of Pisa," and "the inevitable discovery of the falseness of the religious doctrines in which I had been educated." The obvious reluctance with which he proceeds is underlined when he adds, "I

[55]As Joan Abse puts it in *John Ruskin: The Passionate Moralist* (London: Quartet Books, 1980), loss of faith "meant more than the shedding of Evangelical prejudices and concepts, it meant changing the whole basis of being. He had to concern himself wholeheartedly with the problem of the betterment of men's relations with each other, for what else was there to be looked for?" (173).

must not let myself be led aside from my own memories" (482). He resolves that "this breaking down of my Puritan faith . . . shall be traced in this chapter to the sorrowful end" (483). Yet once again he digresses, giving, instead of the expected unconversion, a summary of the next ten years. Events are listed by date, in a kind of telegraphic style ("I get cough") amply indicative of the growing reluctance with which he proceeds. He depicts a decade of illness, bad weather, unfinished work, uninspiring landscapes, and wasted journeys—not subject matter which gives him pleasure to recall. It is, perhaps, the wandering-in-the-wilderness-prior-to-conversion pattern once again. Interestingly, when he reaches 1858 in this summarized version of events, the unconversion is totally elided: in one sentence he goes to Turin, in the next he goes home to his father. Perhaps a sign of his unwillingness to give a conclusive shape to this summary, he gives no hint of the unconversion having taken place in the interstices of those two sentences. The decade ends with a trip to Chamonix in 1860, "where a new epoch of life and death begins" (485)—a reference to *Unto This Last*, written at Chamonix, his first real work of social criticism and the beginning of his new career, about which *Praeterita* is so silent.

Still another digression follows, for Ruskin unexpectedly announces that "here I must trace, as simply and rapidly as may be, the story of my relations with the Working Men's College" (485–86). Instead, he tells two stories about Protestant Bible lessons, counterparts to his conversations with Catholic monk and nun: Frederick Maurice's interpretation of Jael's slaying of Sisera and Mr. Molyneux's story of the prodigal son. Maurice, "taking an enlightened modern view," denounces Jael and the prophetess Deborah for their violence. Ruskin's reaction was "total collapse in sorrow and astonishment," this being, he says, "the first time in my life that I had fairly met the lifted head of Earnest and Religious Infidelity" (486–87). Next, Ruskin turns to Mr. Molyneux's dismissal of the prodigal son's stay-at-home brother as "merely a pictur-

esque figure introduced to fill the background of the parable agreeably" (489). Just as neither the indifferent monk nor the cloistered nun had the answer for Ruskin, so he rejects both Protestant clergymen, the Liberal who despises leaders and prophets, and the Puritan who, preferring the drama of the saved sinner, pronounces faith self-righteous.

Yet, Ruskin says, his own religion would have served him well enough, "within limits," for all his needs, but that "my ordained business, and mental gifts, were outside of those limits. I saw, as clearly as I saw the sky and its stars, that music in Scotland was not to be studied under a Free Church precentor, nor indeed under any disciples of John Knox, but of Signior David; that, similarly, painting in England was not to be admired in the illuminations of Watts's hymns; nor architecture in the design of Mr. Irons's chapel in the Grove" (490).

It seems, then, that Ruskin is announcing that his narrow Protestant religion is too cramped for the full development of his gifts, since these lie in the realm of art, and certainly such an interpretation is in keeping with the numerous aesthetic turning points in *Praeterita*. This stress on art, however, is part of the overt but misleadingly incomplete narrative of unconversion, which he continues with the next "thread of my mental history," his coming into possession of a fourteenth-century Hours of the Virgin, "extremely rich, grotesque, and full of pure colour" (490). The discovery of this book opened "new worlds" to Ruskin, gratifying his "love of toil, and of treasure." For, he says, "again and again I must repeat it, my nature is a worker's and a miser's; and I rejoiced, and rejoice still, in the mere quantity of chiseling in marble, and stitches in embroidery; and was never tired of numbering sacks of gold and caskets of jewels in the *Arabian Nights*" (491).

The Puritan Sabbath denies precisely these two loves of Ruskin's, toil and treasure, forbidding as it does any work or pleasure on that day. This notion of Sabbath keeping was the last straw in the tale of his "final apostasy from Puritan doctrine." Having realized that "Christ's first article of teaching

was to unbind the yoke of the Sabbath" (492), Ruskin at last concludes his many preliminaries and turns to the unconversion itself.

The unconversion occurs during Ruskin's trip to the Continent in 1858, the first since 1845 (recorded in "The Campo Santo") in which he had "complete guidance" of himself. After a Sunday walk in the Alps gathering wildflowers he brought one home to examine, and "it seemed to me wholly right to describe it as I examined; and to draw the outlines as I described, though with a dimly alarmed consciousness of its being a new fact in existence for me, that I should draw on a Sunday" (493). With this act, the sequel to climbing on Sunday a decade before, Ruskin throws off the dominance of the Sabbath and with it the yoke of Puritanism, of which Sabbath keeping had been "the most stern practical precept of that doctrine still holding me" (492). It would seem that the unconversion takes the form of asserting art over religion, as the entire preceding chapter has prepared us to believe. Yet Ruskin observes: "Nevertheless, come to pass how it might, the real new fact in existence for me was that my drawings did not prosper that year, and, in deepest sense, never prospered again." It is this fact that he names "the crisis of change" (493–94). What appears to be the triumph of art over religion really marks the decline of his art. In spite of all the carefully constructed rationalizations of his youth to make art acceptable, his religious scruples prevail in the end. It seems that he can only buy his freedom from religion by sacrificing his art, and by the penitential embracing of social duty that follows this unconversion.

Ruskin's new difficulties in drawing to his own satisfaction lead to "general desolation, and disgust . . . most of all with myself." He abruptly decides to go to Turin, where the final unconversion takes place, not in the mountains but among "military bands, nicely-dressed people, and shops with something inside" (494). He attends a service in a little Waldensian chapel where the dismal self-righteousness of the sermon

contrasts sharply with Paul Veronese's painting *Solomon and the Queen of Sheba*, which he goes to see immediately afterwards:

> The gallery windows being open, there came in with the warm air, floating swells and falls of military music, from the courtyard before the palace, which seemed to me more devotional, in their perfect art, tune, and discipline, than anything I remembered of evangelical hymns. And as the perfect colour and sound gradually asserted their power on me, they seemed finally to fasten me in the old article of Jewish faith, that things done delightfully and rightly, were always done by the help and in the Spirit of God. (495–96)

"That day," he writes, "my evangelical beliefs were put away, to be debated of no more." With these words the chapter closes, reaffirming both art and music, and the gospel of work, love, and charity he had already decided was the only true religion. It is fitting that his unconversion should take place in front of Solomon, for what does this vibrant figure symbolize but treasure and toil? Solomon is famous for the extent of his wealth, sumptuous and splendid, and the unconversion is Ruskin's rejection of the Puritanism that had no room for those artistic riches most essential to his own nature. In simplest terms, Ruskin seems to have chosen art over religion.

But Solomon is also celebrated for the toil of work well done—governing, judging, building the temple, creating a prosperous kingdom. With the greater part of his artistic work behind him (most of *Modern Painters*, the *Seven Lamps*, the *Stones of Venice*), Ruskin now turns from "treasure" to the Solomon-like toil of leading people.[56] The unconversion thus

[56]In *The Aesthetic and Critical Theories of John Ruskin*, George Landow points out that *Praeterita*'s account of Ruskin's unconversion differs significantly from the version described in the April 1877 *Fors Clavigera*, for the autobiography emphasizes "a new faith in work well done, rather than a

signals the most radical turning point of all in his life, his passage from art critic to social critic, from monk to prophet. The concealed but underlying story of *Praeterita*, finally, is that of a monk who goes out into the world, compelled by duty. It is the account of Ruskin's ultimate rejection of the hermithood he was born and raised to. Yet ironically, his call to a "nobler" life originates in a turning away from religion, since it is precipitated by his defiance of Puritan strictures through the act of drawing on Sunday. It is surely significant that he leaves the mountains in search of city life at the end of "The Grande Chartreuse." Mountains, mythically the locus of conversion, come to represent for Ruskin the stimulus to unconversion and the starting point for social mission.

The entire chapter, then, marks the farewell to the first portion of his life, to his youth and to his love of art, to the period in which he believes, by the time of writing *Praeterita*, that his best work was done. It also marks the effective end of *Praeterita*, appropriately enough, for the book was self-announced as being about those things it would give him pleasure to remember, and the failures of his career as prophet were clearly not among them. *Praeterita* is, on the surface, the story of the artist's development. But the story of the prophet, hinted at throughout, underlies and shapes it, emerging only as the repressed or censored subtext. The death, metaphorically speaking, in conversion autobiography is supposed to be that of the former self whom the conversion reveals to have been in error. Here the book ends with the death of the artist, whom the narrating self mourns nostalgically, for he recognizes his post-conversion self, the social prophet, as a failure. Though Ruskin nowhere repudiates the work he went on to do, the whole structure of *Praeterita* indicates his reluctance to

loss of religion" (285). Ruskin is thus consistent to his principle in *Praeterita* of stressing whatever is positive and pleasant, suppressing what is painful. For a further comparison of the two accounts, see Raymond Fitch's "A Religion of Humanity: 1858–1874," in *The Poison Sky*, esp. 297–312.

speak of it. Error, it seems, *begins* here, and the narrative falters to a halt. Ruskin follows the typological pattern, but in doing so only underlines the tragedy of his own story, so different from the conventional one. Told as a conversion, his story really moves towards fall, not redemption. Thus, the notion that this is an unprogressive autobiography is not quite right. Rather, it is told in the form of a progression (artistic development), which is subverted by another concealed and avoided progression (towards unconversion and social criticism). The narrating self tries to repress his own consciousness of the end toward which the narrative is leading. Just as we never find out what became of Saint Ranieri, so we never learn in *Praeterita*, except through hints, what becomes of Ruskin.

Revelation and Return

RUSKIN USES the typological structure of man's life as a journey or pilgrimage to shape much of *Praeterita*. Almost half of the chapters describe his travels, and he himself becomes the type of the traveler, in search of guides and knowledge. "We did not travel for adventures, nor for company," he writes, "but to see with our eyes, and to measure with our hearts" (119). The Ruskins were spectators, traveling in "contemplative abstraction from the world" (118), seeking only to see and to know. But ultimately, as we have seen, the journey that was Ruskin's life ended in despair and failure. This, I think, partly accounts for his love of repetition and return, his circling narration that dwells on places, rather than time or chronology. With the conviction that his quest has ended in defeat, the autobiographer emphasizes not the journey itself but the places he saw and the landscapes he loved. The journey may be the real story, but by a strategy of evasion and lingering the narrator deflects our attention from that journey. Trying to postpone and avoid the final destination, he dwells lovingly on evocations of the places he visited along the way. The narrative

deviations are literally and literarily attempts to escape the outcome. It is with the greatest reluctance that Ruskin finally brings himself to the "sorrowful" climax.

If the concept of a journey implies development and change, then an autobiography committed to denying change must inevitably organize itself around journeys of repetition and return. Nowhere is this truer than in the ending, which finally merges memory and desire, the beginning and the end. If the opening chapters of *Praeterita* represent Eden, the final paragraphs are Revelation. They describe a Paradise regained, with a "little glittering stream . . . paved with crystal" (560), like the "pure river of water of life, clear as crystal" in Revelation 22:1, and Ruskin's mention of the Marriage of Cana typologically prefigures the Marriage of the Lamb to his holy bride, the New Jerusalem. Following to the end in Dante's footsteps, as Dante followed in Virgil's, Ruskin tells of last having seen the Fonte Branda, "under the same arches where Dante saw it" (561–62). On the final page he describes having once entered the gate of Siena in a glorious sunset, like those who "enter in through the gates into the city" of the New Jerusalem (Rev. 22:14). The gate of Siena welcomes Ruskin with "its still golden words, 'Cor magis tibi Sena pandit' " ("Siena opens its heart to you the more"), just as the faithful are welcomed into the Holy City, whose gates "shall not be shut at all by day: for there shall be no night there" (Rev. 21:25). Finally, the closing words tell of "the openly golden sky . . . and the fireflies everywhere in sky and cloud rising and falling, mixed with the lightning, and more intense than the stars" (562). Here Ruskin not only echoes Revelation 21:23 ("And the city had no need of the sun, neither of the moon, to shine in it: for the glory of God did lighten it"), but he ends with the final word "stars" that Dante used to conclude each of the three sections of *The Divine Comedy*. To its final words, *Praeterita* yearns for the recapturing in Paradise of what was lost in Eden.

This vision of Siena as the New Jerusalem is moreover the culmination of a whole series of cities that have been suc-

cessively pictured as Paradise. In Geneva, for example, Ruskin had juxtaposed his delight in viewing the city's finest jewels to a description of the Rhone, "river-of-paradise blue" (327), as if he were praising the jeweled walls of the New Jerusalem and its radiant river of life. "From the first moments I entered their gates," Ruskin says, Rouen, Geneva, and Pisa were images of "perfect harmony"—"tutresses of all I know, and . . . mistresses of all I did" (156). Combining all the previous patterns of recurrence—tutors and enchantresses, Pisgah sights, Edens—these cities are one by one lovingly, ecstatically evoked, with their rivers like jewels and their gates like thresholds to a new world.

Praeterita, like the Bible, begins in a garden and ends in a city: indeed, the same rivers run through both. *Praeterita* opens with "occasional glimpses of the rivers of Paradise" in "The Springs of Wandel" (20), and concludes with the glittering stream "paved with crystal." From the very first chapter Ruskin had been seeking to restore lost kingdoms of the past or the spirit, and his childhood liking and longing for kings prefigures the "King of Kings and Lord of Lords" (Rev. 19:16) who will come in glory to reign over a new city-Paradise at the end of the world:

> Deep yearning took hold of me for a kind of "Restoration.". . . It seemed to me that Charles the Second's Restoration had been, as compared with the Restoration I wanted, much as that gilded oak-apple to a real apple. And as I grew wiser, the desire for sweet pippins instead of bitter ones, and Living Kings instead of dead ones, appeared to me rational as well as romantic; and gradually it has become the main purpose of my life to grow pippins, and its chief hope, to see Kings. (17)

Ruskin doubtless has in mind that King who "liveth for ever and ever," by whom the angel in Revelation swore "that there should be time no longer" (453n). Mixing, even in his first

chapter, Eden and Revelation, apples of desire and the Holy Kingdom to come, he attains, at least literarily, his wished-for Restoration and triumph over time with his final words. Moreover, in a note to the "Kings" passage, he explains that the chief labor of his last years, the St. George's Guild, was devoted to "discovering . . . men capable of Kinghood" (17n). From start to finish, the plan of Ruskin's personal life is finally nothing less than the plan of the Bible itself, to see a Restoration of lost Edens and the advent of the Eternal Kingdoms of Paradise. The end of *Praeterita* thus contains the beginning, as the Apocalypse does Genesis, and having read it, "every syllable through, aloud, hard names and all," there is nothing to do but begin "again at Genesis the next day."

Rewriting Revelation:
The Autobiographer as Idolater
in Gosse's *Father and Son*

RECALLING HER first sight of her future husband as he preached to the "Plymouth Brethren," Edmund Gosse's stepmother wrote that "it was a favourite method with Mr. Gosse to illustrate the New through the character of the Old Testament."[1] Philip Gosse specialized in typological interpretation, and he steeped his son Edmund in it. For, just as Ruskin's mother had forced him to read the Bible from Genesis through Revelation and to memorize long passages, so Gosse's father, as his son tells us, "laboured long and unsuccessfully to make me learn by heart hymns, psalms and chapters of Scripture."[2]

Gosse, then, had as intimate a knowledge of the Bible as

This chapter appeared in slightly different form in the *Victorians Institute Journal*; I thank the editor, Donald Lawler, for permission to reprint it.
[1]Eliza Brightwen Gosse, "Reminiscences of My Husband from 1860 to 1888," printed as an appendix to Edmund Gosse, *The Life of Philip Henry Gosse* (London: Kegan Paul, 1890), 354, hereafter cited parenthetically as *PHG*.
[2]Edmund Gosse, *Father and Son: A Study of Two Temperaments* (1907; reprint, New York: Norton, 1963), 24. Subsequent citations to this edition are noted parenthetically.

Newman or Ruskin or any previous author of a spiritual auto-
biography. And, as might be expected, the traditional typolog-
ical patterns can be clearly traced in *Father and Son*. The Exodus
story, from the bondage in Egypt to the period of wandering in
the wilderness followed by a liberation that is both physical
and spiritual, underlies the structure of the book. The familiar
motifs of spiritual autobiography abound: Eden and the Fall,
the journey and the Pisgah sight, baptism and conversion.[3]

Gosse's biographer, Evan Charteris, has said of him that "he
was familiar to the point of weariness with the language, the
facts and the doctrines of the Bible: indeed he was so saturated
with its literary beauties that the complete absence of its influ-
ence in his writings becomes remarkable."[4] In fact, however,
the Bible is far from absent in *Father and Son*. But Gosse's
unorthodox use of typology has perhaps obscured this. For
while Gosse employs the conventional vocabulary, he trans-
forms it in highly unconventional ways. Where the typological
autobiographer would traditionally identify with Moses,
Gosse shows himself instead as an idolater. This is more than
mere wordplay: throughout the book Gosse deliberately "mis-
uses" typology in order to make a point about its stifling effect
on his own life. Linda H. Peterson contends that Gosse par-
odies traditional spiritual autobiography by imitating its for-
mal generic patterns while emptying them of their traditional
meanings. But where she sees only "an unsystematic series of
local interpretations," I argue that in *Father and Son* Gosse
creates a sustained and coherent pattern of typological rever-
sals. While Peterson concludes that Gosse "empties the her-
meneutic system . . . of its authority," I try to show that it is
only by working *through* the terms of biblical typology that
Gosse can define his own identity.[5]

[3]See Fleishman, *Figures of Autobiography*, 300–309, for a discussion of
Gosse's use of some of these motifs.
[4]Evan Charteris, *The Life and Letters of Sir Edmund Gosse* (New York:
Harper, 1931), 11.
[5]Peterson, *Victorian Autobiography*, 185, 182.

Although Gosse, like Newman, writes a selective auto-biography, one primarily concerned with the history of his religious opinions (he calls it "the narrative of a spiritual struggle"),[6] in fact it turns out to be, like Ruskin's *Praeterita*, the story of an unconversion. *Father and Son* tells of Gosse's search for an escape from the claustrophobic religious environment created by his parents. Images of captivity and enclosure recur frequently: "I was most carefully withdrawn, like Princess Blanchefleur in her marble fortress" (32); "I was bound hand and foot like Mazeppa" (119); "My soul was shut up, like Fatima, in a tower" (161). Thus, for Gosse, the real liberation must be a liberation *from* religion.

In order to escape "this bondage to the Law and the Prophets" (161), Gosse needs to discover an alternative truth to the one his father has taught him. Ultimately, he finds his own truth in the aesthetic language of literature. The literariness of Gosse's choice of similes (the references above are to fairy tales and romances, not to Exodus) demonstrates his subversion of conventional typology. His identification with these imprisoned literary characters illustrates that, for Gosse, the liberating force will be, not the Word of God, but the secular words of literature.

In writing his autobiography Gosse does not renounce typology entirely. Rather, he reverses its standard terms so that the law and the prophets represent not salvation but captivity, and the familiar bugbears of Evangelicalism, art and literature, represent not damnation but release. The parallel to Ruskin is clear, but Gosse goes a step further towards undermining the tradition of typological autobiography. Thus, a kind of progression can be traced in the *Apologia*, *Praeterita*, and *Father and Son*, from conversion to unconversion to subversion.

Gosse, like Ruskin, was the overprotected only child of fanatically religious elderly parents. In spite of the fact that he

[6]Gosse, *Father and Son*, Preface.

was born some thirty years after Ruskin, the resemblances of their early childhoods are extraordinary. Ruskin writes that his mother had "it deeply in her heart to make an evangelical clergyman of me,"[7] while Gosse says, "I cannot recollect the time when I did not understand that I was going to be a minister of the Gospel" (29). The religious enthusiasm with which Mrs. Ruskin had dedicated her child to God even before his birth was still possible when Gosse was born in 1849. Ruskin tells how his mother had "solemnly 'devoted me to God' before I was born; in imitation of Hannah," wryly adding that "very good women are remarkably apt to make away with their children prematurely, in this manner" (PR, 24), while Gosse describes "the solemn dedication of me to the Lord" at the age of six weeks (15). Later on, Gosse adds, people used to speak of him as "another Infant Samuel" (142).[8]

If Ruskin's mother had an "unquestioning evangelical faith in the literal truth of the Bible" (PR, 128), the same was certainly true of Gosse's parents. Religion governed every aspect of their lives: "My parents founded every action, every attitude, upon their interpretation of the Scriptures, and upon the guidance of the Divine Will as revealed to them by direct answer to prayer. Their ejaculation in the face of any dilemma was, 'Let us cast it before the Lord!' " (18). The uncompromising Puritanism that had prevented Mrs. Ruskin from attending the theater took an even more extreme form with the Gosses: Ruskin at least "had Walter Scott's novels . . . for constant reading" (PR, 13) and his father read Shakespeare and the poets aloud, but Gosse never had a single secular story told to him, and was eleven years old before he even knew what fiction was. His father took pride in never having read a word of Shakespeare.

[7]Ruskin, *Praeterita*, 13; hereafter cited parenthetically as *PR*.

[8]Hannah, the childless wife of Elkanah, vowed that if she had a son she would "give him unto the Lord all the days of his life" (1 Sam. 1:11). Her son was the prophet Samuel, whom she brought to Eli the priest as soon as he was weaned.

No friends or entertainment provided relief in either of these strict Puritan households. Gosse "had no young companions, no story books, no outdoor amusements, none of the thousand and one employments provided for other children in more conventional surroundings" (30). This description may remind us of Ruskin, who says of his childhood, "the law was, that I should find my own amusement. No toys of any kind were at first allowed" (*PR*, 20). Gosse's isolation was so extreme that he can write, "I am unable to recollect exchanging two words with another child till after my Mother's death" (37). Even more poignantly, Ruskin suggests that the dominant calamity of his childhood was that "I had nothing to love" (*PR*, 44). Gosse echoes him when analyzing his own peculiar upbringing and concludes: "Here was perfect purity, perfect intrepidity, perfect abnegation; yet there was also narrowness, isolation, an absence of perspective, let it be boldly admitted, an absence of humanity" (18).

The pressures of such a religious environment led in both cases to a crucial unconversion, an experience which both writers cast in terms of an escape from Evangelicalism into Art. But as we have seen, Ruskin's choice was more apparent than real; the guilt he felt because of his extravagant love of art could not be surmounted but only expiated with a lifetime of service. Gosse, on the other hand, seems to have been able to make a complete break. He devoted his entire adult career to the pursuit of literature. In spite of the fact that his training was, if anything, even more extreme than Ruskin's, his unconversion symbolizes what Ruskin's only appears to: a deliberate rejection of Evangelicalism in favor of Art.

Typological Reversals

FROM HIS earliest years Gosse was conscious of a divergence between the plans his parents were making for him and his own inner desires and capabilities. Their dreams for his future were wholly based upon Scripture:

The Great Scheme (I cannot resist giving it the mortuary
of capital letters) had been . . . that I should be exclusively
and consecutively dedicated through the whole of my
life, to the manifest and uninterrupted and uncompro-
mised "service of the Lord." . . . In their ecstasy, my
parents had taken me, as Elkanah and Hannah had long
ago taken Samuel, from their mountain-home of Rama-
thaim-Zophim down to sacrifice to the Lord of Hosts in
Shiloh. They had girt me about with a linen ephod, and
had hoped to leave me there; "as long as he liveth," they
had said, "he shall be lent unto the Lord." (207)

Few writers of autobiography could be more explicitly ty-
pological, but the crucial difference here is that Gosse does not
see himself in these terms; rather, they have been chosen for
him. Typology represents for Gosse not a divinely inspired
way of giving meaning to his entire earthly existence, but an
imprisoning pattern in which he has been trapped since birth:
"I felt like a small and solitary bird, caught and hung out
hopelessly and endlessly in a great glittering cage" (157).
Rather than forge typological links between his own life and
biblical precedents, as the spiritual autobiographer custom-
arily seeks to do, Gosse needs to flee typology's constricting
bondage.

And so, in an intriguing reversal of standard typological
procedure, Gosse casts himself in the role of the faithless and
the sinners. The first example of this is the amusing "O Chair"
incident in which the child acts out a ludicrous scene of idola-
try. His father has assured him in no uncertain terms that
blasphemy consists of offering prayer to idols made from
wood or stone, and further, that God will assuredly manifest
His displeasure with anyone who so offends Him. Awed and
fascinated, the child is unable to resist the temptation to test
both his father and God by trying an experiment:

I knelt down on the carpet in front of the table and looking up I said my daily prayer in a loud voice, only substituting the address "O Chair!" for the habitual one.

Having carried this act of idolatry safely through, I waited to see what would happen. . . . God would certainly exhibit his anger in some terrible form, and would chastise my impious and wilful action. I was very much alarmed, but still more excited; I breathed the high, sharp air of defiance. But nothing happened. . . . I had committed idolatry, flagrantly and deliberately, and God did not care. (44–45)

On one level this anecdote emphasizes the narrow literalness of the training Gosse's parents were giving him, with its tendency "to make me positive and sceptical" (26). On another level, it foreshadows the final unconversion scene where Gosse will again challenge God and then wait, in growing disappointment, for the response that never comes. But, most importantly, the story serves to illustrate how Gosse, throughout *Father and Son*, inverts the terms of the religion he has been taught: just as he will later look to the Scarlet Woman for salvation, so he blasphemously perverts his daily prayer into an act of idolatry. Symbolically, he shows himself allied not with Moses, but with the worshipers of the Golden Calf.

To take another example, when the question of his choosing a profession arises and a well-meaning relative offers to give him a start in banking, Gosse looks on in horror as his father indignantly refuses: "For my silent part, I felt very much like Gehazi, and I would fain have followed after the banker if I had dared to do so, into the night. I would have excused to him the ardour of my Elisha, and I would have reminded him of the sons of the prophets—'Give me, I pray thee, I would have said, 'a talent of silver and two changes of garments'" (209). The son would have leapt at the chance to become a banker, despite the contempt in which moneychangers are

held in the Gospels. But further, Gosse identifies himself with Gehazi, the greedy servant of Elisha. In the Book of Kings Gehazi runs after Naaman, a rich Syrian from whom Elisha has refused to take any payment after healing his leprosy. Gehazi pretends that his master has changed his mind and will now accept some money and clothing (on behalf of his visitors, the sons of the prophets). But he keeps the presents for himself, and lies to Elisha about what he has done. In punishment, Elisha curses Gehazi with the leprosy of Naaman (2 Kings 5:19–27). Thus Gosse plays the materialistic Gehazi to his father's unworldly but self-righteous Elisha. Over and over again Gosse uses typology to undermine the conventional patterns. Subtly, he turns his father's own weapon against him.

The typological contest between father and son becomes more bitter in the exchange of letters which took place after Gosse left home to live in London. Gosse's father tries to justify his relentless probing of his son's spiritual condition: "Holy Job *suspected* that his sons might have sinned, and cursed God in their heart. Was not his suspicion much like mine?" (240). Gosse's reaction reveals his intense frustration: "For this patriarch I came to experience a hatred which was as venomous as it was undeserved. But what youth of eighteen would willingly be compared with the sons of Job? And indeed, for my part, I felt much more like that justly exasperated character, Elihu the Buzite, of the kindred of Ram" (241). The father's analogy proposes himself in the role of Job and Edmund in the role of Job's unfortunate sons, but once again Gosse reverses his father's terms by seeing himself rather as Elihu, the youngest of Job's accusers. Conventionally, of course, Elihu is in the wrong, but Gosse sympathizes with this figure, whose wrath "was kindled . . . against Job . . . because he justified himself rather than God" (Job 32:2). Elihu is an appropriate choice not only because he was the youngest but also because he was the last to speak; by this point in the

endless argument, Gosse implies, he has grown as weary of his father's righteousness as Elihu must have grown with Job.

But whether he allies himself with the worshipers of the Golden Calf, Gehazi, or Elihu, Gosse's extraordinary typological identifications represent not only his rebelliousness but also his impotence. For in the end all of these defiant figures are defeated and punished (it is Elihu who finally provokes God into a reply, and He vigorously condemns Job's accusers). Thus, although one might suspect that Gosse is merely trying to discredit the religious system that bound him, in fact his self-definition, both positive and negative, depends upon it. For these typological inversions point to the entire process of discovering self-identity through negation—Gosse finds out who he is by learning who he is not. Moreover, he indicates the seriousness of his quest for identity by willingly placing himself with the "lost" figures in the Bible in order to achieve his own personal salvation. In this he is rather like his contemporary, Huckleberry Finn, who exclaims, "All right, then, I'll *go* to hell," in order to be free from a religion that tolerates slavery and imprisons his friend Jim. Gosse must define his distance from the typological roles in which he has already been cast—Samuel, the Lamb, and so on—in order to create an opposing self that will ultimately become his true identity. Thus, he subverts typological claims to authority not because he wants to ridicule them, but because only through interacting with them can he establish his emerging personality.

The Scarlet Woman as Saviour

THE CENTRAL typological referent for *Father and Son* is the Book of Revelation. It was the crucial biblical text for Gosse's father, who told his son that "no small element in his wedded happiness had been the fact that my Mother and he were of one mind in the interpretation of Sacred Prophecy" (59). This pur-

suit was not only a diversion that took the place of "cards or the piano," but also a matter of serious and literal belief: in his later years Gosse's father regarded the Second Coming as "absolutely imminent" (229). Each time the date passed "he would be more than disappointed,—he would be incensed" (245).[9]

His parents' preferred reading consisted of commentaries on the Apocalypse. In particular, Gosse recalls, there was "a writer on prophecy called Jukes, of whose works each of my parents was inordinately fond, and I was early set to read Jukes aloud to them. . . . The sight of Jukes' volumes became an abomination to me" (27). Later, during his mother's long fatal illness, her one relief was to listen to Edmund read from her favorite work, "a book of incommunicable dreariness, called Newton's *Thoughts on the Apocalypse*" (52).

When Gosse describes the reading and religious instruction he received as a small child he says that "in our lighter moods, we turned to the 'Book of Revelation,' and chased the phantom of Popery through its fuliginous pages" (75). The lonely bereaved father persuades himself that the seven-year-old is fully capable of joining him in his favorite pastime:

> Hand in hand we investigated the number of the Beast, which number is six hundred three score and six. Hand in hand we inspected the nations, to see whether they had the mark of Babylon in their foreheads. Hand in hand we watched the spirits of devils gathering the kings of the earth into the place which is called in the Hebrew tongue Armageddon. Our unity in these excursions was so delightful, that my Father was lulled in any suspicion he might have formed that I did not quite understand what it was all about. (75–76)

[9]For a discussion of nineteenth-century millennialism and the Victorian fascination with the interpretation of prophetic scripture, see Mary Wilson Carpenter's *George Eliot and the Landscape of Time* (Chapel Hill: University of North Carolina Press, 1986), esp. ch. 1.

Throughout *Father and Son* Revelation acts as a kind of subtext upon which key episodes are based. But just as Gosse transformed other stock biblical allusions, so he transforms Revelation. Gosse describes his parents' peculiarly independent attitude toward other religious groups as follows: "So far as the sects agreed with my Father and my Mother, the sects were walking in the light; wherever they differed from them, they had slipped more or less definitely into a penumbra of their own making, a darkness into which neither of my parents would follow them" (11). This image of "walking in the light" is taken directly from Revelation ("And the nations of them which are saved shall walk in the light of it," 21:24). But Gosse uses the absolute opposition between light and darkness to symbolize the absolutist mental universe his parents inhabit, in which the distinction between the forces of good and evil is complete and unmistakable. Although the parents naturally assume that their son will walk in the light beside them, in fact he speaks of "the darkness of my infancy" (21). Even here, in the opening pages of the book, the lines of battle are being clearly drawn in the cosmic conflict that is to take place between father and son.[10]

From the very beginning a conflict seems inevitable, for the parents' absorption in the next world contrasts sharply with the child's longing to experience this one more fully. For the parents, "pleasure was found nowhere but in the Word of God, and to the endless discussion of the Scriptures each hurried when the day's work was over" (12). They cut themselves off from everything and were perfectly contented, but Gosse says of their secluded existence that they were living in "an intellectual cell" (19). The solitary child was always at the window, watching the world from which he was so "carefully shielded" (71). He used to drag his father out on walks so that he could see the streets and shops, or the ducks and barges on

[10]For a more detailed discussion of the importance of light and dark imagery, see Philip Dodd, "The Nature of Edmund Gosse's *Father and Son*," *English Literature in Transition* 22 (1979): 270–80.

the canal. "These were happy hours," he reminisces, "when the spectre of Religion ceased to overshadow us for a little while, when my Father forgot the Apocalypse" (72).

But such moments were rare: the language used by Gosse's parents is above all the language of Saint John the Divine. On her deathbed Gosse's mother believes herself to be about to enter into the promise of Revelation. Her dying words, "I shall walk with Him in white" (61) echo Christ's promise to Sardis, "They shall walk with me in white" (Rev. 3:4). She urges her husband to "take our lamb, and walk with me!" and although he misunderstands at first, he soon realizes that she is referring to their son. In the Hebrew Bible lambs are merely sacrificial offerings, but in Revelation the Lamb (capitalized) becomes a symbol for the Son of God: "A Lamb stood on the mount Sion, and with him an hundred forty and four thousand, having his Father's name written in their foreheads" (14:1). With these words Gosse's mother identifies her son with the Son of God, the Lamb whom God sacrifices in fulfillment of his own "Great Scheme" for the salvation of mankind. Thus she seals his dedication, attempting to commit him irrevocably to the role she and his father have destined for him.

Throughout his autobiography Gosse capitalizes the word "Father," creating a distancing effect.[11] By doing so, Gosse deliberately associates his own father with God the Father. Furthermore, when he is small the child in some sense actually confuses his father with God (33), and later he repeatedly remarks on the close intimacy that his father presumed to feel with God (242). The title, then, hardly requires translation: *Father and Son* is to be, typologically, the story of God the Father and His Son, the Lamb.

Gosse, however, regards himself as a lost sheep. He is a

[11]Vivian Folkenflik and Robert Folkenflik have observed that Gosse "is very conscious of this kind of typographical emphasis: once he comments on his use of capitals to set a word off, recognizing that it distances what is named" ("Words and Language in *Father and Son*," *Biography* 2 [1979]: 166).

lamb rather in the Old Testament sense, a sacrifice to parental ambitions, to parental fanaticism. He is a lamb as Isaac was to have been, a sacrifice symbolizing the father's perfect unquestioning faith, not a Lamb in the New Testament sense, symbolizing the perfect faith of the Son. But ultimately this son refuses to be sacrificed—he portrays himself as more interested in the Golden Calf than the Lamb, more in sympathy with the covetous Gehazi than the infant Samuel.

There is, then, a widening abyss between the language of the parents and the language of their son. The opening words of the book assert that "there came a time when neither spoke the same language as the other" (9). The son is forced to use their words—he has no others—but he uses them in a sense that is diametrically opposed to theirs. The parents speak literally; their son transforms their terminology literarily. Vivian Folkenflik and Robert Folkenflik, in their excellent article about the centrality of language in *Father and Son*, speak of the growing "linguistic alienation" of the child from his father.[12]

An early example of this occurs when Gosse, as a child suffering from nervous strain, breaks down in hysterics and pleads to be taken to the country: "Like the dying Falstaff, I babbled of green fields" (39). His father agrees to take him to Primrose Hill, overlooking London. Gosse writes: "I was in the highest degree delighted. . . . I expected to see a mountain absolutely carpeted with primroses, a terrestrial galaxy like that which covered the hill that led up to Montgomery Castle in Donne's poem" (39–40). Instead, however, a "miserable acclivity stole into view . . . resembling what I meant by 'the country' about as much as Poplar resembles Paradise"—this is hardly the mountaintop from which Saint John saw the New Jerusalem. The child bursts into tears again and begs to be taken home, but the father is bewildered: clearly he is insensitive to the link between sublime mountain landscapes and religious experience. Interestingly, one cause of the child's

[12]Folkenflik and Folkenflik, "Words and Language," 162.

disappointment is that, like his parents, he regards language in the most literal way: Primrose Hill must be carpeted with primroses. But the adult autobiographer downplays this. He chooses instead to emphasize the linguistic gap between father and son by introducing literary allusions that could not have been made by the child (who in any case would be shielded for a good many years to come from all knowledge of Shakespeare and the poets).

Without even quite realizing what he is missing, the son yearns for a world in which imagination, beauty, and poetry have not been completely excluded. Elsewhere Gosse says that if his parents had allowed some breath of fantasy into their religious teaching of him, they might have kept him longer: "I can but think that my parents were in error thus to exclude the imaginary from my outlook upon facts. . . . Had they wrapped me in the soft folds of supernatural fancy, my mind might have been longer content to follow their traditions in an unquestioning spirit" (26–27). As it is, their prosaic, unimaginative language stifles and impoverishes their son: he longs for Paradise, but the terms in which he envisions it are incomprehensible to his parents.

Nowhere is this more striking than in the passages describing the child's nightmarish visions of Carmine, in which he unconsciously subverts his father's most special text, Revelation. Gosse sets the stage for this episode by recalling how he and his father used to join in reviling the Papacy. For the Book of Revelation is not only about the Second Coming and the New Jerusalem, it is also about the destruction of the enemies of the Church. The new age will be ushered in by the final catastrophe that will defeat Antichrist and destroy Babylon, the symbol of Rome. Translated into nineteenth-century evangelical terms, this meant that the reading of Revelation was also the occasion for "flaming denunciations of the Papacy." Gosse explains: "If there was one institution more than another which, at this early stage of my history, I loathed and feared, it was what we invariably spoke of as 'the so-called

Church of Rome'" (76). Latter-day Protestants may be more moderate, he says, but

> not thus did we approach the Scarlet Woman in the 'fifties. We palliated nothing, we believed in no good intentions, we used (I myself used, in my tender innocency) language of the seventeenth century such as is now no longer introduced into any species of controversy. . . . I do not think I had formed any idea whatever of the character or pretensions or practices of the Catholic Church, or indeed of what it consisted, or its nature, but I regarded it with a vague terror as a wild beast, the only good point about it being that it was very old and was soon to die. (76–77)

This obsession culminates in a recurring nightmare in which the child believes he is galloping through space in the grip of some force that hurries him on "over an endless slender bridge, under which on either side a loud torrent rushed at a vertiginous depth below." The path of their flight "gradually became a monstrous vortex, reverberant with noises, loud with light, while, as we proceeded, enormous concentric circles engulfed us, and wheeled above and about us." The goal of this frantic race, "far away, in the pulsation of the great luminous whorls" was "a ruby-coloured point waxing and waning, and it bore, or to be exact it consisted of, the letters of the word CARMINE" (119).

Gosse interprets his dream by explaining that Carmine was the rarest and most expensive of his father's watercolor pigments, and thus had become for him "a symbol of all that taste and art and wealth could combine to produce" (122). But although he "knew of no object in the world of luxury more desirable than this," he had been strictly forbidden to touch it. Given this aura of mystery, it is no surprise that Carmine should have come to represent the supreme pinnacle of desire. This forbidden substance stands for all the things the

child has been denied: art, beauty, mystery, self-indulgence, freedom. The episode is emblematic of the opposition between the father's goals and the child's, between religion and art.

But, as Vivian Folkenflik and Robert Folkenflik have pointed out, the word "CARMINE," "opaque and glowing, in its forbidding, compelling promise of salvation," also stands for the Scarlet Woman.[13] In the Book of Revelation "the great whore" is described as a woman sitting "upon a scarlet coloured beast" (Rev. 17:1–2): "And the woman was arrayed in purple and scarlet colour, and decked with gold and precious stones and pearls, having a golden cup in her hand. . . . And upon her forehead was a name written, MYSTERY, BABYLON THE GREAT, THE MOTHER OF HARLOTS AND ABOMINATIONS OF THE EARTH" (Rev. 17:4–5). The capital letters Gosse uses for the word "CARMINE" reinforce the identification between his vision and this passage as much as the color itself does. Further, Saint John says that an angel *carried me away* in the spirit into the wilderness" to see the Scarlet Woman (Rev. 17:3; my emphasis), just as Gosse felt himself being carried towards "a ruby-coloured point" by "some force, which had tight hold of me" (119). But in Revelation the Scarlet Woman is an abomination, the beast from which the faithful must be saved. Under his father's instruction, Gosse has already learned to hate and fear this beast, but here, in a dream revealing the unconscious desires of the child, Carmine, the symbol of Rome, becomes the goal. Further, it is a goal that "a frenzied despair in my heart told me we never could reach, yet the attainment of which alone could *save us from destruction*" (119; my emphasis). In a complete reversal of the father's meaning, or indeed the meaning of Revelation itself, the child believes that "the Scarlet Woman" represents salvation. For, as the unconscious mind of the child already realizes, the only possible salvation for him will lie in escaping from his father and the narrow path the father has mapped out for him.

[13]Folkenflik and Folkenflik, "Words and Language," 168.

According to Gosse, a contributing cause of these recurring nightmares was his bizarre "kidnapping" by a crazed member of his father's congregation, Mary Flaw (118). One evening, during church services, Miss Flaw impulsively grabbed his hand and fled outside with the child in her grasp. This episode further reinforces the connection between his dream and the Book of Revelation, for he was carried away by a woman whose name suggests a reversal of the Virgin Mary's (a "flawed" Mary),[14] and, what is more, he was carried away from the church where his father was preaching.

The child's dream, then, is clearly a nightmarish translation of Saint John's vision. Revelation has shaped the child's consciousness just as much as it has the father's, but he totally subverts the meaning of the terms. Perhaps it is even the child's unconscious revenge for the disastrous excursion to Primrose Hill, where the father so utterly failed to understand his son's vision of Paradise, substituting instead a kind of wasteland.

The Scarlet Woman in Revelation is opposed by Him whose "name is called The Word of God" (Rev. 19:13)—and Philip Gosse is the minister of The Word. The conflict between father and son is thus cast in epic terms, as "a spiritual struggle" between "two epochs." Gosse writes of antagonists who are "assailed by forces" leading to "disruption," and calls himself "the survivor" (9). He takes the familiar domestic tale of a child growing up and asserting his independence and turns it into a cosmic battle, like the war in heaven of Revelation.

But in Revelation the scenario is supposed to consist of the Father and the Lamb united and leading one army into battle against the forces of evil. Gosse's father experiences his whole life as waging war for Christ, and Gosse frequently uses military imagery in connection with him: "He was a fortress that

[14]Gosse must take full responsibility for this choice of name, for he tells us in his preface that he thought it best "to alter the majority of the proper names of the private persons spoken of." The significance of this fictitious name is clear from the start of the chapter, when the young Gosse is taken to visit Mary Flaw by Mary Grace, a devoted follower of his father.

required to be stormed" and visitors were "escalading parties" who "attacked us" (126). He trains his son to become his comrade in arms through theological debates in which, "with his mental sleeves turned up, he would adopt a fighting attitude, and challenge me to a round on any portion of the Scheme of Grace." But, Gosse writes, "I was naked, he in a suit of chain armour. . . . I was driven out of my *papier-mâché* fastnesses, my canvas walls rocked at the first peal from my Father's clarion, and the foe pursued me across the plains of Jericho until I lay down ignominiously and covered my face" (242).

The son fights reluctantly, whether beside his father or against him. Like the last king of Judah, who rebelled against Nebuchadnezzar and was captured "in the plains of Jericho" (2 Kings 25:5), Gosse flees from the contest. The passage continues: "I seemed to be pushed with horns of iron, such as those which Zedekiah the son of Chenaanah prepared for the encouragement of Ahab. When I acknowledged defeat and cried for quarter, my Father would become radiant" (242). The prophet Zedekiah had urged the idolatrous king Ahab to go to war: "And Zedekiah the son of Chenaanah made him horns of iron: and he said, Thus saith the Lord, With these shalt thou push the Syrians, until thou have consumed them" (1 Kings 22:11). But in reality Ahab was being goaded on to his own death in battle by the prophet—whom Gosse identifies with his father. The "encouragement of Ahab" was actually a ruse designed by God to bring about Ahab's destruction.[15] Thrust unwillingly into battles that can only end in his own defeat, Gosse imagines himself sharing Ahab's fate.

As always, his typological identifications show him on the wrong side. Here, rather than being a soldier of God, he is like the evil kings who are doomed to fall. While he may in the end be "the survivor," he is also the defeated enemy, "pursued

[15]"And the Lord said, Who shall persuade Ahab, that he may go up and fall at Ramoth-gilead?" (1 Kings 22:20).

across the plains of Jericho" and "pushed with horns of iron."
The Father's scenario derives from Revelation, where the Father and the Lamb join forces against the world; the son's
derives from shameful chapters in Israel's history, when her
own kings betrayed her and their evil resulted in the Babylonian Captivity.

Literature as Salvation: The Unconversion

GOSSE REWRITES his parents' version of salvation history, using
their terms not typologically but poetically. *Father and Son*
charts his gradual discovery of literature, which had been
carefully and successfully withheld from him until he reached
adolescence. The opposition is introduced subtly at first. For
example, Gosse juxtaposes the scene where he reads Newton's *Thoughts on the Apocalypse* to his dying mother with his
own delighted reading of a poem called "The Cameronian's
Dream," a gloomy ballad whose romance "brought a revelation to me" (53). Even at the age of seven, Gosse finds that a
gulf between his parents' and his own source of revelation has
already begun to appear. Similarly, he says of his first exposure to "the amazing beauty" of Virgil's poetry that "a miracle had been revealed to me" (131). *His* miracles are secular,
aesthetic, and literary.

Gosse's parents regard Revelation as literal fact. Speaking of
his mother, Gosse writes: "She had formed a definite conception of the absolute, unmodified and historical veracity, in its
direct and obvious sense, of every statement contained within
the covers of the Bible. For her, and for my Father, nothing
was symbolic, nothing allegorical or allusive in any part of
Scripture" (57). As for the wild imagery of Revelation, "they
did not admit for a moment that these vivid mental pictures
were of a poetic character, but they regarded them as positive
statements, in guarded language, describing events which
were to happen" (58). The parents see themselves as acting

out, in the most literal way, the events promised in the Bible, from dedicating their son like Samuel, to daily awaiting the Second Coming.

Gosse, on the other hand, uses Revelation as a literary model for his own artistic creation, his autobiography. His parents' plan had been that his life story should mirror that of Samuel and Jesus. They envision his childhood as the gradual discovery of the Word, to be followed by his adult career as a preacher of the Word. But instead, his becomes the story of the gradual discovery of words, of literature, and the revelation that this was to him.

As a child, Gosse had not even known that such things as stories or fantasies existed: "Not a single fiction was read or told to me during my infancy. . . . Never, in all my early childhood, did anyone address to me the affecting preamble, 'Once upon a time!' I was told about missionaries, but never about pirates, I was familiar with humming-birds, but I had never heard of fairies" (26). The prohibition against fiction was not lifted in the smallest degree until he was eleven years old, when, almost by accident, his father allowed him to read *Tom Cringle's Log*, a "noisy amorous novel of adventure" by Michael Scott: "I began the story without a doubt that it was true, and I think it was my Father himself who . . . explained to me that it was 'all made up.' " The effect on him was immense: "It was," Gosse rejoices, "like giving a glass of brandy neat to some one who had never been weaned from a milk diet." Significantly, the terms he uses to express his happiness are those customarily used to describe religious ecstasy: the book, he says, "filled my whole horizon with glory and with joy" (160).

Gosse contrasts this delighted reaction to his first encounter with literature to his feelings of despair when he contemplated his future career as an evangelical preacher. Speaking of his father's enthusiastic anticipation of being present at his son's first sermon, Gosse says, "I cannot express the dismay which this aspiration gave me." He continues even more tell-

ingly, making explicit the connection between his nightmares and his father's ambitions: "I saw myself imprisoned for ever in the religious system which had caught me and would whirl my helpless spirit as in the concentric wheels of my nightly vision" (157).

Now, for the first time, a faint hope awoke in him as he glimpsed the possibility of escape. The bliss of reading this lively secular work of fiction produced "a sort of glimmering hope . . . tending towards a belief that I should escape at last from the narrowness of the life we led at home, from this bondage to the Law and the Prophets" (161). The terms of the conflict have now been clearly set out: Religion represents bondage from which only literature can provide salvation. His soul, writes Gosse, had been "shut up, like Fatima, in a tower" and literature suddenly offered a little window and a telescope through which he could look out. Appropriately, he compares himself to an imprisoned figure from a fairy tale (Bluebeard's wife, Fatima, in Charles Perrault's *Mother Goose Tales*). He is on the side of the world of literature and fantasy that his parents have sought to exclude and repress. His nightmare, in which he yearned to reach the forbidden goal which alone could offer salvation, symbolized the truth that for him salvation did indeed lie in the discovery of that which had been forbidden.[16]

This first encounter with fiction marks the turning point in Gosse's development. The final third of the book chronicles his ever-expanding acquaintance with literature, from his meeting with the poet and actor James Sheridan Knowles to his innocent reading aloud at home of Marlowe's "Hero and Leander." Reacting to this work with the same ecstatic pleasure he had shown over his earlier reading of "The Cameronian's Dream," he calls it "a marvellous revelation of romantic

[16]As Vivian Folkenflik and Robert Folkenflik put it, "the language of fiction is the only language which both reaffirms his inner self and permits him to escape the sterility of feeling himself as other" ("Words and Language," 170).

beauty." Stressing once again that for him Paradise lay in poetry, he says, "I was lifted to a heaven of passion and music" (224).[17]

He recounts how "the great subject of my curiosity at this time was words" (215): "When I read Shakespeare and came upon the passage in which Prospero tells Caliban that he had no thoughts till his master taught him words, I remember starting with amazement at the poet's intuition, for such a Caliban had I been" (216). This, on the part of a child who, prior to his public baptism, "testified my faith in the atonement with a fluency that surprised myself" (144). But that had been the language of his parents, a language that he had learned to mime wonderfully, but that could never serve to express his own ideas. What the poets teach him is a new language: "For my Prosperos I sought vaguely in such books as I had access to, and I was conscious that as the inevitable word seized hold of me, with it out of the darkness into strong light came the image and the idea" (216). Despite the biblical resonance of the imagery of darkness and light, for Gosse "the inevitable word" is not the Word of God. Like Caliban, who complains, "You taught me language, and my profit on't / Is, I know how to curse," Gosse has been taught a language inappropriate to his needs, one that he must deform in order to speak at all.

He reads and adores Shakespeare, and finds himself increasingly torn by the conflicting claims of the two languages he now knows. When his father takes him up to London for an evangelical conference, the preacher denounces the "blasphemous celebration of the birth of Shakespeare" on the part of lukewarm Christians, who are "like the Laodiceans, whom the angel of the Apocalypse spewed out of his mouth" (218). The narrowness of his father's interpretations has prevented the family even from celebrating the birth of Christ—how,

[17]It was Knowles who first told him about Shakespeare; reading *The Merchant of Venice*, Gosse says he was "in the seventh heaven of delight" (167).

then, can the son, newly awakened to the glories of literature, help but identify with those whose lack of religious commitment is condemned in Revelation 3:16? The comparison between the two celebrations is further encouraged by Gosse's telling use of a capital letter for what he calls "the Birth at Stratford." Shakespeare has become more important to him than Jesus, for while he had submitted to his father's prohibition against the idolatrous celebration of Christmas, he now reacts violently, as "if some person I loved had been grossly insulted in my presence."

Although Gosse recognized that literature was tempting him "to stray up innumerable paths . . . at right angles to that direct strait way which leadeth to salvation," he still deluded himself into thinking that all would be well as long as he never lost "sight of the main road" (219). But in fact his attention came to be focused more and more exclusively on his secular reading. He "scoured the horizon in search of books in prose and verse" (222), and walked miles back and forth to school in order to save the train fare and buy cheap editions of the poets. But with the episode of reading Marlowe's "voluptuous poem" to his stepmother, the conflict between the two irreconcilable languages comes into the open. His father denounces him "in unmeasured terms, for bringing into the house, for possessing at all or reading, so abominable a book" (225).

This course of reading finally culminates in his unconversion, a scene foreshadowed by the "O Chair" episode. The two incidents combine to frame the entire narrative. The earlier episode only made him doubt his father; now, however, God himself will be tested and found wanting. For a time Gosse experienced an intensification of religious feeling, aided by his father's living in imminent "expectation of the immediate coming of the Lord" (229). His two truths, religion and literature, vie with one another: his thoughts, he says, were "in a huddled mixture of 'Endymion' and the Book of Revelation. . . . In my hot and silly brain, Jesus and Pan held

sway together" (230). At last, one summer afternoon at school he found himself alone by an open window looking out over the garden and the sea. The setting is strongly reminiscent of the climax of the *Confessions* when Augustine and Monica, "alone, leaning from a window which overlooked the garden," experience a mystical communion with God. They had just been saying how "no bodily pleasure, however great . . . was worthy of comparison . . . beside the happiness of the life of the saints," when they seem to feel themselves leaving the body, even passing beyond their own souls, so that for "one fleeting instant" they reach out and touch eternal Wisdom.[18]

Gazing enraptured from his window, Gosse fully expects to experience something equally wonderful. The moment is charged with the "magic of suspense":

> Over my soul there swept an immense wave of emotion. Now, surely, now the great final change must be approaching. I gazed up into the tenderly-coloured sky, and I broke irresistibly into speech. "Come now, Lord Jesus," I cried, "come now and take me to be for ever with Thee in Thy Paradise." . . . And I raised myself on the sofa, and leaned upon the window-sill, and waited for the glorious apparition.
>
> This was the highest moment of my religious life, the apex of my striving after holiness. (231)

But God fails entirely to manifest Himself to Gosse as He had apparently done to Augustine in a similar setting. The anticlimax is even more dreadful than after he had prayed to the chair:

> I waited awhile, watching; and then I felt a faint shame at the theatrical attitude I had adopted, although I was alone. Still I gazed and still I hoped. Then a little breeze sprang up and the branches danced. Sounds began to rise

[18]Augustine, *Confessions*, 197.

from the road beneath me. Presently the colour deepened, the evening came on. From far below there rose to me the chatter of the boys returning home. The tea-bell rang,—last word of prose to shatter my mystical poetry. "The Lord has not come, the Lord will never come," I muttered, and in my heart the artificial edifice of extravagant faith began to totter and crumble. From that moment forth my Father and I . . . walked in opposite hemispheres of the soul. (231–32)

This failure of his ultimate attempt to live according to his father's lights, to imitate him even in his delusions about the imminence of the apocalypse, marks forever the divergence of their two paths. The scene inevitably evokes Augustine, whose conversion formed the typological basis of every subsequent conversion in the tradition of spiritual autobiography, but with a key reversal—Augustine rejects the world, which he has known all too well, while Gosse embraces it with the fervor of a newly released prisoner.

Although Gosse's adult career is not dealt with in *Father and Son*, it would be completely devoted to the literary world. He knew every major writer of his day, from Rossetti and Browning to Henry James and Rupert Brooke. He became best known for introducing Ibsen and other Scandinavian authors to the English public, and for his biographies of literary figures such as Congreve, Donne, and Swinburne. In a real sense, he was to spend his life as a preacher of literature, rather than of religion. This rejection of the Word in favor of words is another reversal of the typological precedent set by Augustine, who believed that his early love of literature had hindered him on his path to salvation. When Augustine was baptized as a Christian he chose to give up his profession of teaching rhetoric, of being what he called a "vendor of words."[19] As the Bible offers the story of Christian salvation, so *Father and Son* tells the story of Gosse's own salvation. But from the very

[19]Augustine, *Confessions*, 189.

preface, where he speaks of "comedy" and "tragedy," the terminology is that of literature and literary criticism—in contrast to the terms of his parents, for whom "nothing was symbolic, nothing allegorical or allusive."

The Autobiographer as Creator

IN EFFECT, by choosing his own language and by choosing his own plot, Gosse becomes the author of his own life. As he says of himself in the closing words of the book, "the young man's conscience threw off once for all the yoke of his 'dedication,' and . . . he took a human being's privilege to fashion his inner life for himself" (250). In doing so, he wrests "authority" not only from his father, but also from God. His parents have destined him to be the Son (the Lamb), but by rebelling against his father he also usurps his role. And later on he becomes, like every autobiographer, his own father through the act of self-authorship.

The process begins when Gosse is scarcely out of infancy and discovers that his father, whom he "confused in some sense with God" (33), is fallible after all. When his father ˙ blames some workmen for ruining their fountain, unaware that his son is the true culprit, Gosse realizes for the first time that his father is not omniscient: "Here was the appalling discovery, never suspected before, that my Father was not as God, and did not know everything. . . . My Father, as a deity, as a natural force of immense prestige, fell in my eyes to a human level" (33, 35). Conversely, Gosse's own power grows: "I had found a companion and a confidant in myself. There was a secret in this world and it belonged to me and to a somebody who lived in the same body with me. There were two of us, and we could talk with one another" (35). In the Bible the Fall of man confirms God's omniscience, but Gosse's own book is based upon a typological reversal: the "fall" of the father gives birth to independent consciousness in the son.

Adam, the Son, learns that he can have no secrets from God and no separate existence; he cannot successfully oppose God and is forced by Him into isolation and exile. Edmund, the Son, learns that he can keep a secret, does have a separate existence; his former isolation diminishes with the new knowledge of his dual identity. The rivalry between father and son is thus shown early on as a kind of rewriting of Scripture in which the son will not be content to play the subordinate role traditionally assigned him.

Gosse reverses the biblical model even more thoroughly. In the Bible, the consequence of Adam's fall is expulsion from Eden. Here, however, the Garden of Eden is destroyed, unintentionally, by the *father*. Gosse describes the rock pools of the Devonshire coast as "gardens of a beauty that seemed often to be fabulous." Making the typological identification perfectly plain, he adds, "if the Garden of Eden had been situate in Devonshire, Adam and Eve, stepping lightly down to bathe in the rainbow-coloured spray, would have seen the identical sights that we now saw" (110–11). The coast had been "undisturbed since the creation of the world," but the naturalist "burst in . . . where no one had ever thought of intruding before." Philip Gosse's books brought hordes of collectors to the shore, and they ravaged the beautiful landscape. Now, if anyone were to go there, he would find nothing, for "the fairy paradise has been violated." The terrible irony, Gosse points out, was that "my Father, himself so reverent, so conservative, had by the popularity of his books acquired the direct responsibility for a calamity that he had never anticipated" (111). The typological inversion could hardly be more overt: not the Son but the Father bears "direct responsibility" for the loss of Eden.

The first intimations of the Son's aspirations to become a Creator in his own right appear with his childhood preoccupation with magic. He has, in a sense, tried to establish his own religion in opposition to that of his parents. Gosse is explicit about the parallel: "My mind took refuge in an infantile spe-

cies of natural magic. This contended with the definite ideas of religion which my parents were continuing . . . to force into my nature" (37–38). As an example of his private religious practices, Gosse describes how he believed that with the right combination of words, he "could induce the gorgeous birds and butterflies in my Father's illustrated manuals to come to life, and fly out of the book"—like God, he wants to be a creator, to give life to animals through the spoken word. Similarly, after being taken to see the Great Globe in Leicester Square,[20] and being enormously disappointed with it, Gosse says that he felt he "could invent a far better Great Globe than that in my mind's eye" (37). He may have been a Caliban, but he seeks to become another Prospero, that master of language and magical creation who transformed "the great globe itself" through the power of his imagination.

This desire to remake the world according to his own lights manifests itself strongly in his passion for geography. Out of mud, Gosse says,

> I created a maritime empire—islands, a seaboard with harbours, lighthouses, fortifications. My geographical imitativeness had its full swing. Sometimes, while I was creating, a cart would be driven roughly into the pond, and a horse would drink deep of my ocean, his hooves trampling my archipelagoes and shattering my ports with what was worse than a typhoon. But I immediately set to work, as soon as the cart was gone and the mud had settled, to tidy up my coast-line again and to scoop out anew my harbours. (168–69)

Just as the adult Gosse would create his own world through literature and language, so the child attempts to create a world through primitive religion and later through these make-believe geographical enterprises. Maps and geography offer a

[20]The Great Globe was "a huge structure, the interior of which one ascended by means of a spiral staircase" (37).

sign-system of their own, a symbolic rather than a literal way of "reading" the world. His passion for geography opens out into imaginative creation, as when he draws maps of the West Indies and envisions a paradise of islands and sea, of emeralds and amethysts "lying on the sea like an open bracelet, with its big jewels and little jewels strung on an invisible thread" (159). The emeralds and amethysts evoke the language of Revelation, here transformed into a purely aesthetic language by the child who loves and longs for beauty.[21]

At one point his obsession with independent creation nearly brings him into conflict with his father. The child's passion for imitation leads him to spend hours, even days, "preparing little monographs on seaside creatures, which were arranged, tabulated and divided as exactly as possible on the pattern of those which my Father was composing for his *Actinologia Britannica*" (134). However, instead of copying ei-

[21]The language the child seeks, and delights in when he finds, is the language of beauty. The parents read the world scripturally and scientifically; the son teaches himself to read it aesthetically. The father carried his literal-minded interpretation of worldly events to the point of utter absurdity; for him, even a broken leg bore a divine message (221). No wonder the son turned with gratitude and relief to his new stepmother for bringing "a flavour of the fine arts with her" into the household (183). Gosse repeatedly tells what an exquisite revelation the beauty of poetry was to him (131, 167, 224), and speaking of his attraction to the Greek gods he says, "the dangerous and pagan notion that beauty palliates evil budded in my mind" (199). In spite of all his early scientific training in observation, he says, he couldn't describe a sea anemone today (137)— but he remembers vividly the splendid beauty of the landscape in which they conducted their investigations (110). Ritual had no meaning for the parents (as the incident of jumping up in the middle of prayers to examine a butterfly so comically illustrates), so the son created elaborate rituals for himself with his practice of natural magic. He needed to satisfy his frustrated longing for the aesthetic pleasure of ritual, to invest the world with the mystery his parents denied it. For further discussion of the progression of Gosse's aesthetic development, and the centrality of the conflict between aestheticism and Puritanism, see James D. Woolf, " 'In the Seventh Heaven of Delight': The Aesthetic Sense in Gosse's *Father and Son*," in *Interspace and the Inward Sphere: Essays on the Romantic and Victorian Self*, ed. Norman A. Anderson and Margene E. Weiss (Macomb: Western Illinois University Press, 1978), 134–44.

ther his father or Nature itself exactly, the child "invented new species, with sapphire spots and crimson tentacles and amber bands, which were close enough to his real species to be disconcerting. . . . If I had not been so innocent and solemn, he might have fancied I was mocking him" (135). The elder Gosse urges him to go out and study Nature, and even forces him to paint "from a finished drawing of his" (136). Paradoxically, the father thinks he is urging his son to be original, whereas in fact he is insisting, as always, that he be imitative by conforming to his own vision. But Gosse has no interest in producing the kind of faithful reproductions that his father specializes in— he wants to be inventive, to use his imagination. He wants to be more than a clear medium. And so he copies his father's method with minute exactitude, but introduces changes of his own, creating fantastical creatures that never existed in reality. The Father is content to be the keen observer and patient recorder of God's creatures; the Son is determined to create for himself. Not content with God's world, he wants to make a new world of his own—he doesn't want to be the Son, but the Father.

For Philip Gosse, Revelation offers the only way of making the world anew. After the Last Judgment and the Resurrection, Saint John sees "a new heaven and a new earth" (Rev. 21:1) and God says: "Behold, I make all things new" (21:5). But Edmund Gosse wants to make things new in his own fashion. In the Book of Revelation God proposes: "He that overcometh shall inherit all things; and I will be his God, and he shall be my son" (21:7). But Gosse sees through this bribe, sees it for the power play it really is: if he accepts such a bargain, he must remain forever the son, a subordinate partner in an unequal alliance.

Instead, Gosse chooses to become an author-artist, creating his own world in magic incantation, childish paintings, and mud pies. By writing his own natural history he writes the history of his own salvation, for he wants to author his own destiny, not act out someone else's Great Scheme. The parents

do everything possible to ensure that their son imitate Jesus, from his premature dedication and baptism onwards. But instead he imitates God himself: he creates his own religion and his own world. It is a blasphemous usurpation, but he has portrayed himself as an idolater from earliest childhood, worshiping a chair. His ultimate rebellion takes the form of claiming "a human being's privilege to fashion his inner life for himself," and finally, as an autobiographer, he does just that: he fashions the story of his own life in yet another act of self-creation.

Truth in Autobiography

WHAT WORRIES Gosse's father about his son's fanciful paintings also disturbed Gosse's mother about all forms of fiction: the fear of what is "not true." This fear must account, wholly or in part, for their literal-minded reading even of Revelation—they cannot admit the possibility that any part of the Bible could be interpreted symbolically or literarily, any more than they will read Sir Walter Scott. They cannot, or will not, distinguish between fiction and lies.

A somewhat similar problem has plagued readers of *Father and Son* ever since its publication. How can a book in which literary conventions are so blatant be strictly true? Surely it is a bit too neat that the first word Gosse spoke should have been "book," or that his unconversion should have taken place in a setting so evocative of Augustine's transcendent converse with God? The first chapter, for example, closes with a literary flourish in which Gosse metaphorically describes himself as having been a little plant growing "on a ledge, split in the granite of some mountain . . . hung between night and the snows on one hand, and the dizzy depths of the world upon the other" (19). The novelistic qualities of this passage have disturbed critics such as Howard Helsinger, who writes sceptically, "we may wonder how a plum such as [this] got into the

loaf from which the slice was cut. . . . this is the stuff of fiction."[22]

Gosse shows himself to be aware of the problem. In his preface he anxiously insists that although his book may look like fiction, it is in fact "scrupulously true." He offers it to his readers "as a *document*, as a record of educational and religious conditions which, having passed away, will never return." He refers to the book's subject matter as "the facts" of his childhood and maintains that it was written while his memory was "still perfectly vivid." Only the names have been changed; in all other respects "this book is nothing if it is not a genuine slice of life."

On one level, Gosse's truth-claims may be seen as no more than the conventional disclaimer: just as novelists, writing fiction, frequently insist that every word is true, so autobiographers, writing "fact," must also insist that it is true because the storytelling techniques they too employ can mislead their audience into thinking they are reading a fiction. But Gosse was extremely conscious of the distinction between autobiography and fiction, and the question of the truthfulness of autobiography was important to him. Ann Thwaite points out how Gosse himself said, in 1920, that in autobiography "there must be no faintest suspicion that the facts have been tampered with (as may freely be done in a novel) in order to make their sequence more amusing or more probable." Nevertheless, Thwaite continues, "in 1887 he had admitted how remote already was his childhood: 'We shall find that our memories are like a breath upon the glass,' he had written, 'like the shape of a broken wave. Nothing is so hopelessly lost, so utterly volatile as the fancies of our childhood.' . . . Gosse himself admitted that 'the end had been slightly arranged.' He told Harold Nicolson so, and Nicolson recorded it in his di-

[22]Howard Helsinger, "Credence and Credibility: The Concern for Honesty in Victorian Autobiography," in *Approaches to Victorian Autobiography*, ed. Landow, 58.

ary."[23] Thus on the one hand we find a scrupulous regard for accuracy, and on the other an open admission that memory is volatile and the facts have been altered.

The issue becomes particularly perplexing if we recall that the greatest humiliation of Gosse's entire career was the accusation by John Churton Collins that Gosse's book, *From Shakespeare to Pope*, was completely unscholarly and riddled with errors.[24] Although most of Gosse's friends rallied around him, the unpleasant fact remained that Collins was more or less right. It was a long time before the furor died down; indeed, the episode was never quite forgotten. Thus to some extent Gosse's autobiography must be seen as an attempt to vindicate his reputation from the charge of untruthfulness, just as Newman's *Apologia* was. The difference in autobiographical strategy is therefore all the more striking: Newman quotes extensively from contemporary letters and diaries, while Gosse writes a book whose fictive characteristics have troubled generations of readers.

Yet, in spite of his realization that it would cast doubt on his veracity, Gosse chose to write in as literary a style as possible.[25] Howard Helsinger argues that, in doing so, Gosse "shows little sensitivity to the role of style in creating the appearance of honesty."[26] But perhaps the explanation may be, not that Gosse is either willfully dishonest or woefully naive, but rather that the literary style cannot be moderated

[23]Ann Thwaite, *Edmund Gosse: A Literary Landscape, 1849–1928* (London: Secker & Warburg, 1984), 435. Thwaite is quoting from Gosse's *Questions at Issue* (London: Heinemann, 1893), 243.

[24]Collins's attack appeared in the October 1886 issue of the *Quarterly Review*. For a detailed discussion of this incident, see chap. 10 ("The Scandal of the Year") of Ann Thwaite's *Edmund Gosse*. She describes Gosse's "anguish and despair" and quotes a sentence he wrote: "No one will ever know what I have suffered" (283).

[25]For a discussion of Gosse's use of narrative and dramatic techniques, see William R. Siebenschuh, *Fictional Techniques and Factual Works* (Athens: University of Georgia Press, 1983).

[26]H. Helsinger, "Credence and Credibility," 58.

because it is essential to Gosse's entire purpose as an auto-biographer. The crux of the book is the tension, even conflict, between fact and fiction, science and imagination, fundamentalism and literature. Through the very literariness of his style Gosse asserts his independent selfhood, just as he did as a child, inventing fantastical creatures in a near-parody of his father's painstakingly observed drawings.[27] It was literature that gave him an escape, and it was through literature that he took his stand against his father. Had he written an objective, straightforward account of his life (insofar as such a thing is ever possible), stripped of every literary technique and allusion, the kind of autobiography that Darwin wrote, he would have been not Edmund but Philip Gosse.

In this context it may be useful to compare the portrait Gosse drew of his father in *The Life of Philip Henry Gosse*, written in 1890, with the portrait we have in *Father and Son*. How does Gosse's style as a biographer differ from his style as an autobiographer? Primarily, the difference is one of emphasis: Gosse devotes the bulk of the biography to recounting in detail his father's early years in the New World and the growth of his vocation as a naturalist, saving for a final chapter a full account of his theological idiosyncrasies. But most interesting is the striking similarity of language: in spite of Gosse's anxiety to establish his candor as a biographer (in the preface he insists that "my only endeavor has been to present my father as he was"), his style is remarkably—but characteristically—literary. In discussing his father's religious views, Gosse uses the same military imagery as in *Father and Son*: "I have never met with a man, of any creed, of any school of religious speculation, who was so invulnerably cased in fully

[27]Howard Helsinger agrees: "The self has come to be seen as the creation of its language. What I have spoken of as Gosse's defense of lying is really therefore a defense of style: a defense of language as the instrument of self-creation, self-discovery, and self-preservation" (62–63).

developed conviction upon every side. His faith was an intellectual system of mental armour in which he was clothed, *cap-à-pie*, without a joint or an aperture discoverable anywhere" (*PHG*, 324). Anticipating the terms of armed conflict he would later use in his autobiography, Gosse calls his father "an antagonist whom it was easy to disagree with, but uncommonly difficult to defeat," for he was "protected by his ample shield, the text of Scripture" (*PHG*, 329). Recalling his father's determination to publish *Omphalos* (1857), Gosse writes that "he must needs break a lance with the windmills of the geologists" (*PHG*, 277). By characterizing his father as Don Quixote, Gosse transforms his religious quest into a literary one.

Similarly, the familiar imagery of bondage and escape figures prominently in *The Life*: Gosse describes the fundamentalist position on Creation as "a fettering order of ideas" from which "the human mind was preparing for a great crisis of emancipation." As for *Omphalos*, its "whole purpose was to bind again those very cords out of which the world was painfully struggling" (*PHG*, 279). Even the notion of two epochs which introduces the theme of dramatic confrontation in *Father and Son* is already present: Gosse writes that his father "could never learn to speak the ethical language of the nineteenth century; he was seventeenth century in spirit and manner to the last" (*PHG*, 335). In short, the art of biography matches the art of autobiography.[28] Rather than casting the strong glare of truth upon the lurid overartfulness of the autobiography, the biography reveals the same reliance upon literary devices. The act of telling a story, even a true one, requires

[28]Even the humorous tone of *Father and Son* is present in the biography; describing his parents' married life, and the interest his mother learned to take in his father's scientific pursuits, Gosse writes: "Not a rotifer was held captive under the microscope, not a crustacean of an unknown species shook a formidable clapper at the naturalist, but the cry of 'Emily! Emily!' brought the keen eye and sympathetic lips on to the scene in a moment. Under her care . . . he had lost his shyness, and had become one of the most genial, if still one of the most sententious of men" (*PHG*, 262).

the use of techniques we associate with fiction—perhaps particularly so for Gosse, who found in literature his own kind of truth.

In his article "Full of Life Now," Barrett J. Mandel argues that the essential truth of autobiography cannot be threatened by fictional techniques because the reader knows that autobiography is not, and cannot be, the literal truth. Autobiography is not life, but may be lifelike, for "language creates illusions that tell the truth."[29] When applied to Gosse's autobiography, this observation may shed some light on the puzzling question of accuracy. The quibbling in which critics have indulged (were those really his mother's dying words?) over the absolute fidelity of every detail becomes irrelevant. Of course Gosse cannot remember the exact words spoken to him, even though he reproduces dialogues as though he could remember, but this doesn't make his autobiography untrue, any more than the prevalence of reconstructed speeches in Thucydides makes his history untrue. No reader imagines that the seven-year-old took notes at his mother's deathbed. But by pretending to give us his mother's own words, Gosse faithfully conveys to us what it was like for him at her death, particularly the burden of his dedication.[30] In this sense, *Father and Son is* true, even though it is impossible, in an absolute sense, for any writing to capture "reality" fully.[31]

[29]Barrett J. Mandel, "Full of Life Now," in *Autobiography*, ed. Olney, 63. Taking issue with the position that all autobiography is essentially fictional, Mandel insists that, in spite of using literary techniques, "Gosse is not writing fiction" (60): "Gosse records minute details in a novelist's fashion. He provides visual metaphors, allows us to feel through tactile images, provides convincing dialogue, plays omniscient narrator. But we do not mistake the passage for fiction" (60–61).

[30]As Walter Houghton observes in reference to the *Apologia*, "Literal accuracy is immaterial because autobiography is an art. All that Newman's words have to do is to convey the essential quality of his past experience" (*The Art of Newman's Apologia*, 60).

[31]In his essay "Conditions and Limits of Autobiography," Georges Gusdorf presents an illuminating discussion of this thorny issue. He writes: "An autobiography cannot be a pure and simple record of existence, an account book or a logbook. . . . in such a case, rigorous precision

Ironically, the question of what is "true" was paramount for both father and son. It was the father's absolutist insistence on one revealed truth, and his absurd attempt in *Omphalos* to reconcile this "truth" with the opposing truth of science, that brought him into disgrace. Philip Gosse's critics were over-simplifying when they summed up his thesis as "God hid the fossils in the rocks in order to tempt geologists into infidelity" (87). But essentially the omphalos theory does assert that objects lie about their past: Adam had a navel, but no mother; the trees were created with rings that did not attest truly to their number of years on earth. Although he refused to see it, Philip Gosse's theory made his own professional life pointless, for it had been entirely devoted to the patient observation of nature—and what becomes of the patient observer who concludes that the evidence of our observation is unreliable? Since the whole fabric of his life was built upon his conviction of the literal truth of Scripture, Philip Gosse forced himself to make a false choice: if Scripture is true, science must be deceptive. He was unable to make a synthesizing leap of the imagination, to consider, for example, the possibility of a symbolic reading of Scripture. Could he have transcended this literalism he might not have been forced to such extremes in his efforts to reconcile divergent readings of reality. Ruskin saw meaning and truth as placed in the world by God. The artist's role was to interpret or translate this meaning for mankind.[32] But Philip Gosse, although he wanted to see divine meaning in the

would add up to the same thing as the subtlest deception" (42). Gusdorf adds that "in autobiography the truth of facts is subordinate to the truth of the man"; thus, even the fact that, for example, "the *Mémoires d'outre tombe* should be full of errors, omissions, and lies . . . [is] of little consequence" (43).

[32]See Dana Brand, "A Womb with a View: The 'Reading' Consciousness in Ruskin and Proust," *Comparative Literature Studies* 18 (1981): 487–502. Brand writes: "One way of believing in the externality of the presence one puts in things is to believe that it has been put there by a paternal source with the power to invest things with presence. This is what Ruskin does. He reads the external world of nature and art as a realm of signs for the divinity" (494).

world, awaiting interpretation by the scientist-preacher, was forced to the conclusion that, instead of radiating the glory of God, the world was all a misleading lie.

But *Father and Son* is about the son's inability to accept revealed truth—or Revelation—and his need to test reality for himself, to verify or discredit the truth of what he has been told about the world. In the "O Chair" episode the son shows himself to be a better scientist than his father, for he doesn't blind himself to the implications of what he calls "my experiment" (44). And, in an earlier episode, the discovery that alternatives to truth exist constitutes his first step towards self-awareness. The child has caught his father in some small error of fact: "The shock to me was as that of a thunderbolt, for what my Father had said 'was not true.' . . . Nothing could possibly have been more trifling to my parents, but to me it meant an epoch" (33). What Gosse calls "the consciousness of self" (32) came to him as a result of this revelation (from which his parents' prohibition on fiction had protected him) that there may be, if not more than one truth, at least an alternative to truth.

This incident may serve as a paradigm of the entire book, for *Father and Son* is, finally, about the enfranchisement of self through the gradual discovery of an alternative language.[33] The whole book is structured around this shift from monolithic meaning to multiple meaning, which is symbolized by the child's finding, as a direct consequence of an innocent and apparently insignificant falsehood uttered by his father, that "there were two of us, and we could talk with one another" (35). He finds, as Vivian Folkenflik and Robert Folkenflik put

[33]As Roger J. Porter points out, "When Gosse initially rejects his father, there is no alternative model because the child 'has no imaginative experience with literature to project himself into; his inner world is empty'" ("Edmund Gosse's *Father and Son*: Between Form and Flexibility," *Journal of Narrative Technique* 5 [1975]: 181). Porter quotes Howard R. Wolf, "British Fathers and Sons, 1773–1913: From Filial Submissiveness to Creativity," *The Psychoanalytic Review* 52 (1965): 206.

it, "someone who speaks his language."[34] This newfound duality of self enables the child to keep a secret, to tell a lie (or at least to understand the possibility of doing so), and to begin to see himself as "other," different both from his parents and from their vision of him.[35] He can be, not an infant Samuel, but Ahab, Gehazi, Elihu, or even Princess Blanchefleur; he may choose any number of roles rather than the one role his parents would choose for him.

From the early episodes of learning of his father's fallibility and worshiping the chair to the final scene of unconversion, the book is about testing the truth of what he has been told about God and about reality. He specifies after his act of idolatry that it was not God he doubted, but his father's knowledge of God: "The result of this ridiculous act was not to make me question the existence and power of God; those were forces which I did not dream of ignoring. But what it did was to lessen still further my confidence in my Father's knowledge of the Divine mind" (45). It is his parents' *reading* of the world that he must continually test. Early on he finds that there is a widening abyss separating their language from his own; he cannot "read" reality through their Book, but must reread it and ultimately rewrite it for himself. The new language he turns to is literature, yet ironically it would be his belief that the illusions created by language create a sufficient truth that would cause the biggest disgrace of his own career, the scandal over his inaccuracies as a biographer. The parallel is painful, but no clearer contrast could be imagined between the conflicting views of father and son: the father's doomed effort

[34]Folkenflik and Folkenflik, "Words and Language," 162.

[35]Howard Helsinger points out how this represents a reversal of Augustine, who "was tormented by the duality he discovered in himself" and who "devoted all his effort and prayer to resolving that duality and restoring his soul's unity in God" ("Credence and Credibility," 59). Gosse, on the other hand, "moves away from the unity of faith and the belief in Truth . . . towards a theatricality which implies not only an acceptance of lying but almost a defense of it" (60).

to harmonize contradictory truths, the son's insufficient attention to ordinary literal truth.

Yet each ultimately demands an act of faith for his own interpretation of reality. As readers, we ask the same troubled question of *Father and Son* as Gosse asked of Revelation—how can a narrative so obviously symbolic be literally true? Revelation, the father's special text, stands in the most problematic relationship to historical truth of any book of the Bible because the events in it are foretold, are set in the future rather than being matters of historical record. Belief in them requires an act of faith. Similarly, the text Gosse offers as his own rewriting of Revelation has always been one of the most problematic of autobiographies, precisely because it too requires of the reader an act of faith: a belief in the literary, if not always the literal, truth of Gosse's idolatrous typology of the self.

Typology and
Autobiographical Fiction:
The Story of David

THE THREE autobiographies examined in this study range from the classic Victorian autobiography of conversion to the most self-consciously literary autobiography of subversion. While they appear to represent opposite ends of the spectrum in terms of self-presentation, method, and goals, each recounts a search for salvation in terms conditioned by biblical narrative patterns. Taken together, the three autobiographies display a gradual progression towards a freer handling of traditional typological motifs and structures and towards a more evident degree of fictiveness. As we have seen, the problematic relationship between fictional techniques and factual truth-telling becomes pronounced in *Father and Son*, where "reality" has been shaped in obviously fictive ways.

Newman, the most anxious of autobiographers to establish his truthfulness—that being the avowed purpose for which he wrote—tries to keep his literary strategies in the background. They are suppressed, subtle, restrained. He overwhelms us with evidence drawn from letters and diaries. Ruskin is more overtly literary. But even here, one must read between the lines to discern the motif of the journey to the underworld

behind his trip to Italy, or the repressed text beneath the surface narration. Finally, the artistic devices of Gosse are so apparent as to be almost distressing. His autobiography brings to the fore the literariness of this supposedly nonfiction genre.

Gosse takes us to the very edge of fiction, prompting us to cross the boundary and explore first-person novels with a thinly disguised autobiographical origin. Here the author, while presenting truths about his own past, does not claim to be doing so. The novelist disguises his past in the form of fiction (leaving biographers to mine his novels for "facts" about his life), whereas the autobiographer claims to offer his past as it really happened. The one insists on the fictionality of his work, the other strenuously denies it.

Novelists as well as autobiographers employ typology, for this is the language of the search for salvation. But ironically, the use of typology, which we have seen as part of the artfulness of autobiography, is for the autobiographical novelist part of the enterprise of mimetic realism. For if the novelist wants his work to look like autobiography (as the subtitles of *David Copperfield* and *Jane Eyre* indicate)[1] he must make use of familiar autobiographical patterns. Thus, the very features that make the truthfulness of the autobiographies suspect, the reliance on these biblical patterns, become for the novelist one of the greatest "proofs" of the authenticity of his narrative.[2]

[1]Dickens: "The Personal History, Adventures, Experience, and Observation of David Copperfield the Younger of Blunderstone Rookery (Which He never meant to be Published on any Account)" and Brontë: "An Autobiography."

[2]It should be noted that I am treating these novels as the fictional autobiographies of David Copperfield and Jane Eyre—not of Charles Dickens and Charlotte Brontë. That is, I am interested in the autobiographical presentation of these characters, rather than the self-presentation of their authors. Other critics have explored the latter issue from a variety of standpoints; for Dickens, see, for example, Philip Collins, " 'David Copperfield': 'A Very Complicated Interweaving of Truth and Fiction,' " *Essays and Studies* 23 (1970): 71–86, and K. J. Fielding, "Dickens and the Past: The Novelist of Memory," in *Experience in the Novel: Selected*

How do autobiographical novelists handle the typological motifs and structures traditionally available to spiritual autobiographers? How does the spiritual model of autobiography influence the writing of those whom Barry Qualls terms "the secular pilgrims of Victorian fiction"?[3] The following examination of two autobiographical novels, *David Copperfield* (1849–50) and *Jane Eyre* (1847), attempts to answer these questions.[4] In each novel the search for salvation is presented typologically, just as in "real" spiritual autobiographies. There are, for example, epiphanic moments that incorporate elements of the traditional conversion experience, such as the mountain setting or the open window, and the supernatural voice. But more specifically, the primary typological referent underlying both narratives is the biblical story of David.

David was traditionally regarded as the type of the autobiographer; he was believed to have written Psalms as direct autobiographical expressions of his own life and his relationship with God.[5] As an autobiographer, then, he was a fitting

Papers from the English Institute, ed. Roy Harvey Pearce (New York: Columbia University Press, 1968), 107–31. For critical analyses of the relation between Brontë's life and her fiction, see Helene Moglen, *Charlotte Brontë: The Self Conceived* (New York: Norton, 1976); Robert Keefe, *Charlotte Brontë's World of Death* (Austin: University of Texas Press, 1979); and Annette Tromley, *The Cover of the Mask: The Autobiographers in Charlotte Brontë's Fiction* (Victoria, B.C.: University of Victoria Press, 1982).

[3]Barry V. Qualls, *The Secular Pilgrims of Victorian Fiction* (Cambridge: Cambridge University Press, 1982).

[4]The question of why individual writers choose autobiographical fiction over autobiography is a complex one. In Dickens's case, an earlier attempt at straightforward autobiography failed, presumably because the material was too painful to be confronted directly; quotations from this autobiographical fragment later appeared in John Forster's *Life of Charles Dickens* (1872–74). As for Brontë, Linda Peterson suggests that social and generic prohibitions prevented nineteenth-century women from writing spiritual autobiography; they turned instead to private journals, memoirs, and the autobiographical novel (*Victorian Autobiography*, 120–25).

[5]Saint Augustine illustrates the influence of Psalms not only in the intensely personal tone with which he addresses God in his *Confessions* but also by interspersing quotations from Psalms throughout his autobiography. Describing the scriptural origins of religious autobiography,

analogue for the autobiographical personae of Dickens and Brontë. Furthermore, David begins his career as an underdog who must do battle with a much stronger opponent; later, he is persecuted and forced to flee into the wilderness. Thus, he provides an appropriate type for David Copperfield and Jane Eyre, who are physically small and must fight powerful enemies (such as the Murdstones, or John and Mrs. Reed), and who are driven into flight for survival. In both novels the disenfranchised of society—the orphan and the governess—are identified with the despised youngest son who becomes king.

The fairy-tale elements of this part of David's story have an obvious appeal for writers narrating the histories of powerless children who long to control their destinies. But while David serves as a figure of wish fulfillment for David Copperfield and Jane Eyre during their childhoods, his story gets more complicated when he grows up. For David is more than a Horatio Alger figure; in the course of his phenomenally successful rise from obscurity to power he also makes mistakes and must undergo a painful learning process. His errors involve love and egotism, and here again he prefigures David Copperfield and Jane Eyre, who must learn what it means to love properly, and how to reconcile their egotism with their genuine desire to do and to be good, to balance self-assertion with self-sacrifice.

But the biblical story of David is less innocent than this summary suggests. It is also a story of arrogance and adultery, betrayal and murder, that functions through complicated doublings and displacements. Dickens closely patterns his story

Paul Delany stresses the absolute centrality of Psalms: "Renaissance divines read *Psalms* autobiographically; the Presbyterian autobiographer Henry Burton, for example, considered the book to be a literal description of David's own life, and cited Psalm lxvi, 16 as proof: 'Come hearken, all ye that fear God, and I will tell you what he hath done for my soule.' John Donne found in *Psalms* a paradigm for every Christian's life" (*British Autobiography*, 28).

on the biblical model, often in remarkable detail. Yet ultimately, I argue that his attempts to depart from that model are the most revealing, suggesting that Dickens was unwilling to confront the darker implications both of the biblical story and of his own. Brontë, on the other hand, exploits the ignoble as well as the glorious facets of David's life. In a series of ironic reversals, she explores the complex resonances of typological analogies, showing how both Rochester and Jane Eyre become Davids, but in ways they—and we—do not expect.

David Copperfield

IN SPITE OF Dickens's evocative choice of biblical names for his hero and villain—David and Uriah—criticism of the novel customarily focuses on the imagery of baptism, death-by-water, and rebirth rather than on the story of David. It is clear that Dickens bases *David Copperfield* at least in part upon the classic typological pattern of loss and redemption: David is expelled from his childhood Eden, but goes to live with Ham in an ark, itself a type of Christian salvation.[6] Baptism is of course a metaphor for conversion and rebirth, since it marks a spiritual divide and the entrance into a new life. After his flight from the tyrannical Murdstones to the haven offered by Aunt Betsey Trotwood, David says, "Thus I began my new life, in a new name, and with everything new about me."[7] So

[6]In *The Victorian Temper: A Study in Literary Culture* (Cambridge: Harvard University Press, 1951) Jerome Hamilton Buckley writes that "a good many Victorian novelists made some dramatic use of water imagery, and a few even resorted to baptismal symbolism in describing the progress of the soul's rebirth. . . . In *David Copperfield* the motif recurs with varying degrees of 'symbolic' force: poor Barkis, resigned to his fate, simply drifts 'out with the tide'; while troubled Martha passionately cries her identity with 'the dreadful river' . . . and Steerforth, drowned in the Yarmouth tempest, retrieves in death his lost innocence" (100).

[7]Charles Dickens, *David Copperfield* (Harmondsworth: Penguin, 1966), 271–72; hereafter cited parenthetically.

radical is the discontinuity that William Spengemann calls the subsequent chapters a new novel entirely.[8]

But it is in the story of David, the unknown shepherd who became a powerful king, that Dickens finds the ideal prototype for David Copperfield, who rises from the blacking factory to become the most celebrated writer of the age. Numerous parallels indicate just how thoroughly Dickens had assimilated the biblical story to his own. Like the biblical David, David Copperfield begins life poor and obscure. In his antagonistic relationship to his stepfather Murdstone we can see echoes of David and his murderous father-in-law Saul: *Murd*stone beats David "as if he would have beaten me to death" (108). As Saul separates his daughter Michal from the son-in-law whom he resents, so Murdstone jealously interferes with the love between David and his mother. Both relationships are characterized by hypocritical friendly overtures on the part of the older man, gestures which both Davids learn to trust at their peril. When he first hears that Murdstone has married his mother, David Copperfield recalls that something connected with "the raising of the dead seemed to strike me like an unwholesome wind" (92). The remark evokes Saul blasphemously calling up the spirit of Samuel from the dead, thus subtly condemning Murdstone's bitter and distorted religion.

Saul becomes king at the request of the Israelites, though the prophet Samuel had warned them what manner of ruler they would have to endure: "He will take your sons, and appoint them for himself. . . . And he will take your fields, and your vineyards, and your oliveyards, even the best of them" (1

[8]"Only the first fourteen chapters of the novel have any serious claim to membership in the genre [of autobiography]," he writes. The "later chapters really tell an altogether different story with an altogether different subject" (William C. Spengemann, *The Forms of Autobiography: Episodes in the History of a Literary Genre* [New Haven: Yale University Press, 1980], 122–23). I suggest instead that the biblical story of David provides the typological underpinning for an autobiographical reading of these later chapters.

Sam. 8:11, 14). Similarly, Mrs. Copperfield takes for herself a new master, which no one else sees the necessity for, and he exercises a repressive authority over both her son and her property. David and his mother soon repent having allowed such a "king" to gain ascendancy over them, just as the people of Israel quickly repent their choice of Saul. The biblical Saul is a complex and tragic figure, but Dickens streamlines his character to suit his own purposes: he wishes to portray Murdstone solely in relation to his adopted son David. Thus, we see only that Murdstone, like Saul, torments David relentlessly; his whole object, as Copperfield says, "was to get rid of me" (208).

David Copperfield's flight from London repeats David's flight from Saul—each journeys alone into the wilderness to escape the persecutions of a malevolent father figure. Each becomes, temporarily, a wanderer and an exile, reduced to begging bread, until he finds refuge in the camp of the enemy (the Philistines, Aunt Betsy). But Murdstone is not the only persecuting figure of authority in the novel: cruel and boastful, Creakle terrorizes the schoolboys as Goliath terrified the men of Israel; David Copperfield calls him "a giant in a storybook" (140) and "an incapable brute" (141). Creakle also shares some of Saul's less attractive traits, including his suspicious nature and a hint of sadism.[9] His abuse of power extends even to the victimizing of his own family: as Saul wished to disown his children for siding with David, so Creakle announces, "My flesh and blood . . . when it rises against me, is not my flesh and blood. I discard it" (135).

David Copperfield describes himself and the other boys as "miserable little propitiators of a remorseless Idol" (142). In this drama of innocence oppressed by megalomania, Salem House school suggests a bitter reenactment of Saul's royal

[9]"He had a delight in cutting at the boys, which was like the satisfaction of a craving appetite. I am confident that he couldn't resist a chubby boy, especially; that there was a fascination in such a subject, which made him restless in his mind" (141).

court, where Creakle, Steerforth, and David form a triumvirate in which Steerforth, like Jonathan, occupies the role of favored son. Despite his special position at the school, Steerforth cannot, or will not, protect David from Creakle's savagery, any more than Jonathan, the king's son, can save David from Saul's plotting.

Dickens models the relationship between David and Steerforth on that between David and Jonathan in other ways as well. Copperfield meets Steerforth immediately after his first confrontation with Creakle, just as David meets Jonathan after slaying Goliath. (Copperfield hasn't slain Creakle, but he has stood up to him, mastering his fear and asking to have the humiliating placard taken off his back.) When Steerforth hears of David's punishment, he pronounces it "a jolly shame," for which, says David, "I became bound to him ever afterwards" (136). His words echo the biblical moment when "the soul of Jonathan was knit with the soul of David, and Jonathan loved him as his own soul" (1 Sam. 18:1); clearly it is love at first sight for David Copperfield, as it was for Jonathan and David. Of the latter pair David Damrosch writes: "The relationship between the friends has clear overtones of a relationship of husband and wife. . . . the language of love is repeatedly used."[10]

Dickens may not wish to go this far in his depiction of Copperfield's boyhood admiration of Steerforth; nonetheless, a potent undercurrent of desire emerges strongly in the bedtime scene where he lies awake gazing at Steerforth, who "lay in the moonlight, with his handsome face turned up, and his head reclining easily on his arm. He was a person of great power in my eyes; that was, of course, the reason of my mind running on him" (140). Of course. The superfluousness of these words suggests the very possibility they intend to suppress, that Steerforth's power is not the reason, certainly not

[10]David Damrosch, *The Narrative Covenant: Transformations of Genre in the Growth of Biblical Literature* (San Francisco: Harper & Row, 1987), 203–4.

the only reason, why David's mind runs on him. D. A. Miller has pointed to "the classic erotics of the scene."[11]

Perhaps only in David's grief over Steerforth's death do we realize the extent to which Steerforth has been the great love of his life. As the biblical David lamented the death of Jonathan, saying "thy love to me was wonderful, passing the love of women" (2 Sam. 1:26), so David Copperfield mourns for the loss of Steerforth more intensely than for his own wife.[12] The sentimental language he uses to describe Dora's death pales beside the despair with which he recalls "an event in my life, so indelible, so awful" that "for years after it occurred, I dreamed of it often. . . . I dream of it sometimes . . . to this hour" (854). The persistence of this unacknowledged love reveals how the sexual undertones of the biblical model erupt into the narrative in spite of efforts to repress them.

Despite these many parallels, it is ultimately in the conflict between David and Uriah that Dickens points most unmistakably—and provocatively—in the direction of his biblical source. In the central drama of David Copperfield's adult life he ousts his rival Uriah Heep in order to marry the woman they both desire. With their explicit references to the biblical prototype, King David stealing Uriah the Hittite's wife, these scenes are the strongest evidence for a typological reading of the novel.[13] When Uriah Heep confesses that he wants to marry Agnes, David would like to kill him: "I believe I had a delirious idea of seizing the red-hot poker out of the fire, and running him through with it. It went from me with a shock,

[11]D. A. Miller, *The Novel and the Police* (Berkeley: University of California Press, 1988), 198.

[12]The sight of Steerforth's drowned body brings back the early days of his love: "I saw him lying with his head upon his arm, as I had often seen him lie at school" (866).

[13]For a more detailed discussion of the parallels between the two David and Uriah stories, see Jane Vogel, *Allegory in Dickens* (University: University of Alabama Press, 1977), esp. her first chapter, "David, Uriah, and Joram."

like a ball fired from a rifle. . . . The strange feeling (to which, perhaps, no one is quite a stranger) that all this had occurred before, at some indefinite time . . . took possession of me" (441). Unlike his biblical namesake, David Copperfield suppresses his murderous impulse. But if he experiences a sense of déjà vu at this moment, it can only be because this scene—or one very like it—has indeed been acted out before.

Dickens carefully arranges for other details to coincide. In the Bible, David recalls Uriah the Hittite to Jerusalem and urges him to go home to bed, but Uriah insists on sleeping "at the door of the king's house" (2 Sam. 11:9); afterwards David arranges the ruse whereby Uriah will be killed. In the novel, following the unpleasant revelation of his desire for Agnes, Uriah Heep stays the night, but although David offers him his bed, Uriah insists on sleeping on the floor outside David's room; all night long David is haunted by dreams of murdering him while he sleeps (442–43).

In the end David does succeed in bringing about Uriah Heep's downfall. He conspires with Mr. Micawber, who exposes Uriah by reading aloud a letter containing a full account of his crimes. The device of the letter, while fully in keeping with Micawber's epistolary bent, also serves to sustain the biblical parallel, for it was by letter that King David got rid of Uriah the Hittite: "David wrote a letter to Joab, and sent it by the hand of Uriah. And he wrote in the letter, saying, Set ye Uriah in the forefront of the hottest battle, and retire ye from him, that he may be smitten, and die" (2 Sam. 11:14–15).

Thus David Copperfield, like his biblical namesake, destroys Uriah in his rivalry over a woman. Yet paradoxically it is in precisely this part of the novel, where Dickens has been at such pains to bring out the biblical echoes, that he veers away from the original most strikingly and suspiciously. For the biblical story is not complete if we read it only as an extraordinary fairy tale of a shepherd boy who becomes king. David's seduction of Bathsheba and his sending of her husband to his death represent a moral nadir, which God will later punish

with Absalom's rebellion. David's sordid behavior looks even worse when we remember that Uriah the Hittite was one of David's own "mighty men," away fighting to defend the kingdom. To avoid discovery as the author of Bathsheba's pregnancy, David calls Uriah home from battle so that Uriah can sleep with her, too. It is when Uriah nobly refuses to break his oath of purity, saying, "The ark, and Israel, and Judah, abide in tents; and my lord Joab, and the servants of my lord, are encamped in the open fields; shall I then go into mine house, to eat and to drink, and to lie with my wife? as thou livest, and as thy soul liveth, I will not do this thing" (2 Sam. 11:11), that David decides to have him killed.

Tellingly, David sends Uriah to his death in a way that is strongly reminiscent of Saul's earlier attempt to get rid of David himself. Saul had pretended to welcome David into the royal family by offering his daughter, Michal: "And Saul said, Thus shall ye say to David, The king desireth not any dowry, but an hundred foreskins of the Philistines, to be avenged of the king's enemies. But Saul thought to make David fall by the hand of the Philistines" (1 Sam. 18:25). Later, when David wants to dispose of the inconvenient husband, Uriah, he first wines and dines him as a respected friend, then offers him a woman (in this case, Uriah's own wife), and finally arranges to have him sent into the most dangerous part of the battle. The similarity between these hypocritical ruses suggests how far David has fallen from his earlier righteousness: David has become another Saul.[14]

But Dickens is not interested in pursuing his biblical model to this conclusion. His David must remain morally blameless throughout. To mitigate for his hero the blame that attaches to the biblical David, Dickens turns Uriah the Hittite, a steadfast figure of faith and loyalty, into a sly and scheming villain. By making him so repulsive, Dickens implies that Uriah deserves

[14]In *The Narrative Covenant*, David Damrosch points out this parallel: "Uriah [is] sent out as Saul had sent David" (241).

his fate. David, then, can only be commended for causing his destruction. But there is an unpleasant scapegoating in this transformation. The very intensity of David Copperfield's loathing (he sees Uriah as a clammy snail, a writhing snake, a slimy fish, and a malevolent baboon, and he believes that Uriah's "sleepless eyes" are always following him about) may make us suspect that there is some measure of unconscious guilt at work. Another clue that there is something dishonest in this attempt to reverse the roles of guilt and innocence is the frequency with which Uriah is described as a corpse: David's first sight of him is "a cadaverous face" appearing at a window; when introduced, Uriah holds out "a long, lank, skeleton hand" (275). David is acutely uncomfortable when they shake hands: "Oh, what a clammy hand his was! as ghostly to the touch as to the sight! I rubbed mine afterwards, to warm it, *and to rub his off*" (281).

It is as if the dead victim, the biblical Uriah, has come back to haunt this second David. The explanation for David's revulsion must surely be that he sees a parallel in Uriah that is too close to home: he does not wish to admit the similarity between his own climb from "labouring hind" to gentleman and Uriah's ambition to "get on." David despises Uriah—a "heep" representing the undifferentiated proletarian mass David has so narrowly escaped sinking into—precisely because they share a nasty secret: David conceals the fact of his rise; Uriah, with his pretense of "umbleness," conceals his desire to rise. Dickens tries to portray David's ambitions in a laudable light: David is always "cutting down trees in the forest of difficulty" (586). But Uriah lays bare the raw face of ambition; he is David's alter ego, a double that cannot be faced. And, as Georges Gusdorf observes: "According to most folklore and myth, the apparition of the double is a death sign."[15] The

[15]Gusdorf, "Conditions and Limits of Autobiography," 32. Gusdorf elaborates: "Narcissus, contemplating his face in the fountain's depth, is so fascinated with the apparition that he would die bending toward himself. . . . Mythic taboos underline the disconcerting character of the

point is that David/Dickens is engaged in looking in the mirror through the act of writing autobiography. And Uriah mirrors only too well the suppressed aggression of their hunger to be middle class and successful. Dickens displaces the ugly underside of ambition—the egotism and ruthlessness required to climb out of the "heep" at all costs—onto Uriah.

Dickens's distortion of the character of Uriah suggests his anxiety to avoid confronting the full implications of his biblical model. He is not sufficiently distanced from his own story to acknowledge its darker elements. The thoroughness with which Dickens covered up the episode of his abandonment in Warren's Blacking Factory is well known. Recreating in fiction the story of his own phenomenal rise from nobody to famous author, Dickens splits himself in two: the good but lifeless David, and the malignant, energetic Uriah. He thus protects his hero—and himself—from probing self-examination.

Yet ironically, even in transforming the biblical story, Dickens unconsciously reproduces it. For Uriah the Hittite is also partly King David's double: just as David was an outsider, a youngest son picked out by Samuel from amongst his brothers, so Uriah the Hittite is also an outsider by virtue of not being a Hebrew. Uriah becomes an intimate of the king, as David himself had been at the court of Saul. In trying to eliminate his rival, David becomes all the more like Saul, the paranoid king who takes in the outsider with a semblance of welcome, only to betray him. For Saul also saw in David a potential reflection of himself, an obscure young man singled out by God to rule over Israel, and feared that David would supplant him.

Thus, in seeking to destroy his double, the outsider whose story reflects his own, David Copperfield imitates the biblical paradigms perhaps more closely than Dickens intended. The reversal of guilt and innocence that Dickens attempts to per-

discovery of the self. Nature did not foresee the encounter of man with his reflection."

petrate doesn't quite come off. He tries to evade the sugges-
tion that his David too becomes a Saul, but in David's treat-
ment of Uriah, in his "killing off" of Dora, in his single-minded
pursuit of success, in his complacent snobbery, in his egotism,
David Copperfield clearly takes on aspects of the powerful
persecuting figures who victimized him. His violent wish to
run Uriah through with a red-hot poker reenacts not only
David's desire to put Uriah the Hittite to death, but also Saul's
own first attempt to kill David: "There was a javelin in Saul's
hand. And Saul cast the javelin; for he said, I will smite David
even to the wall with it" (1 Sam. 18:10–11). When David
threatens to turn into Saul, the narrative has come almost full
circle. The biblical story, with its doublings and displace-
ments, seems to have a life of its own, the resonances of which
neither David Copperfield nor *David Copperfield* can entirely
avoid.

Yet Dickens makes one more significant alteration in the
biblical story, designed to prevent David Copperfield from
finally turning into his own double and opposite. He sub-
stitutes an "Agnes" for the biblical Bathsheba. In 2 Samuel 12,
the prophet Nathan rebukes King David for stealing Uriah's
wife Bathsheba by telling a parable about a rich man who has
stolen a poor man's lamb; the implication is that David has
gone from protecting sheep to stealing them.[16] When he real-
izes that the parable applies symbolically to himself, David
repents of his rapacious actions. Changing Bathsheba's name
to Agnes—which means "lamb"—enables Dickens to invoke
this parable of self-recognition and repentance while simulta-
neously effacing the crime. Further, he places the story in a
Christian context, through the association of the lamb with

[16]As a poor shepherd David convinced Saul to let him fight Goliath by
telling a story: "Thy servant kept his father's sheep, and there came a lion,
and a bear, and took a lamb out of the flock: And I went out after him, and
smote him, and delivered it out of his mouth" (1 Sam. 17:34–35). Nathan
ironically transforms this story about defending sheep, designed to prove
David's fitness to defend Israel, into a parable about sheep stealing that
demonstrates David's unfitness to protect the people he now rules.

Christ. Dickens provides an Agnes, ever "pointing upward," to be the means of bringing David to a new self-understanding.

A conversion experience that David undergoes near the end of the novel reinforces the idea that Agnes represents Christian salvation. The episode employs the familiar conventions of wilderness wandering followed by mountain inspiration. David has gone abroad in despair: "The whole airy castle of my life," he says, was "a ruined blank and waste" (886). He travels aimlessly on the Continent, finally ending up in Switzerland. Here, in the truest tradition of spiritual autobiography, he experiences a revelation among the mountains: "In the quiet air, there was a sound of distant singing—shepherd voices; but, as one bright evening cloud floated midway along the mountain's-side, I could almost have believed it came from there, and was not earthly music. All at once, in this serenity, great Nature spoke to me; and soothed me to lay down my weary head upon the grass, and weep as I had not wept yet, since Dora died!" (887). "All at once . . . great Nature spoke to me;" an unearthly voice saves David from despair, as it did Augustine. At this moment he opens a letter from Agnes—as Augustine opened the Bible to a letter of Paul—and reading it makes a new man of him: "I put the letter in my breast, and thought what had I been an hour ago! When I heard the voices die away, and saw the evening cloud grow dim . . . yet felt that the night was passing from my mind, and all its shadows clearing, there was no name for the love I bore her, dearer to me, henceforward, than ever until then" (888). Now at last, like Ruskin after his ecstatic change of heart in the Alps, David feels inspired to resume his writing. As his thoughts turn to Agnes, David realizes that his "old association of her with the stained-glass window in the church [was] a prophetic foreshadowing of what she would be to me . . . in the fullness of time" (839).[17]

[17]Speaking of this passage, Avrom Fleishman writes that "the phrases 'prophetic foreshadowing' and 'the fullness of time' insist that the narrator is deliberately adopting a typological mode of interpreting his experi-

David, then, is "converted" by Agnes, as the King was "converted" by Nathan's story about the lamb. In a sense, he is converted to Agnes, and from Dora, whom he had loved "to idolatry" (615). For just as King David's first wife, Michal, loved him but could not understand him (she protests his dancing before the ark of the Lord, and is punished with childlessness [2 Sam. 6:20–23]), so Dora represented for David "the first mistaken impulse of an undisciplined heart" (766). The second wife is the "true" wife, who becomes the mother of David Copperfield's children, as Bathsheba was the mother of Solomon, the wise king whose succession to David's throne is a sign of renewal and restoration.

King David is converted to self-recognition through the telling of a story; as in conversions from Augustine to Gosse, the experience is mediated through "literature." Literature, too, plays its role in David Copperfield's salvation: when Murdstone tormented him he consoled himself with books, and at school he became a Scheherazade, courting Steerforth with nightly bedtime stories. The sign of his redemption in the mountains is his renewed ability, like Ruskin after Cumae, to work and to write: "I wrote a Story, with a purpose growing, not remotely, out of my experience, and sent it to Traddles, and he arranged for its publication very advantageously for me; and the tidings of my growing reputation began to reach me from travellers whom I encountered by chance" (889). In a self-reflexive gesture, the "autobiography" concludes with David Copperfield becoming an autobiographer; David's reward is to be able to make his own name by remaking the past fictionally. Like King David singing the story of his victory over his enemies, David Copperfield will go on to enjoy fame and security as an artist. In transforming Bathsheba into Agnes, Dickens has adapted the original narrative to his own purposes: he supplies King David's namesake with a woman

ence. . . . From this point on, theological language is rife in the narration" (*Figures of Autobiography*, 216).

who promises forgiveness and redemption, creating a Christian context for his hero's perilous but triumphant progress towards worldly success and personal revelation.

Yet Dickens wants to save David Copperfield without either of them ever having acknowledged David as a sinner. In this epiphanic affirmation, Dickens makes us momentarily forget that his hero has never owned up to the errors of his past. If we are tempted to accept David's denouement as a victory for both man and writer, in the double sense of winning both Agnes and control over his biblical material, we must also remember that, as an autobiographer, the "saved" David of the book's ending is only now beginning to write the story of his life, and in this he is guilty once more for repressing those parts of the narrative that (still) reveal his own earlier errors of action and vision. Seeking to portray himself as the giant-killer, the winner of kingdoms and wives, he conveniently forgets the rest of the story; the typological analogies he has tried to turn to his own advantage simultaneously uncover the moral price of these accomplishments. Unlike Gosse, who subverts typology to become a man of words, Dickens's effort to bend typology to his own autobiographical ends is partially subverted by the resilience of types and of biblical narrative.

Jane Eyre

THE PLOT OF *Jane Eyre* bears some remarkable resemblances to *David Copperfield*. In both novels orphans are cruelly oppressed and even beaten until they are driven into rebellion, at which point they are first imprisoned at home and then sent away to a dreadful school. Later each gains a victory over powerful opponents, escapes to a place of refuge, and begins the process of shaping a new life, but faces further trials in learning how to love properly and avoid idolatry. Each undergoes a period of wandering in the wilderness, but in the end achieves financial success and personal happiness, as well as

the revelation needed to become an autobiographer. In all of these ways, both novels are conditioned by the biblical story of David.

Yet if Dickens invokes the David story deliberately, but shirks its full implications, Charlotte Brontë exploits its resonances to the hilt. Her use of biblical imagery has been frequently observed; George Landow, for example, points out that in *Jane Eyre* typology becomes a "device for creating and defining character."[18] Jane compares her crushed dream of marrying Rochester to the victims of the tenth plague God brought upon Egypt: "My hopes were all dead—struck with a subtle doom, such as, in one night, fell on all the first born in the land of Egypt."[19] According to Landow, this passage illustrates Jane's recognition that "she is guilty of the sin of the Egyptians" because she has worshipped Rochester: "My future husband . . . stood between me and every thought of religion, as an eclipse intervenes between man and the broad sun. I could not, in those days, see God for His creature: of whom I had made an idol" (302). In contrast to Jane's clear-sighted self-reproach, Rochester's lack of self-knowledge is revealed when he applies a typological reference to himself without grasping its real meaning. By calling Thornfield Hall "this tent of Achan," Landow writes, "he condemns himself by admitting more than he realizes, for Achan was the Israelite who, disobeying God's command that no Jew should take spoil from conquered Jericho, brought disaster upon his people."[20]

However, Brontë's use of typology in *Jane Eyre* extends beyond mere purposes of characterization. Typology places the novel in the tradition of spiritual autobiography as a search for salvation. The subtitle "An Autobiography," writes Barry Qualls, "would have asked any serious reader to acknowledge

[18]Landow, *Victorian Types, Victorian Shadows*, 97.
[19]Charlotte Brontë, *Jane Eyre* (1847; Harmondsworth: Penguin, 1966), 323. Subsequent citations to this edition are noted parenthetically.
[20]Landow, *Victorian Types, Victorian Shadows*, 98.

the book's place in the long line of spiritual autobiographies and biographies that aspired to teach by illustrating one man's self-conquest amidst Vanity Fair's allurements."[21] Yet Linda Peterson has pointed out that this tradition had excluded women precisely by its reliance on biblical typology to interpret one's life. Prohibitions against women engaging in biblical hermeneutics meant that they had to find their own autobiographical structures if they were to write at all. Peterson suggests that Brontë subverts the tradition of spiritual autobiography because, while Rochester sees Jane as Delilah, and St. John Rivers sees her as Lot's wife, Jane herself attempts "to apply the types universally," irrespective of gender. In the end, Brontë gives her the victory of having Rochester regard her as David to his Saul. "He has somehow learned," writes Peterson, "the universal intention of the biblical models."[22]

But if Rochester learns, I would argue, it is only because Jane teaches him. Rather than subverting the autobiographical tradition, Brontë seeks to appropriate the typological paradigms of spiritual autobiography for her own feminist narrative. By reinscribing a woman, Jane, at the center of this "forbidden" discourse, Brontë illustrates a means by which Victorian women could break out of the imprisoning stereotypes of biblical temptresses—such as Eve and Delilah—and into the active and morally inspiriting roles of Moses, David, and even their fulfillment, Christ.

Rochester at first assumes that he himself will play the role of David, by virtue both of being the patriarch and of his talents as a musician. Rochester is the one with the fine voice, while Jane says, "I was no vocalist myself, and, in his fastid-

[21]Qualls, *The Secular Pilgrims*, 51. He adds: "Allusions to Bunyan and to the Bible . . . pervade all of Brontë's novels, which are structured around the journeys of their protagonists through the 'dreary wilderness' of this world." Other discussions of *Jane Eyre*'s indebtedness to *The Pilgrim's Progress* include Michael Wheeler's *The Art of Allusion in Victorian Fiction* (London: Macmillan, 1979), 36–42, and Gilbert and Gubar's *The Madwoman in the Attic*, 336–71.

[22]See Peterson, *Victorian Autobiography*, 134–35.

ious judgement, no musician either" (299). But, ironically, it is Rochester's desire for a woman to whom he has no right—as David desires Bathsheba—that creates the closest parallel, though Rochester refuses to see it. Rochester, like David, wants to get rid of an inconvenient spouse in order to take a new wife. Both men are punished for their presumption by the virtual destruction of their realms: David's kingdom is torn by civil war, Rochester's house is destroyed by fire. David's child by Bathsheba dies; Jane's dream on the night before her wedding, of carrying a crying child that she finally loses, echoes the biblical punishment.

Only at the end of the novel, when Jane returns to the disfigured Rochester, does he remark that "if Saul could have had you for his David, the evil spirit would have been exorcised without the aid of the harp" (463). Now Jane has become the musician with the power to charm: Rochester calls her a skylark and says the real birds have no music, for "all the melody on earth is concentrated in my Jane's tongue" (464). But in fact these role reversals have been prepared for all along: we see a hint of Saul in Rochester when he acts the part of the gypsy fortune-teller (like the witch of Endor whom Saul consulted to find out his future), and in Jane's battle with her childhood enemy, Mrs. Reed, we see a replay of David's contest with Goliath. There is an ongoing struggle between them during which Mrs. Reed oppresses Jane for years, but Jane finally vanquishes her: "I was left there alone—winner of the field. It was the hardest battle I had fought, and the first victory I had gained. I stood awhile on the rug . . . and I enjoyed my conqueror's solitude" (69).

In her triumph over this powerful antagonist, Jane proves that, like King David or David Copperfield, she is an active heroine, an adventurer. At every crisis she takes her fate into her own hands and determines her own course. When her friend, Miss Temple, leaves Lowood school to get married, she resolves to do something with her life. It is a moment of revelation: "Discovery dawned on me . . . I had undergone a transforming process. . . . Now I remembered that the real

world was wide, and that a varied field of hopes and fears, of sensations and excitements, awaited those who had courage to go forth into its expanse, to seek real knowledge of life amidst its perils" (116). The episode takes place in a typically Augustinian setting: Jane has been meditating alone at an upstairs window overlooking a garden. But her thoughts are not of mystical communion with God; rather, she demands of Him the opportunity to gain a wider experience of *this* world. Gazing at the distant mountains, she says, "It was those I longed to surmount; all within their boundary of rock and heath seemed prison-ground, exile limits. . . . I desired liberty; for liberty I gasped; for liberty I uttered a prayer; it seemed scattered on the wind then faintly blowing. I abandoned it and framed a humbler supplication. For change, stimulus. That petition, too, seemed swept off into vague space. 'Then,' I cried, half desperate, 'grant me at least a new servitude!' " (117). Jane, like David Copperfield, wants to be reborn out of her old life into a new one, to exchange her status as a helpless dependent for a secure social and financial position. But although her metamorphosis is also to be marked by a symbolic "baptism," or change of name, it is not accomplished as smoothly as David's transformation to "Trot." The night before her wedding Jane thinks, "Mrs. Rochester! She did not exist: she would not be born till to-morrow" (303). But in Jane's case the expected rebirth turns out to be a stillbirth.

After their interrupted wedding Rochester tries to apologize to Jane for the terrible deceit he has practised on her: "Jane, I never meant to wound you thus. If the man who had but one little ewe lamb that was dear to him as a daughter, that ate of his bread and drank of his cup, and lay in his bosom, had by some mistake slaughtered it at the shambles, he would not have rued his bloody blunder more than I now rue mine" (326). These words allude distinctly to Nathan's parable reproaching King David for seducing Bathsheba:

There were two men in one city; the one rich, and the other poor. The rich man had exceeding many flocks and

herds: But the poor man had nothing, save one little ewe lamb, which he had bought and nourished up: and it grew up together with him, and with his children; it did eat of his own meat, and drank of his own cup, and lay in his bosom, and was unto him as a daughter. And there came a traveller unto the rich man, and he spared to take of his own flock and of his own herd, to dress for the wayfaring man that was come unto him; but took the poor man's lamb, and dressed it for the man that was come to him. (2 Sam. 12:1–4)

The irony of Rochester's reference is that he identifies himself as the innocent poor man who has lost his lamb; in fact, of course, he is really the guilty rich man (King David himself) who has tried to take what does not belong to him. Once again, Rochester misuses typology and misses the implications of his own analogies. Like Dickens, Rochester only wants to see himself as a fortunate David; he is blind to the rest of the story.

David Copperfield "loved Dora to idolatry"; Jane has worshipped the man she loves, calling him "the dread, but adored, type of my unknown future day" (314). But Jane must learn to love Rochester as a man, not a substitute for God. After the hideous revelation that Rochester has a living wife, Jane sits alone contemplating her situation: "I was in my own room as usual—just myself, without obvious change: nothing had smitten me, or scathed me, or maimed me. And yet where was the Jane Eyre of yesterday?—where was her life?—where were her prospects?" (323). So radically altered is she that she must endeavor to connect the self of yesterday with the self of today—the classic problem of the autobiographer. Her impassioned paraphrase of Psalm 69 reflects her despair: "The waters came into my soul; I sank in deep mire: I felt no standing; I came into deep waters; the floods overflowed me" (324). The typological implications of this psalm are powerful, for it continues with the words, "they gave me also gall for my meat;

and in my thirst they gave me vinegar to drink" (Ps. 69:21). Thus, in invoking it Jane associates herself not only with the autobiographer and psalmist David, but with Him for whom David is the type: Christ suffering on the cross.

Yet unlike so many Victorian heroines, Jane refuses to remain passive; her solution is to flee from Thornfield (with its evocative association with the crown of thorns). This decision has often been misunderstood, but like the flight of the biblical and the Dickensian Davids, her flight stems from the instinct of self-preservation, not of self-denial. She fights to save her life, not to drown, like Maggie Tulliver, in a flood of self-sacrifice.[23]

St. John Rivers will later urge Jane not "to yield to the vacillating fears of Lot's wife" (387), but she has already proven she is stronger than that: when she departs secretly from Thornfield she admonishes herself sternly that "not one glance was to be cast back" (347). Like the Israelites fleeing from Egypt, Jane embarks on "drear flight and homeless wandering" (348). She longs to go back to Rochester, but as the pillar of cloud guided the Israelites, so Jane is given heavenly guidance: "Still I could not turn, nor retrace one step. God must have led me on" (348). Thus, in making her escape Jane is like Moses—another ironic typological reversal, for when they were engaged Rochester allied himself with this powerful patriarch, promising that he would "gather manna for her morning and night" (295).

As David Copperfield found a refuge with his Aunt Betsey, so Jane finds a haven with her relations, Diana, Mary, and St. John Rivers. Later, St. John tries to persuade her to marry him and go out to India as a missionary, but she persists in her refusal. He cannot understand her grounds: the fact that she

[23]Elaine Showalter writes that George Eliot misunderstood the novel, for she was "unable to understand in Brontë's fiction . . . the difference between self-sacrifice and self-assertion" (*A Literature of Their Own: British Women Novelists from Brontë to Lessing* [Princeton: Princeton University Press, 1977], 124).

doesn't love him, or he her, is nothing to him, and he accuses her of selfishness. He urges her to "remember the fate of Dives, who had his good things in this life" (443). But Jane knows wherein true selfishness consists—this sacrifice, too, cannot be demanded of her. Her resourcefulness sustains her here, as it did when she fled from Rochester.

She is well aware that both men wish to enslave her—the very word is used, along with "thrall" and "fetters" (424). When Jane and Rochester go shopping for her trousseau, she thinks, "It would, indeed, be a relief . . . if I had ever so small an independency." The smile Rochester gives her is "such as a sultan might . . . bestow on a slave his gold and gems had enriched" (297). When they are married, he says, " 'I'll just—figuratively speaking—attach you to a chain like this' (touching his watch-guard)" (299). Having escaped from the oppressive and imprisoning Gateshead and Lowood, Jane cannot now be satisfied with the "new servitude" that both Rochester and Rivers offer her.

The self-righteous missionary tries to coerce Jane into accepting his apocalyptic vision. Named for the author of Revelation, St. John Rivers "believed his name was already written in the Lamb's Book of Life, and yearned after the hour which should admit him to the city to which the kings of the earth bring their glory and honour; which has no need of sun or moon to shine in it, because the glory of God lighten it, and the Lamb is the light thereof" (442). After pressuring Jane steadily for weeks, St. John has a sublime moment in which he nearly succeeds in overcoming her resistance. She felt that "all was changing utterly with a sudden sweep. Religion called—Angels beckoned—God commanded—life rolled together like a scroll—death's gates opening showed eternity beyond: it seemed, that for safety and bliss there, all here might be sacrificed in a second. The dim room was full of visions" (444). Although Jane has fought against the repressive ideology of self-sacrifice throughout the novel, here the language of Revelation almost overwhelms her. But, alone with St. John in a

dark still house, in a room full of moonlight, "an inexpressible feeling" thrills through her, forcing her senses to wake: "They rose expectant: eye and ear waited while the flesh quivered on my bones. . . . I saw nothing, but I heard a voice somewhere cry—'Jane! Jane! Jane!'—nothing more" (444). Opposing the vision of St. John, her own mystical experience comes to her aid. "It was *my* time to assume ascendancy," she writes, "*my* powers were in play and in force" (445).

Jane calls this moment a "visitation" and an "inspiration." She compares it to "the earthquake which shook the foundations of Paul and Silas' prison; it had opened the doors of the soul's cell and loosed its bands—it had wakened it out of its sleep" (446). Jane likens herself to Paul, not at the moment where he hears a supernatural voice—this is not a conversion—but rather at the moment when he emulates the resurrection of Jesus, when the divine power he represents is affirmed by an earthquake, enabling him to triumph over his jailors (Acts 16:26).

Jane returns to Rochester to find him crippled and blinded from the fire that destroyed Thornfield. Rather than announce herself openly she decides to surprise him, taking in the candles in place of the servant. In the last of Rochester's typological mislabelings of her, he says, "This is you, Mary, is it not?" (458). When she tells him that Mary is in the kitchen he demands to know, "*Who* is it? *What* is it? Who speaks?" Jane replies evasively, "John and Mary know I am here," and Rochester bursts out, "Great God!" Still unable to believe, Rochester asks, "Is it only a voice? Oh! I *cannot* see, but I must feel, or my heart will stop and my brain burst. Whatever, whoever you are, be perceptible to the touch, or I cannot live!" At last she names herself, saying, "I am come back to you" (459).

Jane has come back like one risen from the dead. Just as the disciples doubted the resurrected Jesus, Rochester persists in questioning her: "In truth?—in the flesh? My living Jane?" Like Doubting Thomas, he must touch her before he will

believe. She reassures him, saying, "You touch me, sir—you hold me, and fast enough: I am not cold like a corpse, nor vacant like air, am I?" Thus, in a splendid typological coup, Jane resists the hermeneutic typecasting that would identify her with Mary and becomes instead the risen Christ. She arrives at evening, the same time Christ appeared before the disciples, and the first to recognize and greet her is Mary—who, when she opens the door for Jane, starts "as if she had seen a ghost" (457).[24]

Even after Jane kisses him, Rochester still cannot believe she has really come back. He asks her again if she's not dead, and she tells him, "No, sir! I am an independent woman now" (459). Though the connection may not at first be apparent, it is the information that Jane now has five thousand pounds of her own that finally convinces Rochester of her reality: "Ah! this is practical—this is real!" he cries. The point is, as Virginia Woolf would later elaborate in *A Room of One's Own*, that only financial independence gives a woman power, makes her "real." It is these five thousand pounds that enable Jane to come back in glory.

The reversal in their positions is further symbolized typologically by the epithet "sightless Samson" (456) that Jane applies to Rochester. For in his rage against being trapped by his marriage to a madwoman, Rochester had longed for "Samson's strength . . . [to] break the entanglement like tow!" (330). In addition, the night before their wedding was to have taken place it was Jane who could not believe that Rochester was

[24]Further evidence for reading Jane as a Christ-figure includes the following: Jane's quiet yet redemptive arrival is made known first to a John and a Mary; later Jane orders supper and they eat together, like Jesus and the disciples. Rochester describes how, in her absence, he had longed "for her restoration" (462), and now fears her imminent departure. Jane reminds him that she has been "travelling these last three days" (463), and also describes her "three days of wandering and starvation" when she first left him (464). However, she adds, "whatever my sufferings had been, they were very short" (465). The next morning Rochester refers to her arrival: "When you rose upon me so unexpectedly" (472).

real: he tried to assure her he was no phantom, but she remained unconvinced (307). Finally, in this scene of reunion it is Rochester who turns out to be Dives, although earlier St. John Rivers had accused Jane of fulfilling that type. Describing his life while Jane was gone, Rochester says, "my soul [was] athirst and forbidden to drink" (459). Dramatizing their new relationship to one another, Rochester gives her his watch to keep—the one he had once wanted to chain her with (470).

Throughout the book Jane Eyre contends against the stereotyping of conventional typology. She is neither a weak Lot's wife, a dangerous emasculating Delilah, nor a background figure like Mary—she refuses to be imprisoned in these limiting roles. Nor is she the sacrificial lamb to which Rochester has compared her; rather, because she is no longer helpless and dependent (the lamb is the poor man's property),[25] in her "Second Coming" she is "resurrected" as the Lamb of God. She announces herself as his Messiah, his Saviour, for she will mediate between Rochester and God.[26] She is Christ risen from the tomb—not Christ suffering on the cross, but Christ triumphant. When Rochester tells her she must delight in sacrifice to want to marry him, she exclaims, "Sacrifice! What do I sacrifice?" (470).

The typological evocations of the story of David earlier in the novel prepare the way for this denouement, for King David, like Moses and Adam, was a figure for Christ. Initially Rochester appropriates for himself the standard biblical types:

[25]Rochester's story about the poor man's lamb is prepared for earlier in the novel. One evening during their engagement Jane walks out to meet him; his greeting displays his confident assumptions about their respective roles: "Now I seem to have gathered up a stray lamb in my arms. You wandered out of the fold to seek your shepherd, did you, Jane?" (306). But she knows better, having already realized that "a lamb-like submission," while "fostering his despotism," would not suit his taste or his common sense (302).

[26]The scene closes with Rochester's prayer that he be given "strength to lead henceforth a purer life" and Jane saying that she "served both for his prop and guide" (473).

David, Moses, the shepherd. He does not suspect that he will end up blind and crippled, comforted by a marriage that some have seen as emasculating,[27] and thus reenacting the last years of David, "old and stricken," kept warm by a Shunammite maiden whom "the king knew . . . not" (1 Kings 1:1–4). With terrible irony, Brontë turns the typological tables on Rochester, granting him the role he has claimed for himself all along—but in a way that, as a careless reader of the Bible, he had never anticipated.

There are hints from the very beginning that in fact Jane will be the Christ-figure. On the opening page of the book Mrs. Reed says to Jane, "There is something truly forbidding in a child taking up her elders in that manner" (39). The remark links Jane with Christ, who was continually in conflict with "the elders," from his discussion with them in the Temple as a boy to his arguments with the Scribes and Pharisees as an adult.[28] Shortly afterwards, Jane gets into a fight with her cousin, John Reed, who is physically stronger than she is. She tells him he is like a murderer or a slave driver—or "like the Roman Emperors!" (43). As though she were already wearing a crown of thorns, she feels a drop of blood from her head trickle down her neck, and she experiences "pungent suffering." But Jane fights back, a David to his Goliath, and wins. One of the servants remarks: "Did ever anybody see such a picture of passion!" (43). They treat her as "the scapegoat of the nursery" (47), and later, Jane imagines herself telling Mrs. Reed: "I ought to forgive you, for you knew not what you did" (52).

[27]"Mr. Rochester's sex passion is not 'respectable' till Mr. Rochester is burned, blinded, disfigured, and reduced to helpless dependence. Then, thoroughly humbled and humiliated, it may be merely admitted" (D. H. Lawrence, "Pornography and Obscenity," in *Selected Literary Criticism* [New York: Viking Press, 1966], 39). Richard Chase sees Rochester's injuries as "a symbolic castration" ("The Brontës, or Myth Domesticated," in *Jane Eyre*, ed. Richard J. Dunn [New York: Norton, 1971], 467).

[28]Similarly, when David Copperfield is being particularly oppressed by the Murdstones he reflects that "there *was* a child once set in the midst of the Disciples" (105).

With her radically subversive remaking of patriarchal Western religion, Charlotte Brontë seems to anticipate Florence Nightingale's hope, expressed in her autobiographical essay *Cassandra* (1852), that "the next Christ will perhaps be a female Christ."[29] Her feminization of typology enables her to portray an unconventional heroine who assumes the active roles traditionally reserved for men. From the beginning, Jane Eyre questions the received values others attempt to impose and insists on her own idiosyncratic version: when asked what one must do to avoid going to Hell, the child replies, "I must keep in good health, and not die" (64). Thus for Jane the route to salvation lies in her own self-sufficiency. In the process of overcoming an exclusive and hypocritical code, Jane undergoes a metamorphosis from the marginal status of orphan, governess, and scapegoat to the triumphant role of the risen Christ—a clear-cut feminist victory.

In turning from autobiography to autobiographical fiction we see a shift in focus from the self and the self's relationship with God to the self in its relationships with others. Thus, in both *David Copperfield* and *Jane Eyre*, the Lamb of Revelation becomes a real woman, and the divine marriage an earthly one: the object of desire has become an embodied rather than a purely spiritual goal. As Sandra Gilbert and Susan Gubar write, "Not the Celestial City but a natural paradise . . . has all along been . . . the goal of Jane's pilgrimage."[30] For Brontë reverses the familiar terms: Jane may be Rochester's salvation, but *she* is the focus. Unlike David Copperfield's Agnes, she has power of her own; she is more than a symbol. In the closing pages Jane tells us, with an evident double entendre, that her marriage to Rochester was a close one, "for I was then his vision" (476). Jane, in fact, becomes the vision of Revelation: Rochester recalls how, in his darkest hour, "the alpha and

[29]Florence Nightingale, *Cassandra*, ed. Myra Stark (Old Westbury, N.Y.: The Feminist Press, 1979), 53.

[30]Gilbert and Gubar, *The Madwoman in the Attic*, 370.

omega of my heart's wishes broke involuntarily from my lips in the words,—'Jane! Jane! Jane!'" (471). Barry Qualls objects to this, saying, "But God or Christ is the Alpha and Omega of Revelation. Brontë, with so much quotation from the Apocalypse, begins to make it seem that for Rochester Jane is the New Jerusalem."[31] Precisely. Jane Eyre has transcended the imprisoning version of Revelation offered by St. John Rivers, to manifest in herself the promise of a feminized "new heaven and a new earth" in the masculine world of Victorian typology and autobiography.

[31]Qualls, *The Secular Pilgrims*, 66. This is also what happens in Elizabeth Barrett Browning's *Aurora Leigh* as the heroine becomes the New Jerusalem for *her* blind husband. As they dedicate their lives to one another, Romney "turned instinctively" to meet the divine "Aurora" of a new dawn:

> The first foundations of that new, near Day
> Which should be builded out of heaven to God.
>
> (IX, 956–57)

Bibliography

Abbs, Peter. Introduction. *Father and Son*, by Edmund Gosse. Harmondsworth: Penguin, 1983. 9–31.

Abrams, M. H. *Natural Supernaturalism: Tradition and Revolution in Romantic Literature*. New York: Norton, 1971.

Abse, Joan. *John Ruskin: The Passionate Moralist*. London: Quartet Books, 1980.

Alter, Robert. *The Art of Biblical Narrative*. New York: Basic Books, 1981.

Anderson, Norman A., and Margene E. Weiss, eds. *Interspace and the Inward Sphere: Essays on the Romantic and Victorian Self*. Macomb: Western Illinois University Press, 1978.

Arana, R. Victoria. "Sir Edmund Gosse's *Father and Son*: Autobiography as Comedy." *Genre* 10 (1977): 63–76.

Audra, E. "L'Influence de Ruskin en France." *Revue des Cours et Conferences* 27 (1926): 265–88.

Auerbach, Erich. "Figura." *Scenes from the Drama of European Literature: Six Essays*. Trans. Ralph Manheim. New York: Meridian, 1959. 11–76.

——. *Mimesis: The Representation of Reality in Western Literature*. Trans. Willard R. Trask. Princeton: Princeton University Press, 1953.

Augustine. *Confessions*. Trans. R. S. Pine-Coffin. Harmondsworth: Penguin, 1961.

Autret, Jean. *L'Influence de Ruskin sur la vie, les idées et l'oeuvre de Marcel Proust*. Geneva: Droz, 1955.

Bell, Srilekha. "John Ruskin: A Prophet in Transition." *Essays in Arts and Sciences* 11 (1982): 49–57.

Bibliography

Bercovitch, Sacvan. *The Puritan Origins of the American Self*. New Haven: Yale University Press, 1975.

——, ed. *Typology and Early American Literature*. Amherst: University of Massachusetts Press, 1972.

Bidney, Martin. "Dante Retailored for the Nineteenth Century: His Place in Ruskin's Thought." *Studies in Medievalism* 1 (1979): 33–44.

Blehl, Vincent Ferrer, and Francis X. Connolly, eds. *Newman's "Apologia": A Classic Reconsidered*. New York: Harcourt, 1964.

Brand, Dana. "A Womb with a View: The 'Reading' Consciousness in Ruskin and Proust." *Comparative Literature Studies* 18 (1981): 487–502.

Brontë, Charlotte. *Jane Eyre*. 1847. Harmondsworth: Penguin, 1966.

Brooks, Peter. "Repetition, Repression, and Return: *Great Expectations* and the Study of Plot." *New Literary History* 11 (1980): 503–26.

Browning, Elizabeth Barrett. *Aurora Leigh*. 1857. Ed. Cora Kaplan. London: Women's Press, 1978.

Buckley, Jerome Hamilton. "Autobiography in the English Bildungsroman." In *The Interpretation of Narrative: Theory and Practice*. Ed. Morton Bloomfield. Harvard English Studies 1. Cambridge: Harvard University Press, 1970. 93–104.

——. "The Pattern of Conversion." *The Victorian Temper: A Study in Literary Culture*. Cambridge: Harvard University Press, 1951. 87–108.

——. *Season of Youth: The Bildungsroman from Dickens to Golding*. Cambridge: Harvard University Press, 1974.

——. *The Triumph of Time: A Study of the Victorian Concepts of Time, History, Progress, and Decadence*. Cambridge: Harvard University Press, 1966.

——. *The Turning Key: Autobiography and the Subjective Impulse Since 1800*. Cambridge: Harvard University Press, 1984.

Bunyan, John. *"Grace Abounding to the Chief of Sinners" and "The Pilgrim's Progress."* Ed. Roger Sharrock. London: Oxford University Press, 1966.

Burd, Van Akin. "Ruskin's Testament to his Boyhood Faith: *Sermons on the Pentateuch*." In Hewison, 1–16.

Carlyle, Thomas. "On History." *The Works of Thomas Carlyle*, ed. H. D. Traill. 30 vols. Centenary Edition. London: Chapman & Hall, 1896–1901. XXVII, 83–95.

Carpenter, Mary Wilson. *George Eliot and the Landscape of Time: Narrative Form and Protestant Apocalyptic History*. Chapel Hill: University of North Carolina Press, 1986.

Charteris, Evan. *The Life and Letters of Sir Edmund Gosse*. New York: Harper, 1931.

Bibliography

Chase, Richard. "The Brontës, or Myth Domesticated." In *Jane Eyre*. Ed. Richard J. Dunn. New York: Norton, 1971. 462–71.

Clark, Kenneth. Introduction. *Praeterita*. By John Ruskin. 1949. Oxford: Oxford University Press, 1978. vii–xxii.

Cockshut, A. O. J. *The Art of Autobiography in 19th and 20th Century England*. New Haven: Yale University Press, 1984.

Colby, Robert A. "The Poetical Structure of Newman's *Apologia pro Vita Sua*." *Journal of Religion* 33 (1953): 47–57. Rpt. DeLaura, *Apologia* 452–65.

Collins, Philip. " 'David Copperfield': 'A Very Complicated Interweaving of Truth and Fiction.' " *Essays and Studies* 23 (1970): 71–86.

Columbus, Claudette Kemper. "Ruskin's *Praeterita* as Thanatography." In Landow, *Approaches*, 109–27.

Connolly, Francis X. "The *Apologia*: History, Rhetoric, and Literature." In Blehl and Connolly, 105–24.

Cook, E. T., and Alexander Wedderburn, eds. *The Works of John Ruskin*. 39 vols. London: George Allen, 1903–12.

Damrosch, David. *The Narrative Covenant: Transformations of Genre in the Growth of Biblical Literature*. San Francisco: Harper & Row, 1987.

Damrosch, Leopold, Jr. *God's Plot and Man's Stories: Studies in the Fictional Imagination from Milton to Fielding*. Chicago: University of Chicago Press, 1985.

Dante. *The Divine Comedy*. Trans. John D. Sinclair. 3 vols. 1939. New York: Oxford University Press, 1980.

Darwin, Charles. *The Autobiography of Charles Darwin*. 1887. Ed. Nora Barlow. New York: Norton, 1969.

Davis, Thomas M. "The Traditions of Puritan Typology." In Bercovitch, *Typology* 11–45.

Delany, Paul. *British Autobiography in the Seventeenth Century*. New York: Columbia University Press, 1969.

DeLaura, David J. "The Allegory of Life: The Autobiographical Impulse in Victorian Prose." In Landow, *Approaches*, 333–54.

——. *Hebrew and Hellene in Victorian England: Newman, Arnold, and Pater*. Austin: University of Texas Press, 1969.

Dickens, Charles. *David Copperfield*. 1849–50. Harmondsworth: Penguin, 1966.

Dodd, Philip. "The Nature of Edmund Gosse's *Father and Son*." *English Literature in Transition* 22 (1979): 270–80.

Egan, Susanna. *Patterns of Experience in Autobiography*. Chapel Hill: University of North Carolina Press, 1984.

Egner, G. *Apologia pro Charles Kingsley*. London: Sheed & Ward, 1969.

Evans, Joan. *John Ruskin*. London: Jonathan Cape, 1954.

Bibliography

Fairbairn, Patrick. *The Typology of Scripture*. 1845. Grand Rapids, Mich.: Zondervan Publishing House, 1952.

Fellows, Jay. *The Failing Distance: The Autobiographical Impulse in John Ruskin*. Baltimore: Johns Hopkins University Press, 1975.

Fielding, K. J. "Dickens and the Past: The Novelist of Memory." In *Experience in the Novel: Selected Papers from the English Institute*. Ed. Roy Harvey Pearce. New York: Columbia University Press, 1968. 107–31.

Fitch, Raymond E. *The Poison Sky: Myth and Apocalypse in Ruskin*. Athens: Ohio University Press, 1982.

Fleishman, Avrom. "The Fictions of Autobiographical Fiction." *Genre* 9 (1976): 73–86.

———. *Figures of Autobiography: The Language of Self-Writing in Victorian and Modern England*. Berkeley: University of California Press, 1983.

———. "*Praeterita*: Ruskin's Enclosed Garden." *Texas Studies in Literature and Language* 22 (1980): 547–58.

Folkenflik, Vivian, and Robert Folkenflik. "Words and Language in *Father and Son*." *Biography* 2 (1979): 157–74.

Fontaney, Pierre. "Ruskin and Paradise Regained." *Victorian Studies* 12 (1969): 347–56.

Frei, Hans W. *The Eclipse of Biblical Narrative: A Study in Eighteenth and Nineteenth Century Hermeneutics*. New Haven: Yale University Press, 1974.

Frye, Northrop. *The Great Code: The Bible and Literature*. New York: Harcourt, 1982.

Gabel, John B., and Charles B. Wheeler. *The Bible as Literature: An Introduction*. New York: Oxford University Press, 1986.

Gelpi, Barbara Charlesworth. "The Innocent I: Dickens' Influence on Victorian Autobiography." In *The Worlds of Victorian Fiction*. Ed. Jerome H. Buckley. Cambridge: Harvard University Press, 1975. 57–71.

Genette, Gérard. *Narrative Discourse: An Essay in Method*. Trans. Jane E. Lewin. Ithaca: Cornell University Press, 1980.

Gibbs, Mary, and Ellen Gibbs. *The Bible References of John Ruskin*. London: George Allen, 1898.

Gilbert, Sandra M., and Susan Gubar. *The Madwoman in the Attic: The Woman Writer and the Nineteenth-Century Literary Imagination*. New Haven: Yale University Press, 1979.

Gill, David H. "Through a Glass Darkly: A Note On 1 Corinthians 13,12." *Catholic Biblical Quarterly* 25 (1963) 427–29.

Gosse, Edmund. *Father and Son: A Study of Two Temperaments*. 1907. New York: Norton, 1963.

Gosse, Edmund. *Father and Son: A Study of Two Temperaments*. Ed. Cecil Ballantine. London: Heinemann, 1970.

———. *Father and Son*. Ed. James Hepburn. Oxford: Oxford University Press, 1974.

———. *The Life of Philip Henry Gosse*. London: Kegan Paul, 1890.

Gosse, Philip Henry. *Omphalos: An Attempt to Untie the Geological Knot*. London: J. Van Voorst, 1857.

Gracie, William J., Jr. "Truth of Form in Edmund Gosse's *Father and Son*." *Journal of Narrative Technique* 4 (1974): 176–87.

Griffin, Gail B. "The Autobiographer's Dilemma: Ruskin's *Praeterita*." In Anderson and Weiss, 107–20.

Gusdorf, Georges. "Conditions and Limits of Autobiography." Trans. James Olney. In Olney, *Autobiography*, 28–48.

Hansen, Lesley Alan. "The Frightful Reformation: Victorian Doubt and the Personal Novel of Religious Unconversion." Diss. Columbia University, 1984.

Harrold, Charles Frederick. *John Henry Newman*. Hamden, Conn.: Archon Books, 1966.

Helsinger, Elizabeth K. *Ruskin and the Art of the Beholder*. Cambridge: Harvard University Press, 1982.

———. "The Structure of Ruskin's *Praeterita*." In Landow, *Approaches*, 87–108.

———. "Ulysses to Penelope: Victorian Experiments in Autobiography." In Landow, *Approaches*, 3–25.

Helsinger, Howard. "Credence and Credibility: The Concern for Honesty in Victorian Autobiography." In Landow, 39–63.

Hewison, Robert, ed. *New Approaches to Ruskin: Thirteen Essays*. London: Routledge, 1981.

Hilton, Timothy. *John Ruskin: The Early Years, 1819–1859*. New Haven: Yale University Press, 1985.

Holloway, John. *The Victorian Sage*. New York: Norton, 1953.

Hough, Graham. "Ruskin." *The Last Romantics*. 1949. New York: Barnes & Noble, 1961. 1–39.

Houghton, Walter. *The Art of Newman's Apologia*. New Haven: Yale University Press, 1945.

Hunt, John Dixon. *The Wider Sea: A Life of John Ruskin*. New York: Viking Press, 1982.

Hunt, John Dixon, and Faith M. Holland, eds. *The Ruskin Polygon: Essays on the Imagination of John Ruskin*. Manchester: Manchester University Press, 1982.

Irvine, William. Introduction. *Father and Son: A Study of Two Temperaments*, by Edmund Gosse. Boston: Houghton, 1965. v–xlii.

Bibliography

Jay, Paul. *Being in the Text: Self-Representation from Wordsworth to Roland Barthes*. Ithaca: Cornell University Press, 1984.

Johnson, Lee McKay. *The Metaphor of Painting: Essays on Baudelaire, Ruskin, Proust, and Pater*. Studies in the Fine Arts: Criticism 7. Ann Arbor: UMI Research Press, 1980.

Jung, Carl. *Memories, dreams, reflections*. Ed. Aniela Jaffe. Trans. Richard Winston and Clara Winston. New York: Pantheon, 1963.

Keefe, Robert. *Charlotte Brontë's World of Death*. Austin: University of Texas Press, 1979.

Kermode, Frank. *The Genesis of Secrecy: On the Interpretation of Narrative*. Cambridge: Harvard University Press, 1979.

——. "Novel, History, Type." *Novel* 1 (1968): 231–38.

Lacan, Jacques. *Ecrits: A Selection*. Trans. Alan Sheridan. New York: Norton, 1977.

Landow, George P. *The Aesthetic and Critical Theories of John Ruskin*. Princeton: Princeton University Press, 1971.

——. *Elegant Jeremiahs: The Sage from Carlyle to Mailer*. Ithaca: Cornell University Press, 1986.

——. *Ruskin*. Oxford: Oxford University Press, 1985.

——. *Victorian Types, Victorian Shadows: Biblical Typology in Victorian Literature, Art, and Thought*. Boston: Routledge & Kegan Paul, 1980.

——, ed. *Approaches to Victorian Autobiography*. Athens: Ohio University Press, 1979.

Larson, Janet L. *Dickens and the Broken Scripture*. Athens: University of Georgia Press, 1985.

Lawrence, D. H. "Pornography and Obscenity." In *Selected Literary Criticism*. Ed. Anthony Beal. New York: Viking Press, 1966. 32–51.

Lenz, Sister Mary Baylon. "The Rhetoric of Newman's *Apologia*: The Ethical Argument." In Blehl and Connolly, eds., 80–104.

Levine, George. *The Boundaries of Fiction: Carlyle, Macaulay, Newman*. Princeton: Princeton University Press, 1968.

Macksey, Richard A. "Proust on the Margins of Ruskin." In Hunt and Holland, 172–97.

Mandel, Barrett J. "Full of Life Now." In Olney, *Autobiography*, 49–72.

Manning, Stephen. "Scriptural Exegesis and the Literary Critic." In Bercovitch, *Typology*, 47–66.

Martin, Brian. *John Henry Newman: His Life and Work*. London: Chatto & Windus, 1982.

Matthews, William. *British Autobiographies: An Annotated Bibliography of British Autobiographies Published or Written before 1951*. Berkeley: University of California Press, 1955.

Maurois, André. "Proust and Ruskin." *Essays and Studies by Members of the English Association* 17 (1931): 25–32.

Melvill, Henry. *Sermons*. 2 vols. 1843. New York: Stanford & Swords, 1854.

Miller, D. A. *The Novel and the Police*. Berkeley: University of California Press, 1988.

Miner, Earl, ed. *Literary Uses of Typology from the Late Middle Ages to the Present*. Princeton: Princeton University Press, 1977.

Misch, Georg. *A History of Autobiography in Antiquity*. 3d edition. Trans. E. W. Dickes. 2 vols. London: Routledge & Kegan Paul, 1950.

Moers, Ellen. *Literary Women*. Garden City, N.Y.: Doubleday, 1976.

Moglen, Helene. *Charlotte Brontë: The Self Conceived*. New York: Norton, 1976.

Morris, John N. *Versions of the Self: Studies in English Autobiography from John Bunyan to John Stuart Mill*. New York: Basic Books, 1966.

Newman, John Henry. *Apologia Pro Vita Sua: Being a History of His Religious Opinions*. Ed. David J. DeLaura. New York: Norton, 1968.

———. *Apologia Pro Vita Sua: Being a History of His Religious Opinions*. Ed. Martin J. Svaglic. Oxford: Clarendon, 1967.

———. *Autobiographical Writings*. Ed. Henry Tristram. New York: Sheed & Ward, 1957.

———. *Discourses Addressed to Mixed Congregations*. London: Burns & Oates, 1849.

———. *An Essay on the Development of Christian Doctrine*. London: Longmans, Green, 1906.

———. *Letters and Correspondence of John Henry Newman*. Ed. Anne Mozley. 2 vols. London: Longmans, Green, 1891.

———. *The Letters and Diaries of John Henry Newman*. 31 vols. Ed. Charles Stephen Dessain et al. London: Thomas Nelson, 1961–77.

———. *Loss and Gain: The Story of a Convert*. 1848. Rpt. Tillotson, *Newman: Prose and Poetry*, 111–352.

———. *Newman the Oratorian: His Unpublished Oratory Papers*. Ed. Placid Murray. Dublin: Gill & Macmillan, 1969.

———. *Parochial and Plain Sermons*. 8 vols. 1834–43. London: Rivingtons, 1868.

———. *Sermons and Discourses*. Ed. Charles Frederick Harrold. 2 vols. London: Longmans, Green, 1949.

———. *Verses on Various Occasions*. London: Burns, Oates, 1880.

Nightingale, Florence. *Cassandra*. 1852. Ed. Myra Stark. Old Westbury, N.Y.: Feminist Press, 1979.

Bibliography

Nock, A. D. *Conversion*. London: Oxford University Press, 1933.

Olney, James. *Metaphors of Self: The Meaning of Autobiography*. Princeton: Princeton University Press, 1972.

——, ed. *Autobiography: Essays Theoretical and Critical*. Princeton: Princeton University Press, 1980.

Orr, William F., and James Arthur Walther, eds. *The Anchor Bible: 1 Corinthians*. Garden City, N.Y.: Doubleday, 1976.

Painter, George D. *Proust: The Early Years*. Boston: Little, Brown, 1959.

Pascal, Roy. *Design and Truth in Autobiography*. Cambridge: Harvard University Press, 1960.

Patten, Robert L. "Autobiography into Autobiography: The Evolution of *David Copperfield*." In Landow, *Approaches*, 269–91.

Pearlman, E. "Father and Mother in *Father and Son*." *Victorian Newsletter* 55 (1979): 19–23.

Peterson, Linda H. "Biblical Typology and the Self-Portrait of the Poet in Robert Browning." In Landow, *Approaches*, 235–68.

——. "Newman's *Apologia pro vita sua* and the Traditions of the English Spiritual Autobiography." *PMLA* 100 (1985): 300–314.

——. *Victorian Autobiography: The Tradition of Self-Interpretation*. New Haven: Yale University Press, 1986.

Pike, Burton. "Time in Autobiography." *Comparative Literature* 28 (1976): 326–42.

Plato. *Apology*. In *The Trial and Death of Socrates*. Trans. G. M. A. Grube. Indianapolis: Hackett, 1975.

Porter, Roger J. "Edmund Gosse's *Father and Son*: Between Form and Flexibility." *Journal of Narrative Technique* 5 (1975): 174–95.

Qualls, Barry. *The Secular Pilgrims of Victorian Fiction*. Cambridge: Cambridge University Press, 1982.

Quennell, Peter. *John Ruskin*. London: Longmans, Green, 1956.

Redford, Bruce. "Ruskin Unparadized: Emblems of Eden in *Praeterita*." *Studies in English Literature, 1500–1900* 22 (1982): 675–87.

Reiter, Robert. "On Biblical Typology and the Interpretation of Literature." *College English* 30 (1969): 562–71.

Ron, Moshe. "Autobiographical Narration and Formal Closure in *Great Expectations*." *Hebrew University Studies in Literature* 5 (1977): 37–66.

Rosenberg, John D. *The Darkening Glass: A Portrait of Ruskin's Genius*. New York: Columbia University Press, 1961.

——. "Style and Sensibility in Ruskin's Prose." In *The Art of Victorian Prose*. Ed. George Levine and William Madden. New York: Oxford University Press, 1968. 177–200.

——, ed. *The Genius of John Ruskin: Selections from His Writings*. Boston: Houghton Mifflin, 1965.

Ross, Frederic R. "Philip Gosse's Omphalos, Edmund Gosse's *Father and Son*, and Darwin's Theory of Natural Selection." *Isis* 68 (1977): 85–96.

Ruskin, John. *The Diaries of John Ruskin*. 3 vols. Ed. Joan Evans and John Howard Whitehouse. Oxford: Clarendon, 1956–59.

——. *The Works of John Ruskin*. Library Edition. Ed. E. T. Cook and Alexander Wedderburn. 39 vols. London: George Allen, 1903–12.

Ryan, Michael. "A Grammatology of Assent: Cardinal Newman's *Apologia pro vita sua*." In Landow, *Approaches*, 128–57.

Sawyer, Paul. *Ruskin's Poetic Argument*. Ithaca: Cornell University Press, 1985.

Schneidau, Herbert N. *Sacred Discontent: The Bible and Western Tradition*. Berkeley: University of California Press, 1976.

Scholes, Robert, and Robert Kellogg. *The Nature of Narrative*. New York: Oxford University Press, 1966.

Seynaeve, Jaak. *Cardinal Newman's Doctrine on Holy Scripture According to His Published Works and Previously Unedited Manuscripts*. Oxford: Blackwell, 1953.

Showalter, Elaine. *A Literature of Their Own: British Women Novelists From Brontë to Lessing*. Princeton: Princeton University Press, 1977.

Shumaker, Wayne. *English Autobiography: Its Emergence, Materials, and Form*. Berkeley: University of California Press, 1954.

Siebenschuh, William R. *Fictional Techniques and Factual Works*. Athens: University of Georgia Press, 1983.

Spear, Jeffrey. "Ruskin as a Prejudiced Reader." *Journal of English Literary History* 49 (1982): 73–98.

Spengemann, William C. *The Forms of Autobiography: Episodes in the History of a Literary Genre*. New Haven: Yale University Press, 1980.

Starobinski, Jean. "The Style of Autobiography." Trans. Seymour Chatman. In Olney, *Autobiography*, 73–83.

Stein, Richard L. *The Ritual of Interpretation: The Fine Arts as Literature in Ruskin, Rossetti, and Pater*. Cambridge: Harvard University Press, 1975.

Stendahl, Krister. *Among Jews and Gentiles*. Philadelphia: Fortress Press, 1976.

Sussman, Herbert L. *Fact into Figure: Typology in Carlyle, Ruskin, and the Pre-Raphaelite Brotherhood*. Columbus: Ohio State University Press, 1979.

Svaglic, Martin J. "The Structure of Newman's *Apologia*." *PMLA* 66 (1951): 138–48. Rpt. DeLaura, *Apologia*, 441–52.

——. "Why Newman Wrote the *Apologia*." In Blehl and Connolly, 1–25.

Bibliography

Thwaite, Ann. *Edmund Gosse: A Literary Landscape, 1849–1928*. London: Secker & Warburg, 1984.

Tillotson, Geoffrey, ed. *Newman: Prose and Poetry*. Cambridge: Harvard University Press, 1970.

Trevor, Meriol. *Newman: Light in Winter*. London: Macmillan, 1962.

——. *Newman: The Pillar of the Cloud*. London: Macmillan, 1962.

Tromley, Annette. *The Cover of the Mask: The Autobiographers in Charlotte Brontë's Fiction*. Victoria, B.C.: University of Victoria Press, 1982.

Vargish, Thomas. *Newman: The Contemplation of Mind*. Oxford: Clarendon, 1970.

Virgil. *The Aeneid*. Trans. Allen Mandelbaum. New York: Bantam, 1981.

Vogel, Jane. *Allegory in Dickens*. Studies in the Humanities: Literature, 17. University: University of Alabama Press, 1977.

Walder, Dennis. *Dickens and Religion*. Boston: George Allen & Unwin, 1981.

Ward, Wilfred. *The Life of John Henry Cardinal Newman*. 2 vols. London: Longmans, Green, 1912.

Weinstein, Arnold. *Fictions of the Self: 1550–1800*. Princeton: Princeton University Press, 1981.

Wheeler, Michael. *The Art of Allusion in Victorian Fiction*. London: Macmillan, 1979.

Wilenski, R. H. *John Ruskin: An Introduction to Further Study of His Life and Work*. London: Faber, 1933.

Williams, Carolyn. "Typology as Narrative Form: The Temporal Logic of *Marius*." *English Literature in Transition* 27 (1984): 11–33.

Wilson, Walter Lewis. *Wilson's Dictionary of Bible Types*. Grand Rapids: W. B. Eerdmans, 1957.

Woolf, James D. " 'In the Seventh Heaven of Delight': The Aesthetic Sense in Gosse's *Father and Son*." In Anderson and Weiss, 121–44.

——. *Sir Edmund Gosse*. New York: Twayne, 1972.

Wordsworth, William. *The Prelude: 1799, 1805, 1850*. Ed. Jonathan Wordsworth, M. H. Abrams, and Stephen Gill. New York: Norton, 1979.

Yearley, Lee H. *The Ideas of Newman*. University Park: Pennsylvania State University Press, 1978.

Index

Abel, 6
Abraham, 6, 6n, 51, 94, 100
Abse, Joan, 106n
Achilles, 80–81, 100
Adam, 5, 12, 69, 145, 187
Aeneas, 14, 28, 50, 68, 75, 77, 79–83, 100
Agrippa, 47–48, 55
Ahab, 136, 157
Alter, Robert, 7
Anglicanism, 20, 24–27, 30–31, 33, 48n, 49, 51, 56, 60
Anthony, Saint, 99–100
Apocalypse. *See* Bible, Revelation
Auerbach, Erich, 5n, 6n, 7
Augustine, Saint, *Confessions*, 3, 8–9, 28, 48n, 49, 61, 73, 75n, 76, 80, 82n, 95–97, 142–43, 149, 163n, 175–76, 181
Autobiographical fiction, 13, 159–90
 Brontë's *Jane Eyre*, 13, 162–65, 177–90
 Dickens's *David Copperfield*, 13, 28, 162–78, 180–83, 189
 Newman's *Loss and Gain*, 33n, 35n, 63
Autobiography:
 based on typology, 4–13, 15, 24, 36–38, 41, 54, 60, 70, 72–75, 81, 84, 88, 112, 115, 120–21, 124,

130, 143, 161, 175, 178–79, 182–83
 exclusion of women, 14n, 179
 fictionality of, 15, 149–58, 161–62
 history of, 4, 8–10, 29, 62n, 90–91
 motifs of, 9, 11, 24, 27, 67–68, 82, 120
 problem of change over time, 14, 19–22, 34–38, 44–46, 51–55, 58, 69–74, 87–91, 95, 109, 113–15, 182
 as self-creation, 14–15, 60–61, 127, 138, 144–49, 152, 156
 as self-defense, 13, 20, 28–48, 55–57
 structure of, 3, 14, 24, 67–75, 81–82, 87–88, 90–93, 95–97, 107, 112–15, 120–21, 161

Bathsheba, 170–71, 174, 176, 180–81
Bercovitch, Sacvan, 62n
Bible, 5, 6, 23–24, 58n, 76, 80, 114–15, 119–23, 127, 130, 137–38, 140, 143–45, 149
 Acts, 9n, 28, 29, 37, 45–48, 55, 185
 Corinthians, 54, 62n
 Deuteronomy, 55, 82
 Exodus, 5, 23, 55, 76
 Ezekiel, 55
 Galatians, 9n, 28n

[201]

Index

Index

Index

Index

Uriah the Hittite, 165, 169–74

Vargish, Thomas, 61
Virgil, 78–81, 113, 137
Vogel, Jane, 169

Walther, James Arthur, 55n

Ward, Wilfred, 22n, 50n
Wheeler, Michael, 179n
Woolf, James D., 147n
Woolf, Virginia, 186
Wordsworth, William, 56

Yearley, Lee H., 32n

Library of Congress Cataloging-in-Publication Data

Henderson, Heather, 1955–
 The Victorian self : autobiography and Biblical narrative / Heather Hender-
son.
 p. cm.
 Bibliography: p.
 Includes Index.
 ISBN 0–8014–2294–9 (alk. paper)
 1. English prose literature—19th century—History and criticism. 2. Auto-
biography. 3. Authors, English—19th century—Biography—History and crit-
icism. 4. Newman, John Henry, 1801–1890. Apologia pro vita sua. 5. Ruskin,
John, 1819–1900. Praeterita. 6. Gosse, Edmund, 1849–1926. Father and son. 7.
Typology (Theology) in literature. 8. Bible in literature. 9. Self in literature. I.
Title.
PR788.A9H4 1989 828'.80809'492—dc20 89-7270